❖ ❖ ❖

you are more creative than you think

❖ ❖ ❖

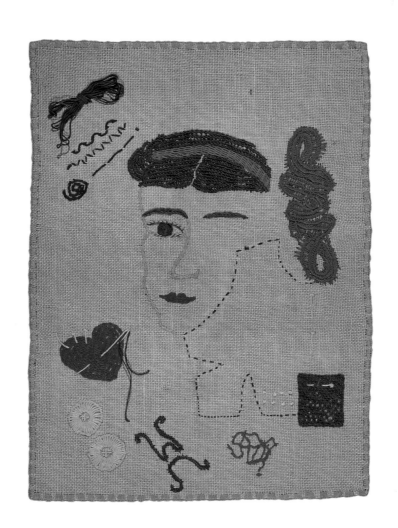

Modern Threads:
Fashion and Art by Mariska Karasz

Ashley Callahan, Curator,
Henry D. Green Center for the Study of the Decorative Arts
January 20–April 15, 2007
Georgia Museum of Art, Athens, Georgia

Published by the Georgia Museum of Art,
University of Georgia. All rights reserved.
No part of this book may be reproduced without
the written consent of the publishers.

Department of Publications:
Bonnie Ramsey and Hillary Brown

Design:
Brett MacFadden

Photography:
Michael McKelvey

Publications Intern:
Katherine Elizabeth Thomas

Printed in Canada in an edition of 1,000 by Friesens.

Typeset in Geometric 415 BT, Apollo MT, Monoline
Script, P22 Folk Art, and Gretel.

Illustrations: cover, cat. no. 145 (detail); back cover,
cat. no. 40; front matter, cat. no. 133; facing table of
contents, cat. no. 135 (detail); page 14, cat. no. 149
(detail); page 20, cat. no. 8 (detail); page 48, cat. no.
70 (detail); page 76, cat. no. 138 (detail).

Partial support for the exhibitions and programs at the
Georgia Museum of Art is provided by the W. Newton
Morris Charitable Foundation and the Georgia Council
for the Arts through the appropriations of the Georgia
General Assembly. The Council is a partner agency
of the National Endowment for the Arts. Individuals,
foundations, and corporations provide additional
support through their gifts to the Arch Foundation
and the University of Georgia Foundation.

Library of Congress Cataloging-in-Publication Data

Callahan, Ashley.
 Modern threads : fashion and art by Mariska Karasz /
by Ashley Callahan.
 p. cm.
 Includes bibliographical references.
 ISBN 978-0-915977-61-1

1. Karasz, Mariska, 1898-1960--Exhibitions. 2. Fashion
design—United States—History—20th century—Exhibi-
tions. 3. Fashion designers—United States—History—
20th century—Biography. 4. Textile designers—United
States—History—20th century—Biography. 5. Embroi-
dery—United States—Exhibitions. I. Georgia Museum of
Art. II. Title.
 TT505.K373C35 2007
 746.9'2092--dc22

 2006026176

SPONSORS

Friends of Fiber Art International

The Friends of the Georgia Museum of Art

The W. Newton Morris Charitable Foundation

LENDERS TO THE EXHIBITION

The artist's family

Cooper-Hewitt, National Design Museum,
Smithsonian Institution

The Costume Institute, the Metropolitan
Museum of Art

Jennifer Alden Cox

Georgia Museum of Art

Museum of Arts & Design

The Portas family

Private collection

TABLE OF CONTENTS

Acknowledgments
8

Preface
Madelyn Shaw
10

Introduction
14

Modern Gowns for the Modern Background:
Mariska Karasz's Fashions for Women
20

"Play suits that are fun to get into":
Mariska Karasz's Fashions for Children
48

Abstract Stitches: Embroideries by Mariska Karasz
76

Appendices
112

Selected Bibliography
114

Catalogue of the Exhibition
120

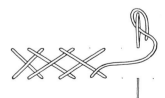

ACKNOWLEDGMENTS

RECENTLY I PURCHASED a vintage copy of Mariska Karasz's book *Adventures in Stitches* (1949). When I opened the front cover, written inside were the words "Have Fun," signed, "Mariska Karasz." And I have had fun—getting to know her family, playing the sleuth in the library, discussing her career with my family and friends, and preparing to share her story with as many people as I can through this publication and exhibition. Mariska makes me laugh, gives me something to be excited about, and reminds me why I am a decorative arts curator. Perhaps scholars should remain detached from their subjects, but Mariska and her sister, Ilonka, have overwhelmed me with their talents and personalities. I hope that in some small way I may contribute to their being better known and more widely appreciated in future decades because I am one of their most devoted admirers.

My colleagues at the Georgia Museum of Art have embraced my interest in the Karasz sisters, and together we presented an exhibition and published a corresponding book on Ilonka, *Enchanting Modern: Ilonka Karasz (1896-1981)*, in 2003. Ilonka worked in many areas, designing furniture, silver, ceramics, textiles, wallpapers, book jackets, and magazine covers, and creating prints and paintings. Though the sisters' careers periodically intersected, each deserves individual study, and now it is Mariska's turn. As with Ilonka, I first encountered Mariska during a course on women and textiles in America taught by Madelyn Shaw in the masters program in the History of American Decorative Arts offered jointly by Parsons School of Design and the Smithsonian Institution. Madelyn included the sisters on a list of under-researched, American, modern, female textile designers, and

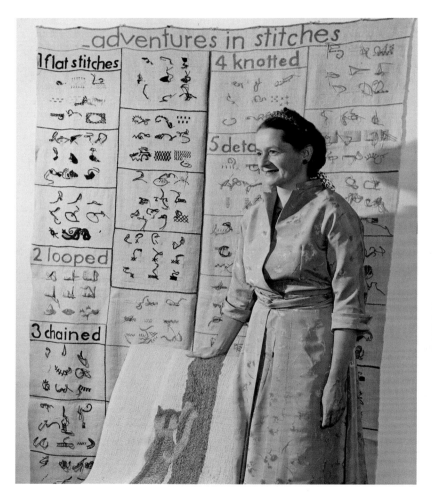

Mariska Karasz with *Adventures in Stitches* sampler, n.d.
Unidentified photographer
Photograph, 10 x 8½ inches
Cat. no. 170

they have been a part of my life ever since. Madelyn has been remarkably generous with her time and advice, even graciously agreeing to write the preface for this publication.

My utmost appreciation and respect go to Solveig Cox and Rosamond Berg Bassett, Mariska's daughters, without whom this project would not have been possible. They have shared family stories, funny and sad, uncovered treasure troves of papers and photographs, lent works of art, and been fabulous hosts. I first met Solveig and her husband, Wendell, in 1998, while a graduate student, and have enjoyed all of my visits and correspondences with them. Both Solveig and Rosamond are artists and both live in modern homes and are great cooks. Solveig is a member of the Hollin Hills Potters and often can be found at the Torpedo Factory in Alexandria, Virginia. Rosamond is a painter, and it was at an exhibition of her work in Georgetown that we first met.

I also wish to thank Ilonka's granddaughter, Ilonka Sigmund, and her family for all of their assistance; Mariska's granddaughter, Jennifer Alden Cox; Renate Reiss for her hospitality and generosity with the Winold Reiss Archives; Madelyn Shaw, Paul Manoguerra, Dennis Harper, Bill Eiland, Tricia Lichter, my husband, Mark Callahan, and my father, Mike Brown, for their comments on the rough draft of this text; Julia Brennan and Patrick McGannon for their conservation work; Taylor Little of Resolution for his scans of delicate material; Mimi Muray Levitt; Glen Kaufman in the fabric design department at the University of Georgia's Lamar Dodd School of Art; Virginia Feher in the Interlibrary Loan Department at the University of Georgia's Main Library; Victoria Haynie Cole and

Sara Brewer, both former interns at the Georgia Museum of Art; Annelies Mondi; Tricia Miller; Herbert L. Shapiro; Maria Ann Conelli; Pam Parmal; Jack Lenor Larsen; Michael Smallwood and Jim Concha at the Smithsonian American Art Museum; Doris Bowman at the National Museum of American History, Smithsonian Institution; Barbara Burkhardt; Monica Penick; Jonathan Chernes at *House Beautiful*; Susan Hudson at the Taft Museum of Art; Patrick McCormick at the Butler Institute of American Art; Allison Satre at the de Young Museum; Ava Ash at F. Shumacher & Co.; Julia Bailey at the Akron Art Museum; Michele Turner at the Currier Museum of Art; Kraig A. Binkowski at the Delaware Art Museum; Ellen Dodington and Greg Wittkopp at Cranbrook Art Museum; Mark Coir at Cranbrook Archives; Jason Van Yperen at the Montclair Art Museum; Janet L. Farber at the Joslyn Art Museum; Ulysses Dietz at the Newark Museum; Louise W. Mackie at the Cleveland Museum of Art; Jessica Batty at the Art Institute of Chicago; and Greg Herringshaw at the Cooper-Hewitt, National Design Museum, Smithsonian Institution. I am pleased to note that this project is supported in part by a grant from Friends of Fiber Art International.

In particular, I would like to thank Rebecca Brantley, who was my intern spring semester 2004. The following summer Rebecca received a Center for Undergraduate Research Opportunities (CURO) Summer Research Grant to investigate the links between Mariska's fashion designs and traditional Hungarian folk art and fashion, a topic she later developed into her honors thesis, titled "Mariska Karasz and Hungary: Early Design and Influences." Thanks also to CURO and the Honors Program at

the University of Georgia for their support of this project through Rebecca's research.

For their help arranging loans to this exhibition, I would like to thank Linda Clous at the Museum of Arts and Design; Barbara T. Duggan and Matilda McQuaid at the Cooper-Hewitt; and the staff at the Costume Institute at the Metropolitan Museum of Art, in particular Charles Hansen. Thanks also to my colleagues at the Georgia Museum of Art, especially to Bonnie Ramsey and Hillary Brown for seeing this publication through to completion and for sharing my excitement about working with Brett MacFadden as designer.

When I initially began researching Mariska's career, I found only limited information. Suddenly, in preparation for this project, letters, lists, photographs, ephemera, and works of art started to emerge from Solveig's closets. The information in these documents does not tell Mariska's entire story, but it is a more complete account than I ever expected. New digital tools also have yielded significant information about Mariska's career, and as these tools improve and expand, I expect that many more details about her career will surface. I hope that this text will serve as a framework for future research on this important modern designer and artist.

Ashley Callahan
CURATOR, HENRY D. GREEN CENTER FOR THE STUDY OF THE DECORATIVE ARTS

Detail of design used on
invitations and stationery, n.d.
Ink on paper, dimensions vary

AS TWENTY-FIRST-CENTURY historians of American art and culture reevaluate the twentieth century, they have begun to broaden our view and add to the canon of artists whose creative endeavors we must understand if we are to appreciate that era fully. This work by Ashley Callahan on the career and contributions of Mariska Karasz reintroduces to contemporary audiences a woman who was widely admired and influential in her day, but whose career, for reasons that have little to do with the caliber of her work, was overshadowed by other names.

Mariska lived a life defined by creativity and shaped by the principles and aesthetics she had absorbed in her birthplace, Budapest. One of the twin capitals of the Austro-Hungarian Empire after 1867, Budapest shared the vital artistic life characteristic of its sister capital, Vienna, in the late nineteenth century. As recent scholarship has shown, Hungarian artists were certainly exposed to the Arts and Crafts and Art Nouveau styles prevalent in western Europe, but in keeping with the cultural nationalism prevalent in Hungary (and indeed many other young nations in Europe) at the time, they tempered these new fashions by consciously including and adapting elements of Hungarian folk art.[1] Hungarian artists, designers, and architects, such as the members of the Gödöllő artists' colony (1901–1921), treated their past with respect, as a source to draw from in creating the modern Hungary, not as a handicap to be discarded in the search for modernity. They also happily accepted certain principles associated with the British Arts and Crafts movement, the Vienna Secession, and its successor, the Wiener Werkstätte (Vienna Workshop). Artists and patrons alike were

encouraged to view all of the arts, from architecture to fashion, as integral to the creation of a cultured environment and character. Among the Werkstätte artists (in these early years), there was little sense of hierarchy—Josef Hoffmann (1870–1956), for example, trained as an architect but designed furniture, textiles, and ceramics, too. The traditional boundaries between art and craft were blurred, and the Werkstätte and its adherents honored good craftsmanship as well as good design. In addition, women were accorded the right and opportunity to seek a career in art. Female artists such as Mitzi Friedmann-Otten (1884–1955) and Vally Wieselthier (1895–1945) were active and prolific members of the Werkstätte, also working in several media, and may well have been role models for younger women. The Viennese artists wanted to create a modern style that had a recognizably national character.[2] Mariska's understanding of what it meant to be an artist was formed within this environment.

When Mariska arrived in the United States, joining her mother and sister just prior to the outbreak of World War I in Europe, she came to a place that was physically very different from her former home but intellectually very similar and just as vibrant. American artists were interested in the new theories of art being propounded in Europe, and the 1913 art exhibition known as the Armory Show brought together many works of Cubist and Futurist painting and sculpture by European artists. This exhibition and those at the New York art gallery run by pioneering photographer Alfred Stieglitz (1864–1946) exposed American audiences to new ways of making, looking at, and thinking about art. Artists and intellectuals gathering in

New York were creating their own community and moving into inexpensive spaces in Greenwich Village formerly occupied by the working class and the urban poor.[3] Many women found that the new avant-garde climate, in which feminism played a significant part, accepted and encouraged their desire to be artists. Just as Hungary's ethnic diversity had contributed to the national character of its arts, immigrants from many nations added their own political and moral philosophies and literary, visual, and performing arts to the cultural crucible that was New York.

At the same time, producers of consumer goods (led by the textile and fashion industries) began to question a long-held belief that American industrial designers could—and perhaps should—only copy, not create. In December 1912, the *New York Times* announced a competition to encourage American "style creators." Ethel Traphagen (1882–

1963), who would later run an important fashion design school in New York, won first prize in the evening dress group for her interpretation of the "color, composition, and entire spirit" of James A. McNeill Whistler's (1834–1903) *Nocturne in Blue and Gold*.[4] In early 1914, American silk manufacturer M. C. Migel & Co. introduced a line of boldly colored printed silk dress fabrics whose designs were based on Mexican and southwestern American Indian motifs. The war in Europe that began in August 1914 sped up America's coming of age in terms of art and design. Britain, France, Germany, Austria-Hungary, Belgium, and Italy, the nations who were the leaders in the arts and in industry, were also those most deeply enmeshed in the war. The huge numbers of men and quantities of materiel that fed the slaughter on the western front left little energy and few resources available to cater to the market for consumer luxuries. With such an opening, theorists including William Laurel Harris and M. D. C. Crawford called for the formation of a national American aesthetic. By 1917, the "Made-in America" movement to encourage American manufacturers to produce quality design independent of European models and, equally important, to encourage American consumers to purchase it, had gained support from many in the fashion industry.[5] Cultural nationalism as the basis for self-consciously modern design—a very different ideology from the reverence for the past that marked the Colonial Revival style—had finally arrived in the United States. It would mature into a kind of cultural eclecticism over time, as Americans realized how immigration, migration, and education had transmitted a broad range of influences across the country.[6]

Mariska and her sister fit into this new social, intellectual, and cultural mix immediately. The fact that they brought with them what they knew of the arts in Hungary meant not only that New York was eager to absorb what they could share, but that they were entering a world they found familiar. As Callahan has pointed out in her 2003 book *Enchanting Modern: Ilonka Karasz (1896-1981)*, Ilonka, who arrived in New York a year before her sister, established herself quickly in Greenwich Village as a pioneer modernist with interests in painting and graphic design who also taught and contributed to avant-garde publications. Mariska's decision to pursue fashion as her medium may have had something to do with her sister's wide-ranging, almost omnivorous, talents. Fashion was the one area Ilonka left alone, and Mariska more than filled the gap.

In the early 1910s, high fashion was still the preserve of the upper class, patrons of the Paris couture houses and elite American custom dressmakers. Ready-to-wear clothing for women was generally confined to garments such as skirts, overcoats, and shirtwaists that could accommodate some range of body types in the fit and sold well at lower price levels. As the fashionable silhouette changed and simplified from the 1910s into the 1920s, ready-to-wear became a more acceptable (less expensive and reasonably well-fitting) option. For many, status still demanded a custom wardrobe, and those women wanted not only impeccable fit, but combinations of fabrics, trim, and details that would not and could not be found in ready-made garments. Opening a new couture business in this transitional period was fraught with obstacles. The high end of custom designing and

dressmaking was an intensely competitive business, with dozens of options open to potential clients. Sustained profitability was dependent on too many factors outside of the proprietor's control to be certain. Clients had to be found, seen in the right places and wearing your clothes in the right way, buy enough, and pay their bills. The clothes had to be in sync with fashion; different enough to be individual but not so bizarre as to be unwearable. Publicity of the right sort had to be obtained, whether by word of mouth or through the fashion press.[7]

Mariska seems to have worked around those factors. She was not a proponent of the extreme edge of fashion. Instead she found a niche that relied heavily on the aesthetic ideals of her youth: a folk design vocabulary brought up-to-date, skilled craftsmanship, vivid colors, the integration of ornament into the structure of the garment. Her business—even her children's wear—was near the top of the scale, but like many other small custom houses, hers was not a featured name in the big fashion magazines. *Vogue* and *Harper's Bazaar*, for example, concentrated their attention on only a few names, such as Jessie Franklin Turner, Elizabeth Hawes, and Sally Milgrim, who headed their own salons, and Sophie Gimbel of Saks Fifth Avenue and Fira Benenson of Bonwit Teller, designers who worked in the custom salons of the big department and specialty stores. Mariska's contract designing for ready-to-wear firms conforms to the pattern of these top designers. Hawes, for example, created several different product lines, including handbags. Very often, designers viewed this commission work as a way to subsidize their custom business.[8]

Mariska's transfer of her talents to embroidery from fashion design occurred at just about the time when the fashion business was growing all across the country. Ready-to-wear clothing was available at all price points, satisfying status-conscious customers who did not have or wish to set aside the time for the two or three fittings necessary for custom-made clothing. Much of the country's textile and clothing manufacturing base was turned over to military production soon after the United States entered World War II in December 1941. What consumer goods were being produced were rationed. Although the press again used the circumstances of the war to push American designers, they focused largely on ready-to-wear designers, whose clothes were worn by the majority of Americans. It was a sensible time for a career change.

Mariska's embroidered works of the 1940s and 1950s were not a departure in the field of hand-made textiles as fine art. From the 1910s into the 1930s many American artists—Marguerite Zorach (1887–1968), Lydia Bush-Brown (1887–1984), and Arthur Crisp (1881–1974), as well as Ilonka and Mariska—were creating unique works of art in embroidery and other textile techniques such as batik, following the tradition of the decorative woven tapestry or needlework hanging. This early work was mostly either pictorial or derived from folk traditions, including vernacular art and the art of non-Western cultures. The objects were often meant to hang on a wall, with the textile plane functioning in the same way as a painted picture. In the 1940s, weavers such as Dorothy Liebes (1897–1972) and Maria Kipp, whose work involved rather more assertive texture, color, and pattern

than most Bauhaus-influenced artists, became more prominent. Their textiles, used primarily as decorative and functional furnishing fabrics, were an important part of the American modernist interior and may have helped pave the way for Mariska's positioning of embroidery as a means of adding warmth and personality to plain, unadorned rooms. The post–World War II emphasis on "Good Design" as a means of bringing higher aesthetic ideals to mass-produced goods and, therefore, to the masses also created a market for publications and exhibitions that sought to educate the public in both recognizing good taste and ensuring that one's home environment exuded it. The publications on dressmaking and embroidery that Mariska produced during this period, however, did not encourage consumption of predigested good design.[9] Instead they harked back to an earlier Arts and Crafts philosophy that valued personal expression and believed in offering the tools of creativity to everyone.

Liebes's free experimentation with new fibers and materials may have influenced many artists who chose to work with fiber in the 1940s and 1950s. Some of these artists, such as Ed Rossbach (1914–2002), Dorian Zachai, Lenore Tawney (b. 1925), and Mariska, began to move away from two-dimensional textile work, drawing materials and techniques into three dimensions, in spite of a critical atmosphere that denigrated work that might be viewed as decorative or that violated the two-dimensional nature of the picture plane. Texture, depth, dimension, and volume were not used by these artists merely as surface qualities, but celebrated as inherent in the chosen medium. By the 1960s, some of this work was fully three-

dimensional and had gone beyond picture into sculpture. The collaged assemblages of the last stage of Mariska's life presage the work of many artists in the 1980s and 1990s, such as Ann Hamilton and Ann Wilson, who adopted fiber materials into their creative expression but did not and do not think of themselves as fiber artists. Mariska, too, would probably have refuted that label, given her early training in an environment that challenged hierarchy and compartmentalization in art.[10]

Mariska Karasz's varied career in the arts fulfilled the training of her youth. Unlike many of her contemporaries, who espoused modernism in its most rational form, Mariska preferred to acknowledge humanity's emotional needs in her work. Her tools were color, texture, and pattern, and her strong belief that art belonged in everyday life was her guiding principle.

Madelyn Shaw
CURATOR OF COSTUME AND TEXTILES, THE MUSEUM OF ART, RHODE ISLAND SCHOOL OF DESIGN

Mariska Karasz, 1918
Unidentified photographer
Photograph, $3\frac{1}{2}$ x $2\frac{1}{2}$ inches
Collection of the Portas family
Cat. no. 48

1 See Juliet Kinchin, "Hungary: Shaping a National Consciousness," in Wendy Kaplan, *The Arts and Crafts Movement in Europe and America, 1880-1920: Design for the Modern World*, 142–77 (New York: Thames and Hudson, in association with the Los Angeles County Museum of Art, 2004). Kinchin's essay provides essential background for understanding the art of both Karasz sisters.

2 Werner J. Schweiger, *Wiener Werkstätte: Design in Vienna, 1903-1932* (New York: Abbeville Press, 1984), 19.

3 See Caroline F. Ware, *Greenwich Village, 1920-1930; A Comment on American Civilization in the Post-War Years* (Boston: Houghton Mifflin, 1935), for a near-contemporary look at this transition.

4 Edward Bok, "Names of the Nine Prize Winners and Descriptions of Their Designs," *New York Times*, February 23, 1913.

5 Lauren Whitley, "Morris De Camp Crawford and the 'Designed in America' Campaign, 1916-1922," in *Creating Textiles: Makers, Methods, and Markets*, 410–19 (New York: Textile Society of America, Inc., 1998).

6 The Arts and Crafts style in America seems to me to owe more to European and Asian design models than to vernacular American arts.

7 For related discussions of dressmaking and the fashion industry see Pamela A. Parmal, "Line, Color, Detail, Distinction, Individuality: A. & L. Tirocchi, Providence Dressmakers" and Madelyn Shaw, "American Fashion: The Tirocchi Sisters in Context," both in *From Paris to Providence: Fashion, Art, and the Tirocchi Dressmakers' Shop, 1915-1947*, ed. Susan Hay, 25–49, 105–30 (Providence, RI: Museum of Art, Rhode Island School of Design, 2000).

8 Elizabeth Hawes, *Fashion Is Spinach* (New York: Random House, 1938), 196–201.

9 I am grateful to Joanne Dolan Ingersoll for pointing out the importance of mass consumption to those most involved in the Good Design movement.

10 See Jane Fassett Brite and Jean Stamsta, "R/Evolution" in *Fiber R/Evolution*, exh. cat., 9–20 (Milwaukee Art Museum and University Art Museum, the University of Wisconsin-Milwaukee, 1986).

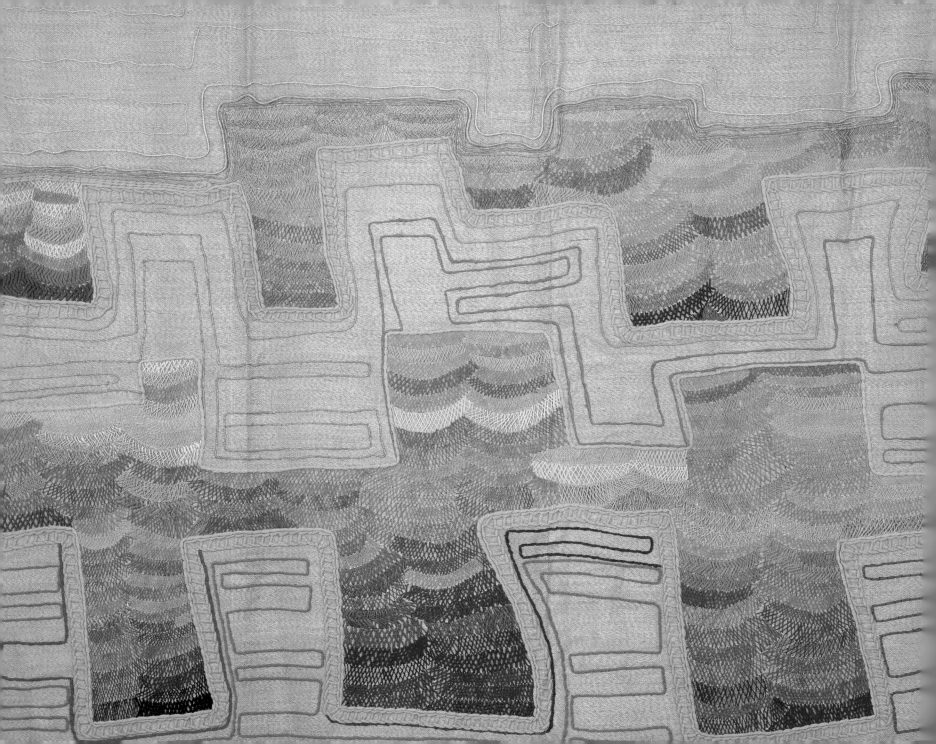

Introduction

MARISKA KARASZ (1898–1960) came to the United States, along with many other European immigrants, in the early part of the twentieth century.[1] She learned to work with textiles as a young girl in her native Hungary, and fabrics and threads remained integral to her subsequent professional careers as a fashion designer and artist in New York. Her foreign background and new American identity defined her custom fashion designs for women in the 1920s, which combined Hungarian folk elements with a modern American style. In the early 1930s, after her marriage and the births of her two daughters, Mariska began designing children's clothing, which was admired by parents, scholars, and critics for its practicality and originality. In the mid-1940s, following a devastating studio fire, she consciously reinvented her career. With her tool and material of choice—needle and thread—she created embroidered pictures that appeared in museums and galleries across the United States. The increasingly abstract wall hangings garnered her extensive national, and even international, attention.

The American Craft Museum in New York, now the Museum of Arts and Design, held an exhibition of Mariska's work with embroidery shortly after her death and is one of many museums with her embroidered wall hangings in its collection. Her fashion design, however, is significantly less well-represented in museum collections. *Modern Threads: Fashion and Art by Mariska Karasz*, presented at the Georgia Museum of Art in 2007, is the first exhibition to feature both aspects of her work and the first in more than forty years to focus solely on her.

Mariska Karasz was born in Budapest, Hungary, on December 2, 1898, to Samuel Karasz, a silversmith, and Maria Huber, who moved by herself to the United States while her children were young.[2] Mariska was the second of three children in a family supportive of education and craft; her older sister, Ilonka (1896–1981), became a successful artist and designer in New York, and their younger brother, Steve, assisted the girls with various creative projects.[3] While Ilonka excelled in drawing, Mariska demonstrated a talent for sewing. She learned to make stitches "so tiny that . . . she wonder[ed] how her eyes could see to make them."[4] According to Beryl Williams Epstein, who included a chapter on Mariska in her book *Fashion Is Our Business* (1945), Mariska "always took advantage of the regular visits of her mother's seamstress, to watch how real grown-up clothes were made, and to help plan her own dresses."[5] After Samuel Karasz died in 1912, the Office of the Matters of Orphans of the town of Nyíregyháza, in northeast

Hungary, granted permission for Mariska to immigrate to the United States to be with her mother, who had been there for approximately five years.[6] Mariska came to New York in 1914, preceded by her sister in 1913 and followed by her brother.

Before Mariska came to the United States, she had decided that she wanted to work with clothing and was already making blouses for her sister and herself, and later for family friends upon request.[7] She initially enrolled in a course in New York, probably in an industrial arts school, where she studied the drafting of patterns, but she was not satisfied with the work and left after six months.[8] Then she enrolled at Cooper Union School of Art in New York, where she studied with fashion designer and teacher Ethel Traphagen, who later founded the renowned Traphagen School of Fashion.[9] Rather than criticizing Mariska's inexpert drawing skills, Traphagen praised and encouraged her originality.[10] Mariska appreciated that Traphagen supported her attempts at individual expression instead of directing her to "conform [her] ideas to a conventional standard" and maintained this independent attitude throughout her career.[11]

Mariska was a vivacious, modern young woman; she even wore her hair fashionably short. During her early years in the United States, her social circle included her sister; photographer

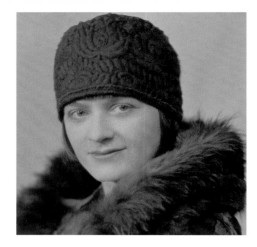

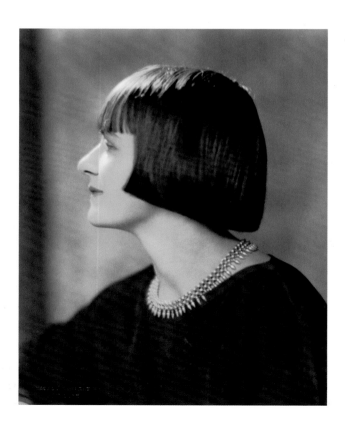

(top left)
Mariska Karasz wearing
an embroidered Hungarian
hat, n.d.
Unidentified photographer
Photograph, 2¾ x 2¾ inches

(bottom left)
Mariska Karasz, ca. 1928
Nickolas Muray (American, b.
Hungary, 1892–1965)
Photograph, 10 x 8 inches
© Nickolas Muray Photo
Archives
Cat. no. 44

(below)
Figure 1
Winold Reiss (American, b.
Germany, 1886–1953)
Mariska Karasz, 1917
Pastel on board
27 x 17 inches
Private collection
© W.T. Reiss Estate

Figure 2
Unidentified photographer
Ilonka Karasz (detail), ca. 1920
Glass slide with wear, approx.
5 x 3½ inches
Collection of the Portas family

Nickolas Muray (1892–1965), another Hungarian émigré; artist and designer Winold Reiss (1886–1953), a close friend of her sister's and a German émigré; Frederick Kiesler (1890–1965), a designer and architect originally from Austria; poet Edna St. Vincent Millay (1892–1950); Irina Khrabroff, who lectured and wrote about Russian art, culture, and gardens; and her friend Margaret Peck.[12] Reiss painted her portrait in 1917, smiling and rosy cheeked (Fig. 1), and Muray photographed her and Ilonka numerous times in the late 1910s and 1920s. The sisters both participated in life at Woodstock, New York, the site of an artists' colony since the beginning of the twentieth century, and Mariska likely was involved in the bohemian Greenwich Village scene in New York, of which Ilonka was an integral part.

Mariska and Ilonka enjoyed a particularly close relationship, and during Mariska's work with fashion their careers repeatedly intersected. In 1921, Mariska wrote a description of her sister, beginning, "To describe one's own sister is like describing one's own anatomy. No one ever thinks of closely observing that which is part or almost part of them, since one grows right up with both without giving any thought to the question why."[13] She stated that she sometimes was mistaken for her sister by individuals who hoped to meet Ilonka, but that even then she appreciated their close

relationship. Some of Mariska's energy for life and love for her sister are conveyed in the following words, "My little sister, as I often call her, may be namely [?] justified by her height which is two inches less than mine, and as to weight I often pick her up for the sheer joy of having her beg me to put her down."[14] Ilonka proved a willing model for her sister's clothing designs. The image in Figure 2 captures Ilonka wearing an outfit probably by Mariska featuring many colors and crocheted seams and edgings. Mariska described Ilonka's habits regarding fashion thusly: "Her desire to dress in something different every so often can only be filled if she wears all new creations made by her sister and if she starts at one end of her ward robe [sic] [and works her way] to the end of the fifty or so garments and begins over again."[15] Ilonka's soon-established reputation as one of the foremost modern designers in the United States likely helped Mariska gain cachet among their peers at the beginning of her career.

In a two-part article published in *Art Life of the Studio Club of New York* in November and December 1919, Mariska's account of a summer hike reveals her readiness to disregard convention and her inclination toward adventure.[16] During a month-long walking trip in upstate New York, Mariska and a friend set out to see part of the country without being bound by traditional

expectations of female attire.[17] In order to lighten their load, they sent their skirts ahead to the next city they expected to visit, but frequently preceded the skirts' arrivals. Mariska described the reactions: "At the sight of our breeches Williamstown was mortified, Rutland took us as a matter-of-course, Plattsburg turned around, Saranac Lake no doubt envied us and Lake George received us with a 'what mischief are they up to' air."[18] They visited with Shakers at Mt. Lebanon, walked in the Berkshires and Adirondacks, saw a creamery near Crown Point, stayed with farmerettes—female farmers—near Schuyler Falls (who wrote about them in the local papers, causing other farmers to recognize them later in the trip), fished and rowed at Saranac Lake, hiked up Mt. Ampersand with a host of black flies, and covered about five hundred miles on foot and a few more by steamer, trolley, and train.[19] These articles also reveal Mariska's

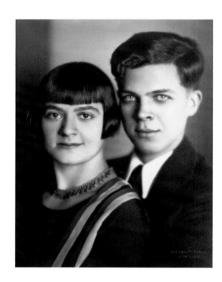

Mariska Karasz and Donald
Peterson, 1928
Nickolas Muray (American,
b. Hungary, 1892–1965)
Photograph, 9½ x 7¼ inches
© Nickolas Muray Photo
Archives
Cat. no. 41

skilled command of English and her interest in writing, an important component of her career in later decades.[20]

During a trip to California in 1928, Mariska met a young naval lieutenant named Donald Peterson (1900–1957).[21] They experienced a whirlwind romance and married soon after, on August 25, 1928. Originally from Minnesota, Donald moved to New York, where he worked in advertising and then radio, producing several shows, including *The Ave Maria Hour, True Adventures of Junior G-Men,* and *The Land of the Free.*[22] Mariska and Donald had two daughters, Solveig and Rosamond, born in 1931 and 1932, and they divorced in the early 1940s, probably 1942 or 1943.[23]

One of Mariska and Donald's wedding presents was a gift of about five acres of land from her sister and brother-in-law, adjoining their own property in Brewster, New York, about ninety minutes from the city by train.[24] Ilonka and her husband, Willem Nyland, began building their home in Brewster around 1920, painting the front door and eaves of the wooden structure with peasant-inspired ornamentations. Mariska and Donald built a modern house of poured concrete, painted white with red trim.[25] The interior treatments featured white walls and natural woods, with modern furniture made by her brother and bookcases with orange lacquer.[26] Mariska and Donald initially spent summers and spring and fall weekends there and winters in New York.[27]

Visitors to Mariska's house in Brewster over the years included Alexander Calder (1898–1976), who arrived one afternoon in his convertible unannounced but very welcome. Visitors to her studio

in New York included Frank Lloyd Wright (1867–1959), who asked Mariska to make neckties for him. She declined, suspecting that he simply wanted her to sew his designs rather than create ties of her own, a situation incompatible with her independent spirit.[28]

The following chapters present the three phases of Mariska's career: as a designer of women's fashion, as a designer of children's fashion, and as an artist working with fiber. She met with increasing success at each stage, gaining respect and admiration from both artistic and domestic audiences. Incorporated into this chronological approach are personal events, which are inextricably linked to Mariska's professional life. The text tells the story of one woman's experience as an artist in the United States from the 1910s through the 1950s within the context of the larger social, political, and artistic changes occurring during those years.

Home of Mariska Karasz, n.d.
Clara Sipprell (American, b.
Canada, 1885–1975)
Photographs mounted on paper
mounted in folded paper,
approx. 9 x 9½ inches each
Cat. nos. 124 and 125

1 Her name is pronounced "Ma-RISH-ka KAR-ahz." In Hungarian, a *karasz* is a type of fish, and later in her career, Mariska often used images of a fish in her work and on her stationery. Informal discussion with Solveig and Wendell Cox, February 11, 1998.

2 Beryl Williams Epstein, *Fashion Is Our Business* (New York: J. B. Lippincott Company, 1945), 171. Maria Huber's first name also appears as Mariska, the diminutive form of Maria or Mary, and her last name is also spelled Hubjer.

3 For more information on Ilonka Karasz, see Ashley Callahan, *Enchanting Modern: Ilonka Karasz (1896-1981)*, exh. cat. (Athens, GA: Georgia Museum of Art, 2003).

4 Epstein, 172.

5 Ibid.

6 Deposition submitted in the matter of the estate of the deceased: Samuel Karasz, October 3, 1912, collection of the artist's family. This document, in contradiction to other sources, lists Mariska's date of birth as June 26, 1899, and place of birth as Nyíregyháza rather than Budapest, which raises the possibility that the duration of her mother's stay in the United States, recorded in the document as five years, may also be slightly inaccurate.

7 Epstein, 173.

8 Ibid. Previously, Mariska attended the Prater Street Middle School for Girls in Budapest, with her general results in 1911–12 categorized as "Excellent." Mariska studied religion, Hungarian, German, history, mathematics, geometry, natural history, health/hygiene, economics, singing, crafts, gymnastics, and French as an elective. Her religion is listed as Lutheran (*Agostai Evangelikus*). Certificate of Girls' Middle School, Matriculation No. 22, June 27, 1912, collection of the artist's family.

9 Traphagen taught at Cooper Union from 1912 until 1932. Wilson Web, Biography Reference Bank, Ethel Traphagen, http://vnweb. hwilsonweb.com, via GALILEO, accessed September 16, 2005.

10 Epstein, 174.

11 "An Hungarian Dress Designer," *Christian Science Monitor*, May 25, 1926.

12 Informal interview with Solveig Cox, June 6, 2004.

13 Mariska Karasz, memorandum, August 23 or 25, 1921, collection of the artist's family.

14 Ibid.

15 Ibid.

16 *Art Life of the Studio Club of New York*, for which Mariska also produced illustrations, was a publication of an outreach program of the YWCA called the Studio Club. Author Elizabeth Wilson, in an account of her work with the YWCA, describes the Studio Club, a residence and meeting ground in Greenwich Village for young women interested in the arts, as "an art students' club with a religious aim." Elizabeth Wilson, "The Students," in *Fifty Years of Association Work Among Young Women, 1866-1916: A History of Young Women's Christian Associations in the United States of America* (New York and London: Garland Publishing, Inc., 1987),

271. Thanks to Rebecca Brantley for her assistance with this section on the Studio Club.

17 The friend likely was Margaret Peck, about whom little is known. Informal interview with Solveig Cox, June 6, 2004. The articles note that the hike occurred in July. As they appeared in late 1919, the hike probably took place in July of that year.

18 Mariska Karasz, "On the Long Trail: Part I," *Art Life of the Studio Club of New York* 4 (November 1919): 5. A trail called the Long Trail exists in Vermont, a 250-plus-mile hike built between 1910 and 1930, but the locations Mariska mentions are primarily in New York.

19 Mariska Karasz, "On the Long Trail: Part II," *Art Life of the Studio Club of New York* 6 (December 1919): 5.

20 Mariska knew some German and French as well. Informal interview with Rosamond Berg Bassett, March 16–17, 2006.

21 There are at least two possibilities regarding how Mariska and Donald first met. Their introduction may have occurred during a showing of her work while he was serving as an admiral's aide or they may have been introduced through followers of the mystic teacher Georges Ivanovich Gurdjieff, with whom Mariska and Ilonka were associated. Mariska was particularly interested in the teachings of Gurdjieff's follower Alfred Richard Orage. Informal interview with Rosamond Berg Bassett, March 16–17, 2006; and email from Solveig Cox, September 18, 2005.

22 Radio GOLDINdex, www.radiogoldindex.com, accessed May 16, 2006; informal interview with Rosamond Berg Bassett, March 16–17, 2006; and email from Solveig Cox, April 18, 2006. He worked primarily with WMCA. Email from Solveig Cox, June 6, 2006. Thanks to Mark Callahan for his assistance finding information on Donald Peterson.

23 Email from Jennifer Alden Cox, July 10, 2006.

24 Informal interview with Solveig Cox, February 11, 1998.

25 Mariska and Donald had to rebuild their initial house at Brewster because of termite damage. After rebuilding, they continued adding on to the house periodically until Mariska declared in 1938 that no more building would occur. Informal interview with Rosamond Berg Bassett, March 16–17, 2006.

26 Ibid; and email from Solveig Cox, August 1, 2006.

27 Informal interview with Solveig Cox, June 8, 2004.

28 Informal interview with Solveig Cox, February 11, 1998.

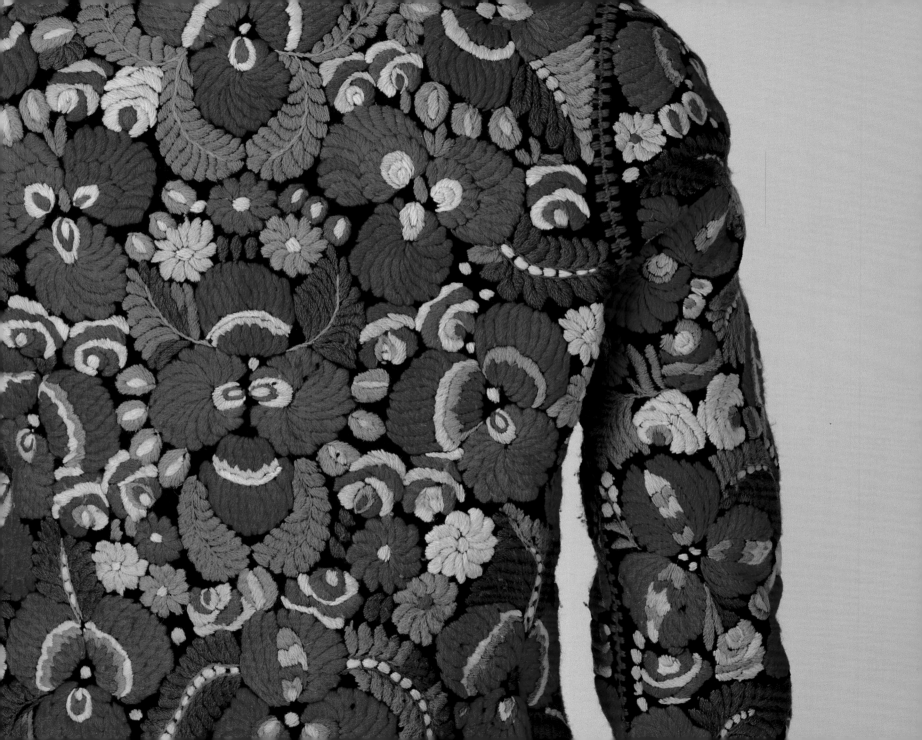

Mariska Karasz is an artist who has chosen for her medium of expression woven materials. She designs and makes dresses and coats and hats, and sometimes bathing suits and smocks or anything else that suits her fancy. She doesn't work with her materials; she plays with them. Her scissors and her needle seem to be having a contest to see which can do the most unusual thing. With the scissors she nips out clever bits of appliqué. With the needle she does a bit of lovely embroidery.

—

FROM THE ARTICLE "EXPRESSING WILHELMINA!"[1]

MARISKA KARASZ began working as a fashion designer at a time when Europe's hold on fashion in the United States was weakened because of limited international travel and diminished resources in European fashion houses caused by World War I. This new independence from the dictates of Parisian designers provided opportunities for American designers to assert their own creations, and Mariska likely benefited from this situation. Fashion historian Caroline Milbank states that New York fashion producers in the early twentieth century fell into several categories: ready-to-wear manufacturers, department stores, ladies' tailors, dressmakers, and specialty shops or custom-import houses, which she describes as selling imported clothing, adaptations of imports, and original designs. The stores in the specialty shop or custom-importer category were, according to Milbank, "the most exclusive, luxurious, and creative."[2] Mariska began by working with department stores, but her subsequent independent studio clearly fits into the last category.

Mariska occupied several apartments in New York in which she both lived and worked early in her career, though her earliest residences remain unidentified. By summer 1926, however, she was at 228 Madison Avenue.[3] Mariska expressed her enthusiasm for this space in a letter to "Wimest" (probably Ilonka's husband, Willem Nyland) in which she recounts her holiday activities and reports, "Ida had me for dinner last night—then she and a roumanian [sic] girl also in the party came up to my studio—Gee but everybody gets such a thrill out of this place—and I the most— Steve actually finished my beautiful cabinet and its [sic] just grand—better than a piano."[4] (Figures 1 and 2 portray Mariska in one of her studios, probably 228 Madison Avenue.) Late in 1928, she moved into a new studio at 107 East 34th Street, just off Park Avenue, and in October held an opening there for her "modern gowns for the fall."[5]

Probably later the following year, she moved a block east to 140 East 34th Street, where she remained until at least May 1931. Milbank notes that during the 1900s and 1910s, "the best establishments for shopping relocated to be near Fifth Avenue in the Thirties, Forties, and Fifties" and that more houses moved to that area in the 1920s, so Mariska's studio was ideally situated amid other quality fashion retailers.[6]

House Beautiful highlighted the studios of the Karasz sisters in August 1928, with written descriptions and black-and-white photographs. Mariska's studio contained a cupboard painted Chinese red placed against a pinkish gray wall, with an Inca rug in tones of red and pinkish gray with lavender tulips on the floor in front. The photographs and descriptions reveal that Mariska also filled the rest of the studio apartment with rich textiles and colors. Another room featured white pine furniture finished with orange shellac, a day bed with a "mulberry cover . . . with pillows of yellow, orange, magenta, and plum color edged with broad German woolen braids," a German handwoven wall hanging, and Russian and Peruvian rugs.[7] One writer described Mariska's studio as "a reproduction as nearly as she can make it of a cottage room in her native Hungary."[8] In addition to attesting to the popularity and renown of the Karasz sisters, the *House Beautiful*

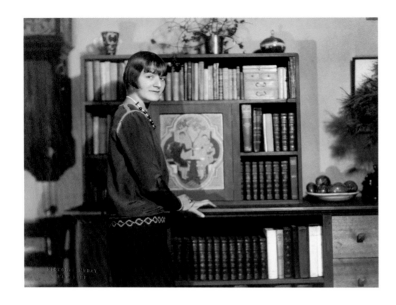

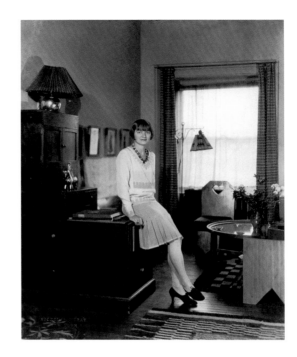

article emphasizes Mariska's interests in color, mixing modern and traditional elements, and gathering materials from around the world, important influences in her work.

Since Mariska had experienced success previously with designing blouses, she returned to that element of fashion after school and took several examples to Wanamaker's department store in New York, probably in the mid- to late 1910s.[9] According to an interview she gave in 1926, Wanamaker's initially promoted her designs through a department that offered French imports but soon gave them a department of their own; the store also hired Mariska part time and engaged two assistants to work on her designs.[10] An earlier reference, from October 1917, to Wanamaker's in an article by Morris De Camp Crawford (who

published as M. D. C. Crawford; 1882–1949) presents a slightly different version of the arrangement and records that several artists worked under the direction of a Miss Moreland, who led a new department specializing in the "development of artistic costumes."[11] Though the clothing illustrated with this reference is not attributed to specific designers in the text, the following words are handwritten over two of the outfits in a clipping of the article, which remains in Mariska's papers: "These dresses/were made by/Mariska Karasz/MDC" (Fig. 4). The illustration depicts two peasant-style costumes, one described as a blouse of turquoise blue silk jersey with crocheted bands of purple, blue, and cerise wool and the other as a dress of black wool jersey with crocheted bands of blue, gray, cerise, purple, and turquoise wool. When discussing the designs at Wanamaker's, Crawford stresses that the artists were all working

(above)
Figure 1
Nickolas Muray (American, b. Hungary, 1892–1965)
Mariska Karasz, ca. 1928
Photograph, 8 x 10 inches
© Nickolas Muray Photo Archives
Cat. no. 42

Figure 2
Nickolas Muray (American, b. Hungary, 1892–1965)
Mariska Karasz, ca. 1928
Photograph, 10 x 8 inches
© Nickolas Muray Photo Archives
Cat. no. 40

(opposite)
Announcement for Mariska Karasz (detail), n.d.
Unidentified designer
Ink on paper, approx. $5\frac{1}{2}$ x $3\frac{1}{2}$ inches
Cat. no. 57

Announcement for fall opening, 1928
Unidentified designer
Ink on paper, 5 x $6\frac{5}{8}$ inches
Cat. no. 60

Announcement for spring opening (detail), 1929
Unidentified designer
Ink on paper, $19\frac{15}{16}$ x $6\frac{1}{8}$ inches (unfolded)
Cat. no. 62

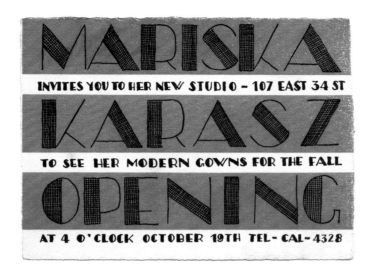

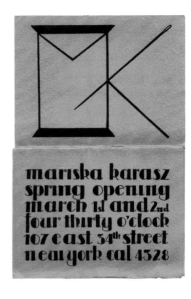

in the United States (though many of them likely were European immigrants) and credits them with creating "American styles."[12] In another article, he specifically emphasized that Mariska was "thoroughly American," a description probably applicable to anyone living in the United States and creating works for a modern American audience, especially when using American materials and technology.[13]

Crawford, who worked as design editor for the daily trade publication *Women's Wear* (which became *Women's Wear Daily* in 1927) and research associate in textiles for the American Museum of Natural History in New York, was a significant force in American textile design in the late 1910s, and his support of Mariska placed her in the heart of innovative textile work in the United States at the time.[14] He regularly wrote articles for *Women's Wear* and, through those, encouraged

designers to look to American Indian, Central and South American, Asian, Middle Eastern, and Central and Eastern European sources for inspiration, mentioning Hungarian peasant art on several occasions. In December 1916, Crawford recognized that foreign critics often cited the absence of peasant art in the United States as a reason that design there was not developing independently. He explained, "I acknowledge the debt that modern decorative arts owe to the peasant arts, such as in Hungary and the Slavic [*sic*], and I admit that we need such a basis for our own creation in this country."[15] Though numerous forces shaped American modern design, many of its most successful designers who emerged during the first few decades of the century came, like Mariska, from countries with strong folk traditions. Mariska and her European-born peers provided an important link to peasant arts that significantly influ-

enced modern American art and design. Crawford encouraged this phenomenon through his support of these artists and helped make it purely American by promoting and facilitating interaction among American designers, museums, and manufacturers, especially through his "Designed in America" campaign. A series of annual textile design contests sponsored by *Women's Wear* and held between 1916 and 1921 helped promote Crawford's efforts and resulted in the manufacture by American companies of textiles designed by American artists and inspired by objects in American museums.[16] Mariska was one of the prizewinners in the 1918 competition, and Ilonka won prizes in several of the contests.[17] Beryl Williams Epstein recorded that the "museums allowed the designers to study actual historic garments," from which they worked out contemporary designs.[18] Mariska later recalled that the

RIBBONS

New York. — Demand Seems to Have Declined—Warp Prints About the Only Merchandise Wanted.—After two or three weeks of a fair degree of activity, ribbons are again dull. About the only demand noted is in warp prints, principally dark colors, for fancy knitting bags, and perhaps a few other minor purposes. Aside from this very little is interesting the trade. Nearly all factors are convinced that for a time, at least, the market will remain as it is.

It seems that buyers have ceased taking merchandise until they know

Warns Against Giving Credit on Long Terms

Consumers Should Pay Cash for Necessaries, Says National Credit Association

While no concerted action has been taken as yet by merchants as a whole toward protecting themselves against extravagant purchases on the part of the consuming public, individual instances are said to be numerous where the merchant is seeking to do away with the uncertainty of long-

(above)
Figure 3
Clipping from unidentified newspaper (detail), ca. 1917
Newsprint mounted on paper, 9⅝ x 8 inches
Cat. no. 47

(left)
Figure 4
Clipping from *Women's Wear* (detail), 1917
Newsprint mounted on paper, 10 x 11⅞ inches (unfolded)
Cat. no. 46

research she did with the group involved in the contests was one of the most interesting experiences of her life.[19]

An undated sketchbook further documents Mariska's interest in the study of museum objects. It contains numerous drawings by her of ethnographic costumes and details of repeated patterns and singular abstract geometric, floral, and animal motifs, sometimes with colors indicated and occasionally with brief notes regarding origins or measurements. For example, Mariska sketched Coptic costumes, Slovak motifs, "Volkstrachten" (folk costumes), Dogrib Tribe (an ethnic group indigenous to what is now Canada) decorations, African patterns, and a vase by the Aymara Indians of Bolivia.[20] Crawford suggests many of these influences in his book *One World of Fashion*, providing further evidence that Mariska's activities closely coincided with his initiatives.[21]

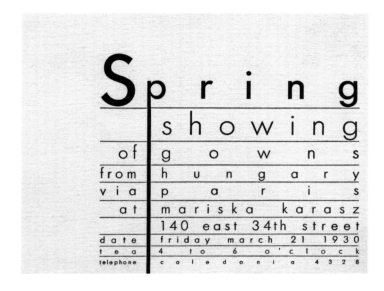

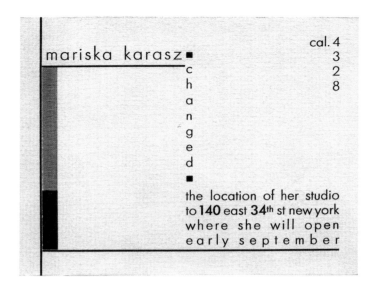

Crawford highlighted Hungarian peasant art in *Women's Wear* in January 1917, praising it for having "the fluorescence of an art drawn from many sources," adding that in Hungary many common objects such as "looms, . . . spinning wheels, boxes, [and] lintels of houses, are covered and painted in brilliant colors."[22] Mariska's work epitomized the qualities Crawford praised in Hungarian peasant art; she drew inspiration from a variety of sources and utilized rich colors in unexpected combinations. While Hungary played a significant role in Mariska's designs, she matured as an artist in the United States, absorbing influences from her experiences in New York, incorporating them into her work, and justifying her designation by Crawford as "thoroughly American."

One undated article by Crawford focusing solely on Mariska illustrates three peasant-inspired blouses that are described as both artistic and practical (Fig. 3). Crawford enumerates the specific attributes Mariska brought to her work from her native Hungary (including a love of fine coloring and skill in embroidery), commenting that "anyone familiar with Magyar peasant art will see the basis of this child's inspiration."[23] He also praises Mariska's skill while lamenting that fashion designers in the United States are not as appreciated as they are in Paris and expresses hope that the United States' perceived division of art workers (fine arts versus applied or decorative arts) will end: "Those things that enter our daily lives should be beautiful and if an artist devotes talent to this work, he deserves consideration as much as one who paints a picture."[24] Both Mariska and Ilonka worked in areas of art and design not traditionally categorized as fine arts, but they worked as artists and considered their work art. Mariska's contemporaries recognized this position, as seen in *Christian*

Announcement for spring showing, 1930
Unidentified designer
Ink on paper, 4⅜ x 5⅝ inches
Cat. no. 63

Announcement of change of address, 1929
Unidentified designer
Ink on paper, 4⅜ x 5⅝ inches

Figure 5
Nickolas Muray (American, b.
Hungary, 1892–1965)
Mariska Karasz, ca. 1928
Photograph, 10 x 8 inches
© Nickolas Muray Photo
Archives

Figure 6
Unidentified photographer
Mariska Karasz, ca. 1920
Photograph, 10 x 6⅝ inches
Collection of the Portas family

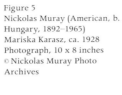

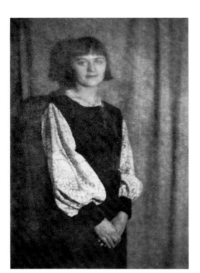

Science Monitor reporter Helen Johnson Keyes's description of her in 1931 as "an artist who has chosen for her medium of expression woven materials."[25] Mariska further emphasized the artistic nature of her work by advertising in the magazine *Creative Art* alongside fine art galleries, designers of modern interiors and furniture (including Ilonka), and antiques shops.[26] Crawford regrets that if Mariska's garments had come from abroad, they would sell for "fabulous" prices and be used as the basis for other creations, but because they were made in the United States, all she could expect to receive for them was "the mere price paid for excellent hand work."[27]

Another article from about the mid- to late 1910s describes Mariska's blouses as the "'studio type' overblouse," noting that she preferred the "straight hanging Russian cut of blouse to the more fitted Basque."[28] This early article indicates many of the characteristics that came to distinguish Mariska's fashions: distinctive use of color, individuality of design, and the synthesis of a traditional Hungarian folk style with a modern American aesthetic. The article notes the unusual fabric combinations Mariska employed in her blouses, such as "white wool gabardine, with trimmings of wool jersey in taupe"; blue chiffon over white satin with batik trimming; and a brilliant purple and white batik in an allover pattern with silk crochet shoulder pieces. The author adds, "every number seems to have some little touch that distinguishes it from the more usual run of studio work." Of particular note is Mariska's use of batik, which was in vogue at the time.[29] Two photographs survive of Mariska wearing clothing with batik; in one she wears a jacket possibly of a handmade batik

(Fig. 5), and in the other (Fig. 6), she wears a dress with sleeves of a machine-produced batik pattern designed by Ilonka and manufactured by H. R. Mallinson & Company, Inc., in 1918, as part of the *Women's Wear* contests.[30]

During this time, Mariska also took a position at the New York department store Bonwit Teller and Company in Jessie Franklin Turner's department.[31] Turner (1881–1956), an American couturier known for her use of fabrics inspired by museum objects, ran a custom salon at Bonwit Teller between 1916 and 1922 and was a close colleague of Crawford.[32] For one project, Mariska designed negligees and bathing costumes; the department store even presented a window display of her beach clothes (significant exposure for such a young designer) with designs based on American Indian patterns she had seen as part of Crawford's museum research program.[33] Mariska later described these clothes as "often extreme and fantastic," explaining that "very little restraint is required in designing these types of garments in which eccentricity is often desirable—or at least desired."[34] Ilonka made several drawings in the mid- to late 1910s that may record Mariska's designs for beachwear. Two (Fig. 7) appeared in the *Modern Art Collector*, an avant-garde publication produced in New York, in 1915, as "Modern Designs Used by Bonwit Teller & Co." One is a close-up of the head and shoulder of a woman wearing a polka-dotted bathing cap with water and seagulls behind her, while the other shows a full view of a woman with attenuated limbs wearing a modern bathing costume and posed as if preparing to dive against a background of abstracted waves and scattered puffy clouds.[35] A related drawing by

Figure 7
Ilonka Karasz (American,
b. Hungary, 1896–1981)
Detail from "Modern Designs
Used by Bonwit Teller & Co.,"
1915, published in the *Modern
Art Collector,* detail approx.
2¾ x 4⅛ inches
Private collection

Invitation to 228 Madison
Avenue, n.d.
Unidentified designer
Ink on paper, approx. 4¼ x 7½
inches (unfolded)
Cat. no. 56

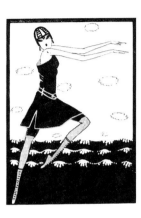
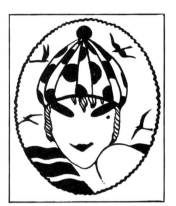

Ilonka of a woman in a polka-dotted bathing
costume appeared in another important avant-
garde periodical, *Playboy: A Portfolio of Art and
Satire,* in 1919.[36] Whether or not Ilonka's illustra-
tions depict Mariska's designs, the timing, the close
relationship of the sisters, and the dual links to
Bonwit Teller and beachwear suggest that it is
possible.

Mariska enjoyed working with the department
stores, but she eagerly accepted a chance to work
independently when a Hungarian friend opened a
shop on Eighth Street and invited her to show her
fashions there. Her work sold well, and after a year
she decided to open her own studio on Madison
Avenue with one seamstress.[37] When she had
enough money, Mariska traveled abroad to seek
"various Hungarian craftsmen who could execute
the kind of embroidery and appliquéd designs she
wanted" for use in her clothing designs.[38] Epstein
reports that "[Mariska's] reputation grew steadily,
and before she had been at work many years she
was recognized as the source of a particular kind of
exquisite workmanship, featuring native handwork,
that was seldom available in this country."[39]
Peasant-influenced designs were popular in the
mid-1920s, and the *New York Times* noted in 1925
that the couturiers of New York and Paris encour-
aged colorful needlework elements in fashion,
especially from Hungary and Bulgaria.[40] Mariska
incorporated both the forms and details of
traditional Hungarian peasant costume in her work,
providing unique designs to the New York fashion
world.

Accounts vary as to the precise nature of the
exchange between Mariska and the Hungarian
craftsmen, but it likely involved a combination of

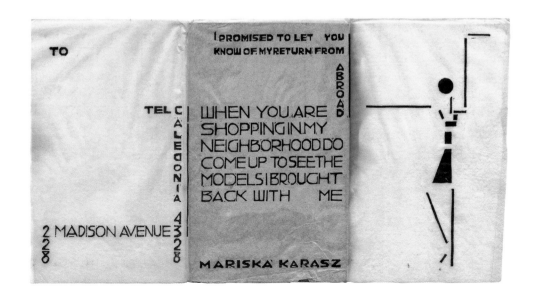

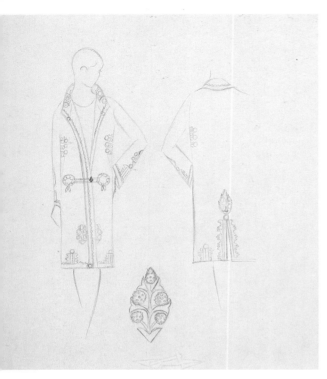

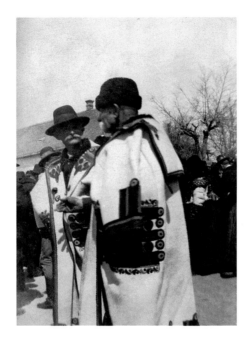

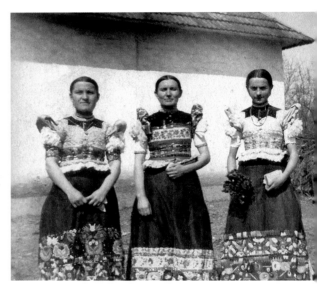

arrangements, with the goal of having Hungarian elements on outfits styled to Americans' tastes. In most cases the garments were designed and cut in the United States, sent to Hungary to be embroidered or appliquéd, and returned to the United States to be assembled. Mariska often highlighted the overseas connection, advertising in 1928, "ORIGINAL/DESIGNS/GOWNS•HATS•/IMPORTATIONS," and announcing, "I promised to let you know of my return from abroad. When you are shopping in my neighborhood come up to see the models I brought back with me" and "Mariska Karasz has returned from her trip abroad with many colorful things."[41]

One of Mariska's particularly Hungarian clothing designs was based on the *szür*, a traditional man's outer coat worn for centuries by Hungarian shepherds and peasants. The *szürs* were long and heavy, typically made with white back-

grounds, worn over the shoulders and fastened across the chest with the sleeves seldom used (and sometimes sewn shut and adapted for storage). Though their popularity in Hungary waned after World War I, they came to be a symbol of Hungarian nationalism.[42] Mariska, beginning at least by spring 1926, presented a *szür*-inspired coat as "a delightful evening wrap."[43] The *Christian Science Monitor* records that, for one, "on its thick, almost felt-like surface of ivory white she appliqués bands of color cut into charming designs."[44] A photograph of Mariska wearing an authentic *szür* survives (Fig. 10), as well as photographs she took of men wearing the coats in Hungary (Fig. 8). Her interpretation of this form included a more narrow profile than the original, functioning sleeves, and traditional placement of decorative elements. Rosamond recalls that Mariska's coat (Fig. 11), which is no longer extant, was of a thick white or

Szür-style jacket (detail), ca. 1926
Graphite on Fabriano paper,
11⅛ x 9 inches
Cat. no. 23

Figure 8
Unidentified photographer,
possibly Mariska
Hungarian men wearing
traditional *szürs*, n.d.
From Mariska Karasz's
scrapbook with photographs
of her trip to Hungary
Photograph, 3¼ x 2¼ inches
Cat. no. 51

Figure 9
Unidentified photographer,
possibly Mariska
Hungarian women wearing
traditional embroidered
costumes, n.d.
From Mariska Karasz's
scrapbook with photographs
of her trip to Hungary
Photograph, 2¼ x 3³⁄₁₆ inches
Cat. no. 51

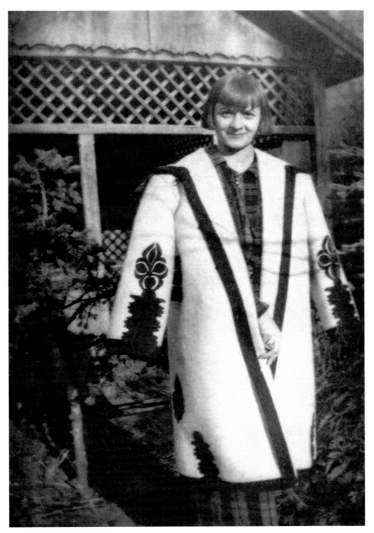

Figure 10
Unidentified photographer
Mariska Karasz wearing a
traditional *szür* in Hungary, n.d.
From Mariska Karasz's
scrapbook with photographs
of her trip to Hungary
Photograph, 2⅝ x 1¾ inches
Cat. no. 51

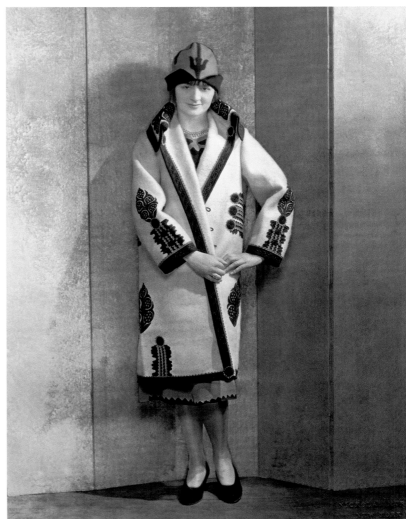

Figure 11
Nickolas Muray (American,
b. Hungary, 1892–1965)
Mariska Karasz, ca. 1926
Photograph mounted on board,
10 x 8 inches
17½ x 12½ inches (board)
© Nickolas Muray Photo
Archives
Cat. no. 38

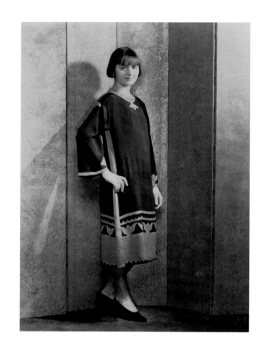

off-white wool with red and black and possibly green decorations.[45]

Two of the elements that most closely tie Mariska's fashion design to Hungary are her use of the fine embroidery for which the country is renowned and appliqué, which also has a long history in Hungary, especially in combination with embroidery in *szür* ornamentation. (A photograph from Mariska's scrapbook of a trip to Hungary [Fig. 9], shows women in traditional costumes with embroidery.) The embroidery in Mariska's clothing designs was primarily floral, often brightly colored, and in keeping with the Matyó folk embroidery style, which emanated from Mezőkövesd in northeastern Hungary. Mariska incorporated the embroidery both as decorative insets on outfits and as an allover pattern on jackets and vests. Traditional Hungarian folk appliqué often employs felt or leather, but the light-weight appliqué on

Mariska's clothing more closely resembles that made in Buzák in the southwest of Hungary, which utilizes primarily cotton and linen in appliqués. There, a design is basted to the support and the edges are turned in $^1/_{16}$ to $^1/_8$ inches, and sewn about $^1/_2$ inch at a time.[46] Mariska's appliqués variously appear as American jazz-age-inspired designs as well as motifs recalling traditional Hungarian folk art.

By the mid-1920s, Mariska was receiving favorable press about her independent work with women's fashion design. In her small custom studio she designed two groups of clothing a year, for spring and fall collections. An article from the *Christian Science Monitor* in May 1926 presents the most extensive account of Mariska's work to this point and includes a full-length photograph of her wearing one of her dresses (Fig. 12).[47] The unnamed female author describes Mariska's studio as a "spacious and orderly atelier" with "hand-made furniture . . . sometimes accentuated by flat tones of bright-colored paint" and Mariska as "a delightful young Hungarian artist" with "a gentle courtesy, a grace and graciousness which exalt the selection of a wardrobe into a social ritual." The writer acknowledges the Hungarian aspects of Mariska's work but adds that she "is too individual to be purely national." She also notes that Mariska used the finest materials and that her workmanship was impeccable. The article includes the following from Mariska of her activities as a fashion designer:

"For some time," said Miss Karasz, as she set on the table her gay dishes, "I worked for two New

York department stores. One of them formed a new shop for the sale of the blouses I designed. For the other I made negligees and bathing suits After doing this work for years I realized that I really wanted to be a free lance [sic]. So first I made up models which a little shop sold exclusively. But now I see my clientele and can plan my styles and colors for people whom I know."[48]

An undated letter from Dorothy Hoffman (Mrs. Paul G., probably the wife of Paul Gray Hoffman, who served as president of both Studebaker Corporation from 1935 to 1948 and the Ford Foundation from 1950 to 1953 and was later a U.N. delegate) of South Bend, Indiana, documents an example of Mariska working closely with an individual client.[49] In the letter, Hoffman expresses to Mariska her pleasure and enthusiasm about her new clothes: "I love the blue wool with the bright bands and the red velvet is charming." She also discusses minor adjustments that needed to be made to a cap and a dress. Hoffman records that she likes the sketch of an outfit with red moiré and white satin but asks Mariska if she really is enthused over it, adding, "If you like the combinations, and think it will really be striking, you may make it up please." She also suggests having a high collar across the back, as that is becoming to her. Hoffman praises Mariska on her ability to write "thoroughly good business letters," which she believes are unusual to receive from a woman.[50]

In her discussion with the writer of the *Christian Science Monitor* article in 1926, Mariska also addressed financial aspects of her practice: "All my dresses range between certain prices, which I think are moderate. My customers are

(opposite)
Figure 12
Nickolas Muray (American,
b. Hungary, 1892–1965)
Mariska Karasz, ca. 1926
Photograph, 10 x 8 inches
© Nickolas Muray Photo
Archives
Cat. no. 37

Figure 13
Dress with slip, ca. 1930
Silk with zipper, length approx.
51 inches
Cat. no. 6

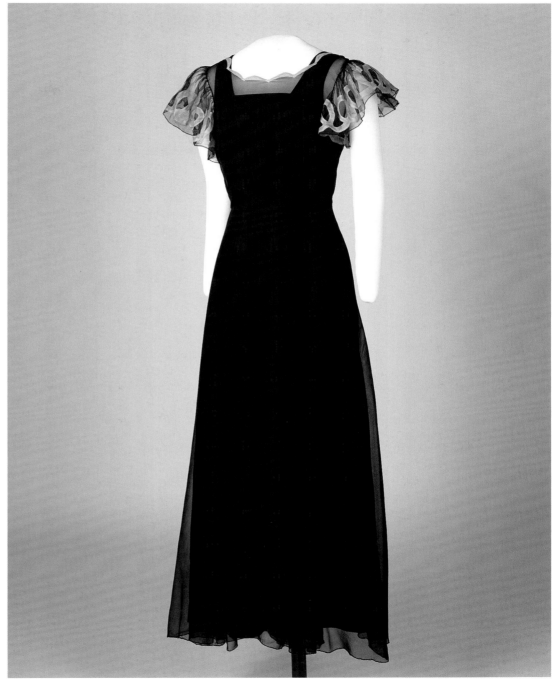

pleased that they can get from me unusual hand-made frocks which are not made in duplicate at a cost which is lower than usual hand-made dresses can be bought in the shops; and I am entirely satisfied with my profits."[51] Mariska added that she engaged women to sew for her and that those women were sympathetic to the standard she set. When asked if these women were Hungarian, Mariska replied that they were Americans, primarily African Americans, whom she found especially "reliable and skillful," and with whom she got along very well. Prompted by the writer, Mariska also spoke about the differences she perceived between American young people and European young people; she enjoyed "gay times" with Americans, but liked Europeans' inclination to discuss serious matters.

The article describes several examples of clothing Mariska prepared for her 1926 spring and summer models. A jumper dress featured a russet kasha (a cashmere and wool fabric) skirt with inverted pleats at the sides, "and to which was attached the waist made of all-over embroidery in shades of russet, yellows and greens." The jumper was cut to suggest a bolero and was worn with a cream-colored sports blouse. Another sports model "was fashioned of white flannel and edged with magenta braid." The skirt had three appliquéd bands, "one a dull purple, another cerise and the third green." The same colors appeared in reverse on the blouse with "a quaint design of little houses and trees."

Another article, titled "Expressing Wilhelmina!" from an unidentified publication in 1927, includes two photographs of Mariska wearing outfits of her own design.[52] The unnamed author conveys Mariska's energy by describing her as "Peter Panlike," and recounting that "she flaps her wings and crows and summons all to come see what she has made" and then "forgets about it and has interest only for the next creation." The reporter also notes Mariska's use of peasant embroidery, which she selected during annual trips to Europe; appliqué; and sometimes designs by her sister, including batik.

In December 1929, fashion writer Alida Vreeland wrote an extensive article on Mariska's work for the *Christian Science Monitor*, titled "Hungarian Ideas Modernized."[53] Vreeland notes that, "unlike most designers who seek to bring the animation of eastern European dress to the attention of American women, Miss Mariska Karasz has modernized her patterns of Magyar derivation until they are scarcely recognized as such." Vreeland pays particular attention to the modernity of Mariska's designs, praising her "adept" introduction of "skyscraper and other modernistic motifs to her dresses" and her skillful use of color and design to meet "the demands of the smartly dressed cosmopolitan woman." Vreeland's emphasis on modernity also reiterates Mariska's Americanness by highlighting her connection to the most American of icons, the skyscraper.

Vreeland outlines Mariska's use of fabrics, which are primarily silks: chiffons and velvets for eveningwear and flat crêpes, crêpe-failles, or crêpe-de-chines for afternoon dresses and pajama ensembles. She notes that the cuts of Mariska's dresses are simple so as not to compete with the decorative motifs, but always in touch with the changing silhouette. Vreeland highlights Mariska's daring use of appliqué, adding that "the illusiveness of chiffon holds no terrors either for her or her skilled assistants." She explains that the motifs "are often worked in the form of inserts, one piece being fitted to another with the flatness and smoothness of inlay," and compares the carefully executed designs to mosaics or stained glass windows.

Though only a few dresses have survived from this period of Mariska's career, Vreeland provides detailed descriptions of numerous outfits, documenting the styles, colors, and fabrics of these lost dresses:

> Reflection of winter sunset tones were suggested in one [model] of gray-violet chiffon velvet and violet chiffon with elaborate and delicately wrought appliqués of magenta chiffon. The velvet was softly gathered to a semi-fitted bodice, while an underskirt and blouse were composed of the chiffon. The magenta was applied down the center blouse front and part way down the skirt and served at the same time to join the velvet at the waistline where it did not quite meet in front. The appliqué motif was repeated on the puffed sleeves.

> Sheep-skin velvet, which is of a delightful chamois-like texture and light parchment tone was employed to fashion another dress. Against this, small flame-colored wool embroideries stood out brilliantly. The same color in crêpe-de-chine was used to line a low-placed flounce dipping toward the back. This dip gave added prominence to the lining, strengthening in color at the same time the lower part of the gown.

> Pink wool-embroidered flowers were the rather naïve decoration applied with undeniable charm

to a black velvet afternoon dress. A bolero jacket effect distinguished the back, its lower edge cut in two points to conform with the line of the flaring flounces of the skirt.

. . . . Gray, black and white were also quite arrestingly combined in several dresses, the loveliest of all being one of a very pale gray foundation with a double appliqué effect achieved by placing a small pale gray leaf pattern on a black leaf and allowing this to weave itself over the upper part of the dress while the tones all seemed to fuse together in a flaring and dipping flounce back.

. . . . [One model for pajamas] is on the capucine theme, showing trousers of autumn-brown and coat of orange with brown border, while the blouse is yellow with orange dots and brown wiggle designs appliquéd. Miss Karasz termed this a winter pajama ensemble as the blouse had long sleeves, which are likewise bordered with appliqué work.

Another astonishing set [of pajamas] was in a vivid Napoleon blue with a two-and-a-half-inch border formed of small magenta dots appliquéd around the trouser leg, pajama coat and sleeves. The blouse was literally a mass of beautifully worked out appliqués in magenta, and violet.[54]

In 1931, the *Christian Science Monitor* again featured an article about Mariska's fashion designs.[55] The author, Helen Johnson Keyes, notes, like Vreeland, that Mariska used the accepted silhouettes of fashion, but that "within these fences she [worked] out patterns and color alliances not to be found elsewhere." Also like Vreeland, Keyes

provides detailed descriptions of numerous costumes:

> [Crocheting together the breadths of a frock] gives chic to a terra cotta suit of French basket weave whose parts are united by a crochet of black yarn, and to a rough blue basket weave interestingly assembled with terra cotta crochet. In this case the crochet is used not only to unite the pieces but also to make long loops for the buttons that fasten the frock.

> Appliqué is used effectively on a black canton jacket suit, in silk patterns of green, cream and salmon; and in a skirt and tunic blouse. Here the much grayed mauve of the skirt is heightened by the purple and magenta appliqués on the blouse.

> [An] evening frock is of very deep-toned ivory velvet girdled with a metal band, hand woven in Albania, whose rich gold background is set off by small detached figures in scarlet, maroon, black, green and blue. The shoulder straps are of the same derivation but are not identical.

> A fourth evening frock is developed from the apron of a Hungarian peasant. The bright green of this costume feature is set off by brown chiffon draped over chartreuse; and this color scale is carried out in arresting details throughout the costume.

Reporters repeatedly remarked on Mariska's distinctive use of color, with one referring to her "subtle medleys of strange colors," and in 1931 Mariska wrote an article about this aspect of her

work titled "Color-Scheme or Color-Scream."[56] She submitted it to *Charm*, a magazine aimed at working women, but it remained unpublished.[57] In the article, she acknowledges that Parisian fashion is beginning to use color, something she had been doing instinctively for some time. She writes, "I remember in art school we had depicted the color chart and were to make complimentary [*sic*] and analogous color harmonies how I cheated, ignored all I was told—worked out the given color problems by instinct and got put at the head of the class." She laments that countless women of good taste had been wearing subdued tones of dull blacks, blues, and browns, explaining that many "color starved" women came to her. Mariska initially gained their confidence by using a dark or neutral background with small touches of color carefully placed to accentuate their features "and the good lines of the dress." She also addresses how colors are viewed because of their associations, asking if the sight of a red, white, and blue dress would not cause in the viewer an urge to sing the "Star Spangled Banner," and noting that a flame-red outfit might be dangerous to wear in England because of its association with Soviet Russia, while it would be welcome in India, where red signifies joy. It "is always a sin to wear a shade because it is fashionable," she writes, going on to describe a recent fad for purple as "rather disastrous." Yet, she argues that purple "can be one of the most beautiful shades on people who look best in warm colors," and suggests purple, magenta, and blue as a perfect color scheme for women with brown hair and blue eyes who wish "to look interesting and be noticed with dignity." Mariska advises that hair, skin, and eye color must be considered as part of

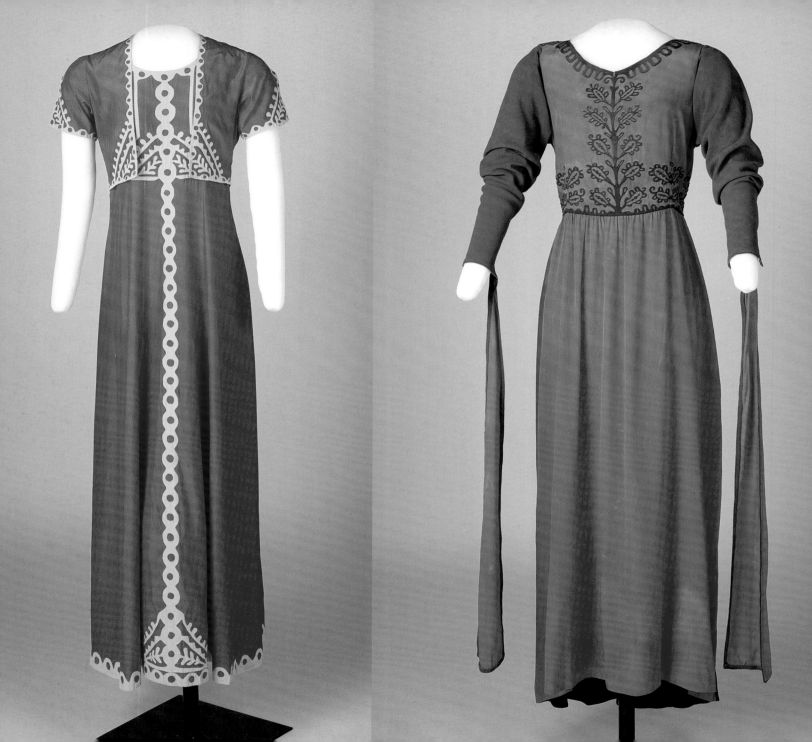

Figure 14
Dress, ca. 1930
Silk with zipper, length approx.
53¼ inches
Cat. no. 7

Figure 15
Dress, ca. 1930
Silk with zipper, length approx.
53 inches
Cat. no. 5

the scheme when selecting colors for clothing. She also acknowledges the effect of lighting and states that she selects her fabrics in stores under sunlight lamps or evening light lamps depending on when the particular fabric will be worn.[58]

In the article, Mariska recounts an example of the importance of color in Hungary:

A small village in Hungary on a Sunday morning. People going to church. According to custom the men and women take the opposite pews during the service. They all take their places according to age. I noticed the recognition they give to the traditional use of their (what we think haphazard) colors. The smallest children took the first few rows dressed in white with perhaps pink hair ribbons. Then the young girls dressed perhaps in blue—The newly married ones in bright kerchiefs the older ones dressed in darker shades—The old women in deep purples and black—which gave an array of exactly the color spectrum in gradation. In spite of their naivite [sic] these peasants had more feeling as how to dress rightly than one could ever suspect.[59]

Tamás Hofer and Edit Fél, in *Hungarian Folk Art*, describe the significance of dress in Hungarian religious services as "a great living chart showing the whole complicated inner structure and unity of rural society," and their description of the colors worn corresponds to Mariska's.[60] Though still a teenager when she left Hungary, Mariska must have absorbed this cultural significance of color, present in many rural communities around the world.

The article Mariska proposed for *Charm* not only provides evidence of her interest in and

sophisticated understanding of color, but it also reveals her playfully competitive attitude toward Paris when she suggests that city is behind in its endorsement of color. Solveig relates that her mother went to Europe about every other year to meet with relatives who were sewing for her and to visit Paris—"She always had stories about going to Paris."[61] Mariska periodically referenced Paris in regard to her work, for example describing her spring 1930 collection as a "showing of gowns from Hungary via Paris at Mariska Karasz."[62] Paris was an undeniable presence in the fashion world between the wars, but Mariska met it with confidence and intelligence, never copying Parisian styles, but remaining aware of current trends.

A list of possible descriptive titles for Mariska's fall 1929 collection indicate how she viewed her clothing, or at least what aspects of it she wished to promote, including individuality, originality, modernity, a New York connection, and Parisian accents:

MODERN GOWNS FOR THE MODERN BACKGROUND

Individual Gowns for the Discerning Individual

Announcing my Fall Collection of Individually Designed Gowns

For Gowns of Distinction

Announcing my Autumn Showing

My Fall Showing is now Taking Place

Exclusive fashions for the New York exclusive

For the smart fashion individually interpreted

Significant Fashions individually interpreted

Original modes for Autumn 1929

The mood of Paris in original modes

Autumn Originations

Original modes

Why Go to Paris when les dernier [sic] modes are here?

For those who appreciate the individual

Paris transferred to New York

The Modern gown for the discerning modern

For the gown that dominates in this era of individuality.[63]

An undated, typed outline in Mariska's papers suggests how one of her fashion shows would have been conducted. According to the notes in this outline, she began with an introduction that covered topics such as how she came to be a fashion designer, the history of her "personal romance," and interesting facts about her studio.[64] She followed with an explanation of the pageant's sequence, then the six segments of the show. The first segment featured pajamas for wearing to breakfast or to get the mail and to which could be added a skirt to make a dress effect for an outside tea; this outfit cost $150. She then showed a "Sun Costume" for wearing on the patio or to the beach club; it featured a jacket with a silk designed by Ilonka and cost $100. The sports segment featured two costumes, a green and gold outfit of Chinese influence "inspired during a visit to S. F.'s Chinatown," and a "Hungarian Coat" and hat that featured a "crown of loose cotton crepe to keep [the] head cool"; these were $125 and $95, respectively. The fourth segment, "Lunch," included a green chiffon outfit with a motif inspired by an African robe in the Berlin Museum ($125), while during the fifth segment, "Bridge Tea," she

presented three outfits: "Blue Chiffon Afternoon Chartreuse" (inspired by eating ripe green olives), "Blue and Egg Shell—Inspired by a piece of peasant pottery," and "Flame and Brown—Squares used to give length of line by optical illusion" ($150, $165, $175). Mariska ended with the "Dance" segment, featuring two dresses, one brick and gold with a two-color slip and a design cut in one piece from the front panel of the skirt and continuing under the arms, and a blue outfit with a slip-over blouse, for $165 and $150.[65] The information preserved in this document provides important details about Mariska's inspirations for clothing: San Francisco's Chinatown, peasant pottery, a Hungarian coat, museum objects, a modern informal life, and her sister's textiles, as well as her inclination to collect materials and influences from a variety of sources.

When asked in 1926 about her customers, Mariska replied that she had "a very steady clientele," and that some patrons bought whole wardrobes from her, adding, "sometimes a customer becomes so attached to a special model that she wants me to repeat it in different material and coloring."[66] Keyes discusses who wore Mariska's fashion: women who chose to be distinguished and "whose personality is effectively emphasized by unique patterns."[67] Another clipping describes Mariska's work as appropriate "for the woman who loves daring in her apparel" because of its "flamboyant color, originality of design, [and] beautiful hand embroidery."[68] When asked who wore her mother's dresses, Solveig echoed this sentiment, replying, "people who were daring enough to wear something different."[69] Solveig also recalls that her mother used the Social Register for developing her mailing list.[70]

Numerous receipts for Mariska's dresses survive from the late 1920s and early 1930s, revealing specific clients as well as details about outfits and prices. Mrs. Meredith Hare, an arts patron in New York, purchased a black and gray coat and slip with square appliqués, an evening gown, a green jumper with an embroidered top, a gray and white blouse with an appliquéd Indian motif, and a gray embroidered coat for about $500 total. Mrs. Blanche Grant of New York (possibly the artist) purchased a "Majenta [sic] Ensemble" for $145.[71] Louise Cline purchased a green moiré gown for Dorothy Peterson (1899–1979), film and stage actress and Mariska's husband's sister, for $135 on January 2, 1929. Mrs. C. F. Samson of New York purchased a blue-green dinner gown and a gray chiffon ensemble for $310 in January 1929. Mrs. R. Schwarzenbach of New York (possibly the wife of Robert Schwarzenbach of the silk company Schwarzenbach and Huber) purchased a green and blue appliquéd gown, a black and gray ensemble, and a matching silk hat in April 1929 for $280.[72] Dorothy Peterson subsequently purchased more clothing, including a black velvet gown, an outfit with black and gray checks and a terra cotta slip with a matching cap, a "Taupe Kossack [sic] Coat Ensemble," an evening wrap, a yellow evening coat and gown, and a "White Rodier Plad-Orange [sic] Cape." Artist Ruth Guinzburg of Chappaqua, New York, bought a "greek [sic] lines evening gown" at half price for $62.50 and wrote on the receipt, "Dear Mariska—Your exhibit was glorious! Congratulations, Bravo, And all good wishes."

One receipt, circa 1929, reveals that the Film Guild Cinema, located at 52 West 8th Street and designed by Austrian-born architect Frederick

Kiesler, purchased from Mariska six costumes for usherettes and one costume with a collar for a cashier at $25 each.[73] This important modernist cinema featured an eye-shaped screen and was arranged like the inside of a camera with the bellows extended. The New York Times described the opening of the theater as "something of an event," attended by "Notables" including writer Theodore Dreiser.[74] The selection of Mariska's costume designs for this experimental space indicated significant peer approval of her work and provided an opportunity for her designs to be seen with those of her sister, who designed furniture for the cinema.[75] Mariska remained friends with Kiesler, and Solveig remembers him visiting the family and wearing a feather boa.[76]

Mariska likely knew many modern designers besides Kiesler through her sister, the earlier Women's Wear contests, and her participation in AUDAC, the American Union of Decorative Artists and Craftsmen, in the early 1930s. AUDAC formed in 1928, held two exhibitions in 1930 and 1931, published the book Modern American Design in 1930 (republished in 1931 as the Annual of American Design 1931), and disbanded after the second exhibition because of the national economic crisis.[77] Founding members of AUDAC included Paul T. Frankl, Donald Deskey, Kem Weber, and Kiesler, among others. A blue, white, and red hat and clutch ensemble of wool embroidery on flannel by Mariska appears in AUDAC's book.[78] The AUDAC exhibition at the Brooklyn Museum in 1931 included several mannequins by Austrian-born ceramicist and sculptor Vally Wieselthier, adorned in dresses by Mariska.[79] In an installation of his work at that exhibition, German-

Receipt from Mariska to Mrs.
Joseph Pike, ca. 1929
Ink on paper, 6⅜ x 8¾ inches

MARISKA KARASZ 107 EAST 34TH STREET NEW YORK

Mrs. Joseph Pike
Mayflower Hotel N.Y.
TERMS: NET 15 Central Park West DATE June 25th.

Alteration – new sleeves on rust & orange silk appl.	5.00
Mending of belt & dry cleaning whole outfit	6.00
Green & Yellow ensemble – cloth coat	
Hat to match	150.00
Brown, yellow & green silk ens. long coat with sleeves	150.00
Lavender & Magenta Evening gown Coat to match	165.00
Blue & White Chiffon ensemble	165.00
2 Straw hats to order	50.00
Brown jacket to go with jumper of ecru emb.	45.00
	751.00

born, California-based designer Kem Weber (1889–1963) included two brightly colored embroideries—a table cover with a backgammon design and a wall hanging with an Arcadian scene—attributed to the Karasz sisters.[80] Mariska's association with America's avant-garde designers underscores her relevance to early American modern design and indicates that her fashion should be viewed as part of that history rather than exclusively within the context of fashion.

More than seventy sketches of designs for Mariska's dresses survive. All are undated, though several can be matched to photographs of actual dresses from circa 1928. They are drawn by several different hands, primarily in graphite. One sheet with numerous dress top designs survives; the sketches are more informal and perhaps indicate that Mariska did these rough designs, then had others execute the more formal renderings. A few dress designs specifically note the use of appliqué, and several clearly indicate the incorporation of embroidered panels and crocheted seams. The majority of the silhouettes are basic, columnar forms, with many chemise dresses, in keeping with the trend toward simpler, less restrictive garments. There are several variations of a long-sleeved tunic-style dress with upright abstract flowers regularly spaced along the bottom edge and on the ends of the sleeves.

The designs of Mariska's dresses as recorded in the sketches overall are simple, with large areas of unadorned fabric. Most of the decorations on the dresses are limited to the edges (especially along the bottom hems), the ends of sleeves, and around the collars. Often the design is asymmetrical, and frequently it continues from the front to

Dress (detail), ca. 1925–30
Ink and crayon over graphite
on Fabriano paper,
11$\frac{13}{16}$ x 9 inches
Cat. no. 11

Dress (detail), ca. 1925–30
Graphite on Fabriano paper,
11$\frac{1}{16}$ x 9 inches
Cat. no. 12

Dress (detail), ca. 1925–30
Graphite on Fabriano paper,
11$\frac{1}{4}$ x 9 inches
Cat. no. 14

Dress (detail), ca. 1925–30
Ink over erased graphite on
Fabriano paper, 11$\frac{13}{16}$ x 9 inches
Cat. no. 10

38

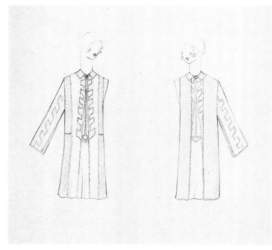

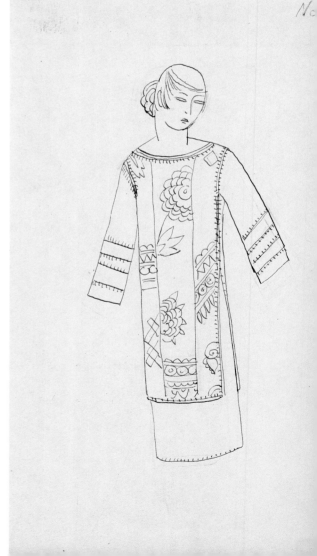

Dress (detail), ca. 1925–30
Graphite on Fabriano paper,
11⅟₁₆ x 9 inches
Cat. no. 16

Dress (detail), ca. 1928
Graphite on Fabriano paper,
11 x 9 inches
Cat. no. 24

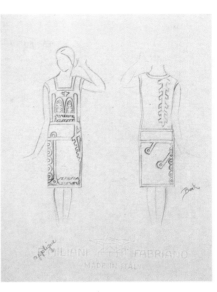

Two dresses (detail),
ca. 1925–30
Ink over erased graphite on
Fabriano paper, 11⅟₁₆ x 9 inches
Cat. no. 15

Dress (detail), ca. 1925–30
Graphite on Fabriano paper,
11⅛ x 9 inches
Cat. no. 13

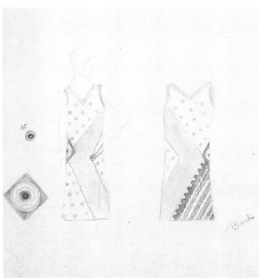

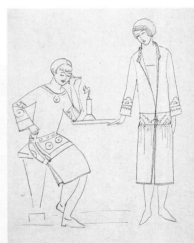

Model wearing dress by
Mariska Karasz, ca. 1928
J. C. Milligan (American)
Photograph, 9¹¹⁄₁₆ x 7¾ inches
Cat. no. 28

the back of the dress. A few dresses have allover patterns—both small repeated motifs and larger scattered patterns, likely produced through appliqué rather than the use of printed fabrics. Some demonstrate clear ties to Hungary, particularly in the inclusion of elaborate floral embroidery, the *szür*-inspired coat, and certain floral appliqués. Others suggest inspirations from American Indian patterns, an influence also promoted among artists such as Alfred Stieglitz, Georgia O'Keeffe, and their circle.[81] The predominant design character is modern and geometric, and the dresses abound in zigzags, circles, rows of dots, spirals, and chevrons. Abstract floral motifs also appear, both purely geometric interpretations of tulips regimentally arranged and vaguely peasant-inspired curvilinear motifs spilling across confined areas. The designs include jackets, often matched to dresses. Generally, the jacket has a more minimal pattern than the dress, with a complementary placement of the design elements: for example, in one outfit a motif that outlines one side of the dress's neckline appears on the opposite side of the coat's. By and large the surfaces of the dresses are composed of flat planes, but a few feature pleated skirts and some are gathered at the waist.

In addition to these sketches, a small collection of photographs of women modeling Mariska's dresses survives (some with damage, probably from the studio fire). Several taken in California probably date to 1928 and include an image of a woman wearing a *szür*-inspired coat, several of women in knee-length dresses with abstract appliquéd motifs, and one of a woman wearing a simple two-color dress. In the photograph of a trio of women, one wears a vest covered in Hungarian floral

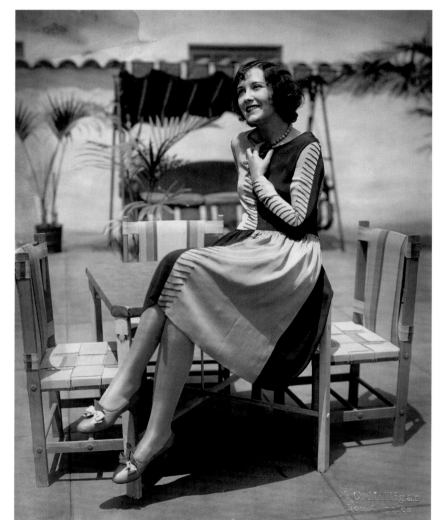

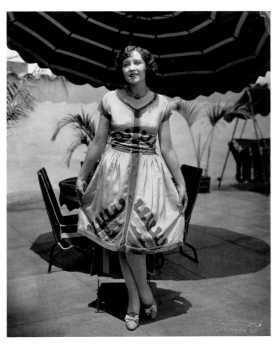

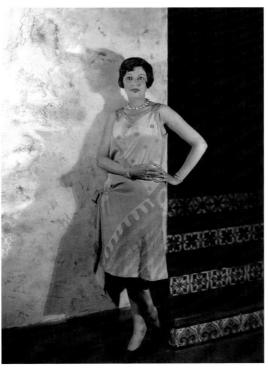

Model wearing dress by
Mariska Karasz, ca. 1928
J. C. Milligan (American)
Photograph, 9¹¹⁄₁₆ x 7¹¹⁄₁₆ inches
Cat. no. 27

Model wearing dress by
Mariska Karasz, ca. 1928
J. C. Milligan (American)
Photograph, 9¹¹⁄₁₆ x 7¹¹⁄₁₆ inches
Cat. no. 29

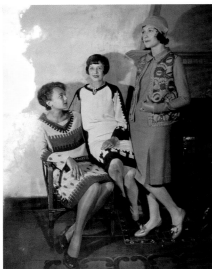

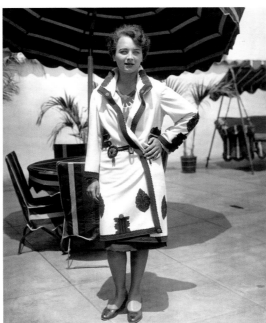

Three models wearing dresses
by Mariska Karasz, ca. 1928
J. C. Milligan (American)
Photograph, 9¹¹⁄₁₆ x 7¾ inches
Cat. no. 30

Model wearing dress and coat
by Mariska Karasz, ca. 1928
J. C. Milligan (American)
Photograph, 9⅝ x 7¹¹⁄₁₆ inches
Cat. no. 26

Figure 16
Unidentified photographer
Actress Dorothy Peterson
modeling dress by Mariska
Karasz, ca. 1930
Photograph, 9¹⁵/₁₆ x 8 inches
Cat. no. 34

(top right)
Figure 17
Unidentified photographer
Model wearing ensemble by
Mariska Karasz, ca. 1930
Photograph, 8 x 10 inches
Cat. no. 32

(bottom right)
Figure 18
Unidentified photographer
Model wearing dress by
Mariska Karasz, ca. 1930
Photograph, 8 x 10 inches
Cat. no. 33

embroidery while another wears a tunic dress with abstracted tulips along the hem.

Four photographs, probably from New York and possibly slightly later than 1928, based on the lower hemlines, also survive and show women posed with furniture that appears to be by Ilonka. All of the outfits feature appliquéd designs. Dorothy Peterson (Fig. 16) stands wearing a two-part dress (or tunic and skirt) with an inverted scallop and dot pattern running along the edges and crossing below her waist, cut with the bias. Another woman, seated (Fig. 18), wears a dress with a sheer outer layer on the skirt and sheer fabric loosely draped over her shoulders and falling just above her waist, with an undulating abstract vine and leaf motif. The third woman, reclining (Fig. 17), wears what appears to be a divided skirt or pants outfit with a jacket ornamented with rows of appliquéd dots and diamonds, concentrated along the edges.

Few articles of clothing designed by Mariska from this period survive. The Costume Institute at the Metropolitan Museum of Art accessioned two dresses in 1977, both dated circa 1927, and curator Richard Martin included one of them in an exhibition and publication titled *Cubism in Fashion* in 1998. He linked the designs of this navy dress and jacket with off-white appliqués to Henri Matisse's cutouts and the interest of modern artists in peasant art.[82] This dress also appears in Claire B. Shaeffer's *Couture Sewing Techniques* (2001), in which she notes that "the stitches are so fine and uniform that they form their own pattern inside of the unlined coat."[83] The second outfit at the Costume Institute, an afternoon ensemble, is a sleeveless dress with a long-sleeved jacket in

purple, magenta, fuchsia, and cyclamen pink in crepe and chiffon. Both contain labels reading "Mariska Karasz, New York."

Other garments, possibly dated slightly later, remain in the collection of Mariska's family. A sleeveless silk dress in scarlet and light peach with a short-sleeved bolero is decorated with an appliquéd motif along the hem and neckline, running down the center, and just above the high waistline (Fig. 14, p. 34). The abstract, vaguely foliage-like motif and dot pattern is echoed on the jacket along the edges, in the corners, and on the split sleeves. A jacket (Fig. 19) of rust-colored silk on a sheer charcoal background is especially Hungarian in its treatment of the abstract floral appliqués. Also surviving are an elegant sheer black dress with white scalloped trim on the sleeves and neckline with an opaque black slip (Fig. 13, p. 31) and an unusual green and orange dress with Hungarian peasant-style appliqués on the front and full upper sleeves tapering to the wrists, with narrow strips of fabric, perhaps suggesting medieval hanging sleeves, descending from the wrists to the ground (Fig. 15, p. 34).

While the above costumes demonstrate Mariska's use of appliqué, jackets also survive that show her incorporation of Hungarian embroidery. One is a knee-length coat with brown floral embroidery on a tan base, which belonged to a friend of hers who later gave it to Rosamond. Mariska also designed waist-length jackets with Hungarian floral embroidery, two of which survive in the collection of the Smithsonian Institution's National Museum of American History and one of which (Fig. 20) remains with Solveig. These brightly colored jackets are covered with the type of embroidery associated

with Mezőkövesd and Mariska continued making them, possibly into the early 1940s.

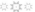

Though Mariska primarily showed her work in New York, in 1928 she traveled to California to present her clothing in several venues. On July 19, as part of a summer series of artists' dinners, the California Art Club, which met in Hollyhock House (designed by the architect Frank Lloyd Wright), hosted Mariska at Barnsdall Park Art Center's Little Greek Theater. The *Los Angeles Times* reported, "crafts members of the club are sponsoring a novelty program in the form of a fashion show created by Mariska Karasz, who has introduced the Hungarian peasant motif into gowns of modern fashions." The newspaper also noted that several well-known female artists had volunteered to appear as models.[84] A subsequent notice in the newspaper reported that the event was "largely attended."[85] Announcements for Mariska's fashion shows surviving from her time in California document that her work was presented in socially prestigious, modern venues. One announces a fashion show in Los Angeles on July 12 in the Madrid Room at the Roosevelt-Hollywood Hotel, which was built in 1927 on Hollywood Boulevard, across from Grauman's Chinese Theatre, and quickly became a focal point for the glamorous Hollywood scene (Fig. 21, p. 45). Another announces a "Dinner Fashion Review" at the Sunset Dining Room of the Pacific Coast Club in Long Beach on July 24. This "center of social and business activity" was built in 1926 and featured a blue tile roof and decorated curved ceilings. A letter from 1930 suggests that Mariska may have

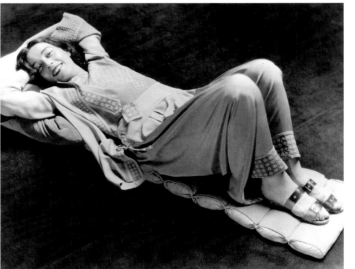

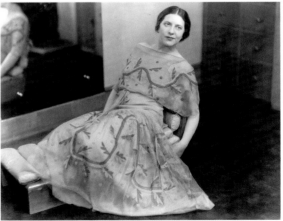

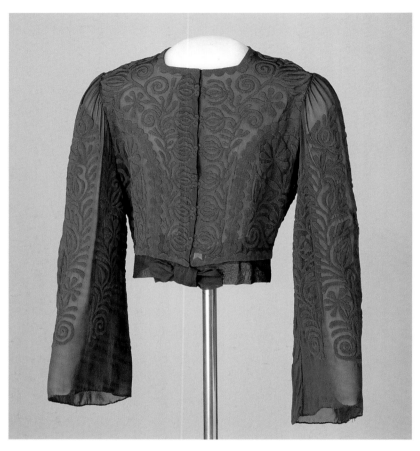

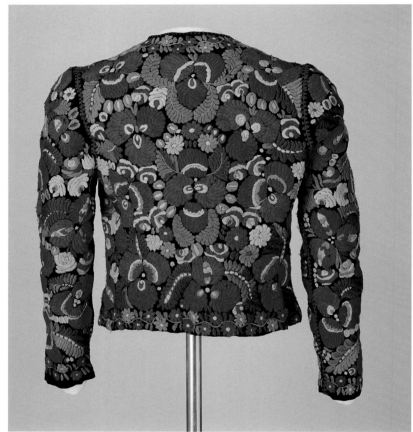

Figure 19
Jacket, ca. 1927
Silk, length of body approx.
16½ inches; length of sleeve
approx. 21 inches
Cat. no. 3

Figure 20
Embroidered jacket, ca. 1935
Multicolored wool embroidery
on wool, length approx.
19 inches
Cat. no. 8

New York

Fashion Show

madrid room
roosevelt-hollywood hotel
7010 hollywood boulevard
**thursday
july 12th
4 o'clock**

for information phone GRanit 9586

Figure 21
Unidentified designer
Announcement for fashion
show at the Roosevelt-
Hollywood Hotel, 1928
Ink on paper, 10⅞ x 8⅝ inches
Cat. no. 59

had continued contact with individuals or representatives in California.[86]

An undated clipping reveals that in advance of a larger public fashion show in California, Mariska presented her clothing at a private preview in the Los Angeles studio of Bavarian-born artist Jacob Asanger (1887–1941). Others in the "intimate group" included Mr. and Mrs. Kem Weber, Swiss-born artist Franz Herding (1887–1968), Russian-born artist Victor Mall (1901–1989), F. K. Ferenz (director of the Plaza Art Center in the Italian Hall), and Ilona Fülöp (a Hungarian-born screenwriter who was involved with Ilonka in the theater in Greenwich Village).[87] In addition to the California Art Club, southern California was also home to the Los Angeles Modern Art Society. With a thriving arts community, many modern architects, the fast-paced glamour of Hollywood, and the informal, independent culture, Mariska and her fashion designs must have received a warm reception.

Though much remains to be learned about the details of Mariska's career as a designer of women's fashion, she clearly ran a successful studio and created distinctive modern clothing sought by individualists and artists on both coasts. Hungary remained an important part of her clothing designs, but always as filtered through the artistic talents and tastes of an American.

1 "Expressing Wilhelmina!" unidentified publication, March 1927 (the back of the clipping lists the tide schedule for March 21, 1927), page unknown, collection of the artist's family.

2 Caroline Rennolds Milbank, *New York Fashion: The Evolution of American Style* (New York: Harry N. Abrams, Inc., 1989), 62, 66.

3 Mariska advertised to sublet this space in June 1926 and May 1928. Classified ad, *New York Times*, June 20, 1926; and classified ad, *New York Times*, May 23, 1928.

4 Mariska Karasz, New York, New York, to Wimest, January 5, probably 1926, collection of the artist's family.

5 Advertisement, *Creative Art* 3 (October 1928): xvi.

6 Milbank, 64.

7 "The House in Good Taste," *House Beautiful* 64 (August 1928): 149–52.

8 "Expressing Wilhelmina!"

9 A biographical article from 1935 indicates that Mariska's work with department stores took place after she finished school and that it lasted for several years. Virginia Cotier, "Designers of Today and Tomorrow," *Women's Wear Daily*, May 8, 1935.

10 Beryl Williams Epstein, *Fashion Is Our Business* (New York: J. B. Lippincott Company, 1945), 174; and "An Hungarian Dress Designer," *Christian Science Monitor*, May 25, 1926.

11 M. D. C. Crawford, "American Styles Created by American Artists," *Women's Wear*, October 3, 1917.

12 Ibid.

13 M. D. C. Crawford, "Blouses That Show Beauty and Comfort," unidentified publication, date and page unknown, collection of the artist's family. Crawford states that Mariska is nineteen years old and that she has been in America for about five years, dates that do not exactly correspond, but that suggest a date for the article of circa 1918.

14 For an in-depth study of Crawford, see Lauren Whitley, "Morris De Camp Crawford and American Textile Design 1916-1921" (master's thesis, State University of New York, Fashion Institute of Technology, 1994).

15 M. D. C. Crawford, "Lack of Peasant Art Handicap to American School," *Women's Wear*, December 8, 1916.

16 Crawford later credited the curator of the Brooklyn Museum, Stewart Culin, for his efforts after World War I to collect and preserve examples of peasant arts, including, as indicated by an illustration accompanying this statement, Hungarian textiles. Mariska also collected historic costumes, fully participating in the ideals promoted by Crawford. See M. D. C. Crawford, *One World of Fashion*, 3rd rev. ed., ed. Beatrice Zelin and Josephine Ellis Watkins (New York: Fairchild Publications, Inc., 1967), 84–85; and informal interview with Solveig Cox, February 11, 1998.

17 "Early Exhibitions of the Season: Art at Home and Abroad," *New York Times*, October 20, 1918.

18 Epstein, 175.

19 Ibid.

20 The sketchbook, in the collection of the artist's family, is difficult to date. Many of the pages appear to be from this early period of Mariska's career, but the contents of some pages are obviously later, depicting designs for baby bibs and children's clothing. One page contains an illustration of the *U. S. S. Constitution*, which did not take its maiden voyage until 1952.

21 Crawford, *One World of Fashion*.

22 M. D. C. Crawford, "Manicured Chickens More Important Than Art," *Women's Wear*, January 2, 1917. Crawford also referenced Hungarian art in an article published the following day: M. D. C. Crawford, "Persian Found in Hungary," *Women's Wear*, January 3, 1917. Thanks to Rebecca Brantley for her work identifying Crawford's specific mentions of Hungary and Hungarian arts.

23 Crawford, "Blouses That Show Beauty and Comfort."

24 Ibid.

25 Helen Johnson Keyes, "Diversity Within the Law," *Christian Science Monitor*, December 23, 1931.

26 Advertisement, *Creative Art* 2 (April 1928): vi.

27 Crawford, "Blouses That Show Beauty and Comfort."

28 "'Studio Type' Blouse also Uses Gabardine, in Wool," unidentified publication, date and page unknown, collection of the artist's family.

29 For more information on the batik craze in the 1910s, see Nicola J. Shilliam, "Emerging Identity: American Textile Artists in the Early Twentieth Century," in Marianne Carlano and Nicola J. Shilliam, *Early Modern Textiles from Arts and Crafts to Art Deco*, 28–44 (Boston: Museum of Fine Arts, Boston, 1993).

30 For more information on Mallinson, see Madelyn Shaw, "American Silk from a Marketing Magician: H. R. Mallinson & Co.," in *Silk Roads, Other Roads: Proceedings of the Textile Society of America's 8th Biennial Symposium* (Northampton, MA: Textile Society of America, Inc., 2002), CD-ROM; and Shaw, "H. R. Mallinson & Co., Inc.," in Jacqueline Field, Marjorie Senechal, and Madelyn Shaw, *American Silk: Artifacts and Entrepreneurs, 1830-1930* (Lubbock, TX: Texas Tech University Press, forthcoming, spring 2007).

31 Epstein, 175.

32 For more information on Turner see Patricia E. Mears, "Jessie Franklin Turner: American Fashion and 'Exotic' Textile Inspirations," in *Creating Textiles: Makers, Methods, Markets*, 431–440 (New York: Textile Society of America, 1998); and Elizabeth Ann Coleman, "Jessie Franklin Turner: A Flight Path for Early Modern American Fashion," *Dress* 24 (1998): 58–64.

33 Epstein, 175.

34 "An Hungarian Dress Designer."

35 M. A. C. Supplement, *Modern Art Collector* 1 (September 1915): n.p.

36 Ilonka Karasz, drawing, *Playboy: A Portfolio of Art and Satire* 4/5 (1919): 11.

37 Epstein, 175.

38 Ibid., 176.

39 Ibid.

40 "Trimmings Are Quaint," *New York Times*, January 4, 1925.

41 Advertisement, *Creative Art* 2 (April 1928): vi. Rosamond remembers that later packages from Hungary arrived in beautiful peach-colored envelopes with Hungarian stamps. Informal interview with Rosamond Berg Bassett, March 16–17, 2006.

42 Veronika Gervers-Molnár, *The Hungarian Szűr: An Archaic Mantle of Eurasian Origin* (Toronto: Royal Ontario Museum, 1973); and Tamás Hofer and Edit Fél, *Hungarian Folk Art* (Oxford, London, New York: Oxford University Press, 1979). Thanks to Rebecca Brantley for her assistance with locating information about *szürs* and for noting in her undergraduate honors thesis that "the Hungarian Foreign Trade recognized the resource of their country's arts and crafts, and starting in the thirties and forties, began publishing materials advertising folk art to potential tourists, emphasizing the nationalistic role that traditional crafts played in their culture. One publication mentions the major French designer, Elsa Schiaparelli, who revealed an interest in Hungarian folk art. She visited the Ethnographical Museum of Budapest in the forties and told a Hungarian newspaper, 'I have made notes and sketches, and I am taking back with me many treasures to Paris.'" *Hungarian Domestic Crafts and Peasant's Art*, ed. the Hungarian Foreign Trade Board (Budapest: Ernest Koltia, 1940–1948?), quoted in Rebecca Brantley, "Mariska Karasz and Hungary: Early Design and Influences" (Honors thesis, University of Georgia, 2005), n.p.

43 "An Hungarian Dress Designer."

44 Ibid.

45 Informal interview with Rosamond Berg Bassett, March 16–17, 2006.

46 For more on Hungarian embroidery and appliqué, see Kataling Kristó-Nagy and Margit Nagy-Jara, *Hungarian Embroideries* (Passaic, NJ: Hungarian Folk Museum; and New York: Püski-Corvin, 1983), especially 19 and 34 for appliqué.

47 "An Hungarian Dress Designer."

48 Ibid.

49 Dorothy Hoffman (Mrs. Paul G. Hoffman), South Bend, Indiana, to Mariska Karasz, Monday night, undated, collection of the artist's family; and The Paul G. Hoffman page of The History of the Conspiracy Against Tobacco, www.smokershistory.com/PHoffman.htm, accessed August 3, 2005.

50 Hoffman to Karasz.

51 "An Hungarian Dress Designer."

52 "Expressing Wilhelmina!"

53 Alida Vreeland, "Hungarian Ideas Modernized," *Christian Science Monitor*, December 18, 1929.

54 Ibid.

55 Keyes, "Diversity Within the Law."

56 Ibid.

57 Camille Davied, Newark, New Jersey, to Mariska Karasz, New York, May 6, 1931, collection of the artist's family. The magazine experienced several cuts, probably financial, and Davied, the editor, could not get Mariska's article published; *Charm* was absorbed by *Glamour* in 1959. Davied was married to designer Egmont Arens (1888–1966) and later worked as editor at *McCall's*. Email from Solveig Cox, August 1, 2006.

58 Mariska Karasz, "Color-Scheme or Color-Scream," unpublished article, submitted to *Charm* in 1931, collection of the artist's family.

59 Ibid.

60 Hofer and Fél, 19. Thanks to Rebecca Brantley for her assistance with this area of research.

61 Informal interview with Solveig Cox, June 8, 2004.

62 Announcement for spring showing, 1930, collection of the artist's family.

63 List, ca. fall 1929, collection of the artist's family.

64 The categories covered are listed as "How occasioned," "History of Acquaintance," "Outline of Personal Romance," and "Odd Bits of interest about studio, etc."

65 Outline, undated, collection of the artist's family. A second undated typed paper lists the different sections with names beside the dresses, presumably the models: Mrs. Cameron, Mrs. Billard (two dresses), Mrs. Younkin (three dresses), Mrs. Gard (three dresses), Mrs. Holmes, and Mrs. Tizard. Mrs. Gard and Mrs. Tizard are noted as hostesses. List, undated, collection of the artist's family.

66 "An Hungarian Dress Designer."

67 Keyes, "Diversity Within the Law."

68 Clipping, unidentified publication, date and page unknown, collection of the artist's family.

69 Informal interview with Solveig Cox, June 8, 2004.

70 Email from Solveig Cox, October 19, 2005.

71 According to the inflation calculator on the website of the Bureau of Labor Statistics, http://data.bls.gov/cgi-bin/cpicalc.pl, $145 in 1929 would equal approximately $1,700 in 2006 (accessed June 22, 2006).

72 All preceding receipts are on stationery with Mariska's 107 East 34th Street address, collection of the artist's family. All following ones are on paper with the 140 East 34th Street address, collection of the artist's family. Mariska moved from 107 East 34th Street to 140 East 34th Street probably in late 1929.

73 The receipt, from the collection of the artist's family, is dated January 31, and likely is from 1929, the year the cinema opened. According to the inflation calculator previously referenced, $25 in 1929 would equal approximately $300 in 2006. The Film Guild Cinema later was called the 8th Street Playhouse. Cinema Treasures, http://cinematreasures.org/theater/4699/, accessed July 17, 2007.

74 "Film Arts Guild Opens New Theatre," *New York Times*, February 2, 1929.

75 Valentina Sonzogni, comp. "Biography," in *Friedrich Kiesler, Designer: Seating Furniture of the 30s and 40s* (Ostfildern-Ruit: Hatje Cantz; Portchester: Art Books International [distributor], 2005), 121.

76 Informal interview with Solveig Cox, June 8, 2004.

77 For a study of AUDAC, see Mel Byars, "What Makes American Design American?," introduction to reprint edition, R. L. Leonard and C. A. Glassgold, eds., *Modern American Design by the American Union of Decorative Artists and Craftsmen* (New York: I. Washburn, 1930; reprint, New York: Acanthus Press, 1992).

78 Leonard and Glassgold, 69.

79 Walter Rendell Storey, "Arts and Crafts Attuned to the Hour," *New York Times*, May 3, 1931.

80 These works are illustrated in Karen Davies's catalogue *At Home in Manhattan*, and she credits the source of the information as Russian émigré designer Nathan George Horwitt, who was involved with the original installation. Karen Davies, *At Home in Manhattan: Modern Decorative Arts, 1925 to the Depression* (New Haven, CT: Yale University Art Gallery, 1983), 42–43 and 53. These works, one of which closely relates to Hungarian folk embroidery and the other to modern painting, are the only non-fashion embroideries from this period I have identified thus far.

81 Thanks to Paul Manoguerra, curator of American art at the Georgia Museum of Art, for recommending the following source, which addresses how early-twentieth–century modern artists defined Americanness: Wanda M. Corn, *The Great American Thing: Modern Art and National Identity, 1915-1935* (Berkeley, CA: University of California Press, 1999).

82 Richard Martin, *Cubism and Fashion* (New York: The Metropolitan Museum of Art with Harry N. Abrams, Inc., 1998), 102–103.

83 Claire B. Shaeffer, *Couture Sewing Techniques* (Newtown, CT: The Taunton Press, 2001), 200.

84 "California Art Club to Be Host," *Los Angeles Times*, July 17, 1928. Wright designed Hollyhock House for oil heiress Aline Barnsdall in 1921.

85 "Local Statuary Draws Criticism at Art Dinner," *Los Angeles Times*, July 20, 1928.

86 Marcelle de Jaurnel (?) wrote to Mariska apologizing for the (unspecified) difficulties Mariska was having. Jaurnel was sick at the time and assured her that the complications would not have occurred had she been well. The letter mentions Mariska's clothes and is written on stationery from La Casa del Camino, a resort hotel built in 1927 in Laguna Beach. Marcelle de Jaurnel (?), Laguna Beach, California, to Mariska Karasz, July 3, 1930, collection of the artist's family. Laguna Beach.com, http://www.lagunabeach.com, accessed August 8, 2005.

87 "Distinctive Modes Shown at Preview," unidentified publication, ca. 1928, page unknown, collection of the artist's family.

"Play suits that are fun to get into": Mariska Karasz's Fashions for Children

I remember your adorable children's dresses which I first saw many years ago. They bore the mark of high artistry; nothing like them had ever happened in the world before. I saw, too, the children who wore them; they had the poise and the confidence which comes when the apparel brings out one's best personal qualities. There are few greater sources of self-satisfaction.

—

HUGHES MEARNS, CHAIRMAN, DEPARTMENT OF CREATIVE EDUCATION, SCHOOL OF EDUCATION, NEW YORK UNIVERSITY, 1943[1]

THOUGH EXPECTING to give up her professional career with the birth of her first daughter, Solveig, in 1931, motherhood instead led Mariska to a slightly different, more specialized area of fashion design. When trying to find clothes for Solveig, she was disappointed to encounter only pastel clothing in fragile fabrics with fussy decoration, "and Solveig simply wasn't that kind of a baby."[2] She later recalled, "I was appalled at the belaced and beruffled clothes that were on the market for children. I wanted things that were more original, and more practical, too. More apropos of the times."[3] So Mariska made clothing for Solveig of sturdy fabrics with bright colors and in designs that allowed for a toddler's active life. When her other daughter, Rosamond (nicknamed Rozsika), was born eighteen months later in 1932, she had redoubled reason to design modern children's clothing.

Mariska's career in children's fashion progressed from designing for her family and friends to limited designs for manufacture and quickly to a successful custom business. As with her women's fashion, her children's clothing featured a distinctive use of color, peasant-influenced designs interpreted in a modern American fashion, the incorporation of embroidery and appliqué, and quality craftsmanship. With children's clothing, she remained particularly aware of her young clients and their mothers, selecting fabrics that were colorfast, sturdy, and washable; creating patterns that allowed for ease of movement; using fasteners, such as zippers, that were simple for small fingers to operate; and embellishing the outfits with playful decorations and clever names (such as *Play with Me* and *In My Garden*) to engage their youthful wearers.

Mariska held biannual shows of her children's clothing in the spring and fall from spring 1934 through at least fall 1941, and catered again to an exclusive clientele. More than once, writers described her children's clothing as heirlooms, "handed down lovingly from one child to another" and commented on their timelessness.[4] Mariska usually made no more than six of one model and took care "that duplicates [did not] go to little girls who might meet at the same party."[5] She received extensive favorable press for her work and in May 1935 *Women's Wear Daily* featured a lengthy article about her. The author, Virginia Cotier, described Mariska as an "Innovator of Children's Wear" and "a Symbol of the Age" and remarked on the success of her "new fashion design path."[6] Only a few examples of Mariska's clothing for children survive, and these are in the collections of family members and of the Smithsonian Institution's National Museum of American History, through a gift from her daughters. In addition to actual garments, numerous drawings for children's clothing and related photographs and ephemera exist in her papers.

During her career as a designer of children's fashion, Mariska first lived and worked at 143 East 45th Street; from at least fall 1934 until early 1936, her address was 121 Madison Avenue, on the eleventh floor. A description of one of her early studios portrays it as "aglow with kindergarten colors . . . calculated . . . to appeal to children."[7] By fall 1936, her address was 20 East 56th Street, around the corner from Tiffany's, "in the heart of the 'custom-made,' private dressmaking sector."[8]

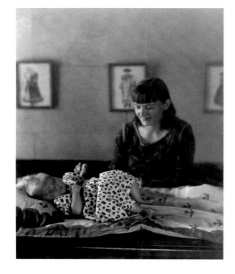

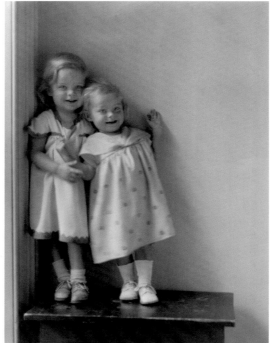

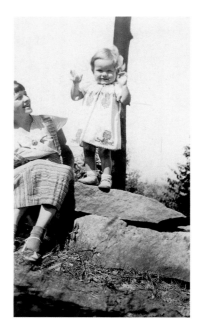

An undated clipping describes this last studio as "attractively worked out with the primary colors, featuring Chinese red curtains, ultra-marine blue low chairs, and hand blocked drapes in a horse design."[9] Mariska believed that her clothing was appropriate to a modern background and provided such in her studio.[10]

During the 1930s, Mariska's "fashion-conscious" daughters participated in their mother's business by modeling clothing for her shows.[11] They appear in a photograph in the March 1940 issue of *Harper's Bazaar* by fashion photographer Louise Dahl-Wolfe (1895–1989) wearing matching dresses with cherries and birds. The girls also wore clothing designed by Mariska to school and other activities, Solveig often in blue (see her pajamas in Figure 1) and Rosamond in pink. The family lived comfortably—Solveig does not recall that the Depression had any great effect on them—and they traveled,

employed a cook, and had nannies to help care for the girls.[12]

<p align="center">✿✿✿</p>

Mariska's involvement with children's clothing design occurred during a period rife with the development and dissemination of new ideas based on science about raising children. Institutes and groups devoted to children's welfare were established or expanded. Academic interest in child science increased, and more schools developed programs to deal with these issues. Though science was the basis for the new ideas about child rearing, the most successful articles came from intelligent mothers rather than from academics, and parents often sought information on raising children from popular sources, such as the radio and *Parents' Magazine*, rather than scientific sources.[13] *Women's Wear Daily* reported that Mariska, as a mother of

Mariska with baby (probably Solveig), ca. 1931
Clara Sipprell (American, born Canada, 1885–1975)
Photograph, 8⅞ x 7 inches
Cat. no. 89

Solveig and Rosamond, ca. 1934
Unidentified photographer
Photograph, 8¹¹⁄₁₆ x 6⁵⁄₁₆ inches
Cat. no. 91

Mariska and Solveig, ca. 1932
Unidentified photographer
Photograph, 4½ x 2¾ inches
Cat. no. 95

two young daughters, was well suited to designing children's clothing, and gained important insight into the needs of her small clients by observing her own children.[14] An undated card promoting a showing of Mariska's children's clothing in Philadelphia claims that psychologists approved highly of her designs for children, and another announcement includes a quotation from Christine Heinig of the Child Development Institute at Columbia University, stating that Mariska's clothes were what she and her colleagues called "the right clothes."[15]

The Lincoln School, the progressive experimental school of Columbia University's Teachers College, presented a showing of Mariska's children's clothing, indicating its approval of her designs.[16] Mariska later wrote of this experience: "When the nursery group teachers at Columbia College began the study of self-help clothes for the very young I was invited to show my models because they combined the ideal features of comfort, color appeal to the emotions plus design that simplified the task of dressing the jet propelled young."[17] Hughes Mearns (1875–1965), head of the Lincoln School and founder of the Department of Creative Education at New York University, was an advocate of Mariska's work.[18] Certainly the support of such a prominent figure in progressive education lent credence to the promotion of Mariska's clothing as important to child development rather than simply fashionable. Mearns encouraged creative, individual expression in children, a self-expression that Mariska's unique outfits would have fostered.

Mariska acknowledged in 1935 that while other areas concerning the well-being of children

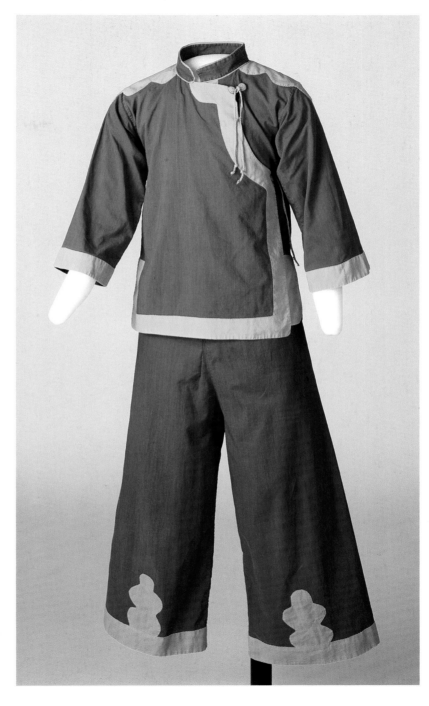

Figure 1
Pajamas, ca. 1935
Cotton, length of top 18 inches;
length of pants 25¾ inches
Cat. no. 67

(opposite)
Figure 3
Nursery at Saks Fifth Avenue,
New York, 1935
Wyatt Davis (American)
Photograph, 9⅛ x 8¾ inches
Collection of the Portas family

52

Detail of design used on
invitations and stationery, n.d.
Ink on paper, dimensions vary

Figure 2
Harry Watts Studio (American)
Solveig and Rozsika with dolls,
ca. 1938
Photograph, 10 x 8 inches
Cat. no. 94

were growing, such as nursery design and the establishment of progressive schools, children's clothing received little attention. She found that giving "individuality to styling for children . . . [was] regarded as somewhat revolutionary."[19] Mariska's interest in modern children's clothing coincided with Ilonka's pioneering efforts to modernize the American nursery, and Mariska argued that, just as parents were carefully considering the surroundings of their children and incorporating modern nurseries into their homes, they should consider clothing in the same modern light.[20] The sisters exhibited together at Saks Fifth Avenue in September 1935 (Fig. 3), an event that Epstein recorded as "a particularly happy experience."[21] In their efforts in their respective fields, Mariska and Ilonka created elements intentionally designed to educate children. For instance, Ilonka color coded drawers to help children learn to keep their things organized, while Mariska designed clothing so that children could dress themselves, exercising their minds and muscles and gaining a sense of independence.

The Child Study Association, one of the groups promoting new, scientifically based ideas about child development, borrowed work from Mariska in 1935 for an exhibition titled *Summer Planning for the Family* and presented an article about her children's fashion in its publication, *Child Study: A Journal of Parent Education*, in February 1937.[22] The writer describes Mariska's children's clothing as "without reservation . . . the most beautiful [she had] ever seen," and highlights Mariska's experience as a mother, strong use of color, practical detailing, quality handmade construction, and design inspiration from Hungary, though clarifying,

as Crawford had earlier, that everything was thoroughly American.

Representatives of *Parents' Magazine*, which also helped spread modern ideas about raising children and was considered the "most popular educational periodical in the world" at the time, attended the showing of Mariska's fall 1938 collection, and included the following description in their magazine: "Her colorful studio on 56th Street, east of Fifth Avenue, was alive with lights, enthusiastic guests and the friendly clink of tea cups. Miss Karasz, whose individual creations are worn by New York's smartest children, had surpassed herself in silhouette, startling colors and her inimitable hand embroideries."[23] Wishing to share the delight of her clothing with their readers, the magazine's representatives convinced Mariska to design patterns for two versions of the same dress, with different appliqués, that could be included in *Parents'*.[24] They requested that the original models be photographed on Mariska's "pixie-like" daughters, and Solveig and Rosamond, aged seven and five, asked to have their dolls dressed and photographed with them (Fig. 2). Solveig and her doll, Gloria (who had her hair styled for the occasion), each have a single appliquéd flower with a long stem running down the front of their dresses, and Rosamond has three paper-chain-like female figures along her neckline while her doll, Nancy, has one.

Evelyn Boatwright, writing about Mariska for *The New York Woman* in 1937, raised another factor that may have contributed to the growing interest in children's fashion: the increasing number of young celebrities such as child star Shirley Temple and Princess Elizabeth.[25] Most of the

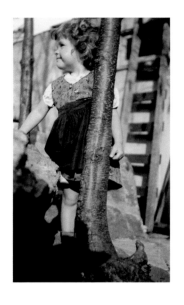

Child's Sun Suit and Hat

"Play with Me" we've named this cunning sun suit. It's sweet with its short bib front held by two straps from one button in the back. The cape collar smartly buttons to the straps in front, and is removable. A very gay modern bird forms a pocket. Rows of rickrack cleverly trim the suit. The rickrack is sewed on in a cunning manner—three little stitches taken at the outer points of the rickrack. The brim of the sun hat buttons to the crown, thus simplifying the laundry problem amazingly.

Child's Dress and Panties

"Gay Shoulders" is the fitting name of this smart frock. Quaint peasant embroidery is worked on the shoulders in bright colors. It's a delightfully designed dress for sunset color combinations. The sections of the round yoke are prettily joined with feather stitching. Box pleats, front and back, provide fulness. Well cut panties match the dress. It's sweet when made of linen, pique, flannel, chambray, silk crepe or cotton broadcloth.

children wearing Mariska's custom clothing were from wealthy families and likely were viewed as trendsetters as well.

The debut of Mariska's first collection of children's clothing took place in spring 1934 in the studio of the artist Nura (Nora Woodson Ulreich, 1882–1950). *Women's Wear Daily* reported: "For the first time yesterday afternoon [Mariska Karasz] presented a comprehensive and nicely diversified collection of dresses and sunsuits, before an audience that was enthusiastic and frankly outspoken in its admiration of the models."[26] Marionettes by scenic designer Ted Weidhaas, "two-dimensional figures of wood in life size," modeled the clothing, and Mary Wilder, who represented Mariska, described them aloud as they "came forward hesitatingly upon the stage." In

addition to custom work, the collection featured several original models for designs that were created for reproduction, including some for paper patterns produced by *Good Housekeeping* and *McCall's*.[27] A photograph of Solveig (Fig. 4) shows her wearing a dress Mariska sold to *Good Housekeeping*, according to a note on the back, while Figures 5 and 6 show patterns *McCall's* retailed based on Mariska's designs.

Numerous publications featured drawings and descriptions of clothing from Mariska's spring 1934 collection. *Women's Wear Daily* included images of a sunsuit of "vermillion wool braid and ultramarine trimmings and applique" held together with cork buttons, a cotton "Sunday-go-to-meeting dress" with fine tucking and "aquamarine blue stars on rose petal pink," and a dress for an older girl, age seven to fourteen, of georgette in "five shades of blue," with a finely pleated skirt and a top with

Figure 4
Unidentified photographer
Solveig wearing a dress, for
Good Housekeeping, ca. 1934
Photograph, $4\frac{1}{2}$ x $2\frac{3}{4}$ inches
Cat. no. 97

Figure 5
Unidentified designer
Sleeve for McCall's pattern for
child's sun suit and hat by
Mariska Karasz, ca. 1934
Ink on paper, 8 x $6\frac{1}{4}$ inches
Cat. no. 100

Figure 6
Unidentified designer
Sleeve for McCall's pattern for
child's dress and panties by
Mariska Karasz, ca. 1934
Ink on paper, 8 x $6\frac{3}{8}$ inches
Cat. no. 102

Figure 7
Unidentified designer
Announcement for spring
showing (detail), ca. 1938
Ink on paper, 7½ x 6 inches
(folded)
Cat. no. 110

Figure 8
Unidentified designer
Announcement for special
showing at Dewees, ca. 1936
Ink on paper, 6¼ x 4⁷⁄₁₆ inches
Cat. no. 103

Announcement for spring
collection (detail), ca. 1934
Unidentified designer
Ink on paper, 11 x 8½ inches
Collection of the Portas family
Cat. no. 98

"transverse applique in two shades."[28] Another publication presented a drawing of three of the dresses on the wooden mannequins: "a yellow linen everyday dress box-pleated onto a yoke appliquéd with red cut-out dogs . . . a white organdie party dress with red appliqué scallops . . . a party dress in crêpe de Chine with net cape appliquéd with the crêpe."[29] *McCall's* illustrated a red and white linen sunsuit titled *Play with Me* with a bird appliquéd on the pocket, rickrack trimming, a detachable collar, and a matching hat (Fig. 5); a red-and-white-checked gingham dress titled *In My Garden* with red and blue appliqués of flowers on the bodice and pocket and white trim; a blue linen sunsuit titled *Sun Daughter* trimmed with dark blue and featuring rose and red prints with a matching bonnet; and a dress and panties in sunset colors titled *Gay Shoulders* with brightly colored "peasant embroidery" on the shoulders (Fig. 6).[30]

As with her earlier fashion designs for women, Mariska's designs for children's clothing in the 1930s featured modern interpretations of central European, primarily Hungarian, folk styles; according to *Women's Wear Daily*, "colorful hand-sewn appliques in intricate designs of peasant origin" were "always identified with this house."[31] The spring 1938 collection, in particular, reflected the influence of a recent trip by Mariska to Hungary, including the reappearance of the *szür* coat: "An actual Hungarian shepherd's coat with fitted body and flaring skirt, of dark gabardine and bright embroidery, is suggested for traveling, and its line adapted in brighter shades for small wearers."[32] An article later that year describes a *szür*-inspired child's coat in more detail: "A winter coat for the young girl is in navy gabarrdine [*sic*] trimmed with cut outs of colored felt adapted in a most modern mood from European peasant

styles."[33] Mariska emphasized the Hungarian aspects of her design through the imagery on her flyers and announcements, such as a drawing of a man on a horse wearing a *szür*, over the words "back from hungary," for her spring 1938 collection (Fig. 7) and a drawing of a little girl wearing a *párta*, an elaborate headdress traditionally worn by unmarried Hungarian girls, on an undated card for a fall collection (Fig. 8).[34]

Though Hungarian influences permeated her work, Mariska referenced a variety of other sources, including "a dress worn by a child in a famous French painting" and motifs from early American quilts.[35] *Women's Wear Daily* described one dress by Mariska, "a heavy linen costume including a circular skirt, sleeveless jacket and cape adorned with red braid," from the spring 1935 collection as "very Russian," and *Good Housekeeping* illustrated a sunsuit inspired by a "Swiss farmer's hooded

Flyer for spring showing
(detail), ca. 1937–41
Unidentified designer
Ink on paper, 10⅞ x 8½ inches
Collection of the Portas family
Cat. no. 105

Flyer for fall collection, 1941
Unidentified designer
Ink on paper, 11 x 8½ inches
Cat. no. 116

Flyer for spring collection, 1940
Unidentified designer
Ink on paper, 8½ x 10⅞ inches
Cat. no. 112

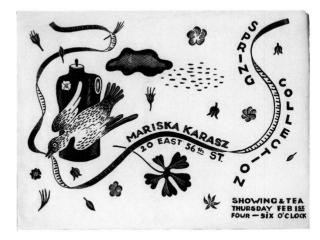

jacket."[36] Occasionally Mariska incorporated specific elements made in Europe outside of Hungary. For example, in 1937, she presented linen dresses trimmed in Bavarian braid.[37] Drawing upon her earlier experiences with M. D. C. Crawford and her studies of museum objects, Mariska also looked to American Indian sources, an influence specifically noted with the spring 1934 collection.[38] Mariska's sophisticated use of these diverse influences led one reviewer to comment that her designs transcended "any provincialism" and were "truly cosmopolitan."[39]

European influence also appears in Mariska's use of the dirndl, a traditional German and Austrian peasant dress with a full skirt and tight bodice worn with a blouse, which was particularly fashionable in the United States in the mid- to late 1930s. One writer in 1940 even credits Mariska with launching the dirndl.[40] This may be an overstatement, but Mariska certainly played a role in promoting the

style as desirable in American high fashion. Mariska introduced the dirndl silhouette in the spring of 1937.[41] A few months later, the dirndl's popularity significantly increased due to its association with the romance of the Duke of Windsor and Mrs. Wallis Warfield Simpson, who received a dirndl as a gift from the duke after he returned from Austria.[42] Mariska continued to use the dirndl for several seasons, and in spring 1938 featured a dress for a young teen of white wool challis in the dirndl style with scarlet embroidered flowers allover and a row of chartreuse velvet buttons down the front.[43]

Mariska's influences changed with the increasing international tensions leading up to America's involvement in World War II, and her daughters remember that when their mother could no longer travel to Europe to find embroiderers, she went to Mexico and Guatemala instead.[44] She presented at least one spring collection, in 1941,

inspired by travels to these countries.[45] This collection included a sheer pink linen dress for an older girl with a natural linen bolero appliquéd with green and pink flowers and birds, a corn-colored sheer linen dress with Guatemalan wool embroidery on the yoke, a sheer green linen dress for a little girl with appliquéd chickens on the collar, and an outfit with Mexican beadwork on crepe linen.[46] Drawings of dresses possibly inspired by Guatemala and Mexico survive, including the drawing in Figure 15 (p. 63) of a dress that features a bolero and embroidered roadrunners. The shift from Europe to the Americas in Mariska's design inspiration was part of a larger shift in the fashion industry away from warring European countries and toward Central and South America.[47]

A program for a spring collection (probably 1941) by Mariska inspired by Mexico and Guatemala lists the outfits in order of appearance:[48]

sololá (mother and child's suit)

tulip bibs (for big and little sister)

pit-a-pat

atitlan (gingham)

huichol belt

can you tie this one?

navy gabardine (young girl's suit)

mereshere

acquas [*sic*] calientes

eggs in two baskets

chickens (mother and little daughter)

quiche (sisters party dress)

china-pueblana

candy stick

coban

flower pots (gingham)

banana blossom

tropical

guatemala sun dress

cherry jumper

la chiquita de cholula

chichicastenango (coat and dress)

Though Mariska worked with Mexican and Guatemalan elements for only a brief time, this activity demonstrates her resourcefulness, commitment to the technique of embroidery, and continued interest in gathering inspiration and materials from around the world.

A key aspect of Mariska's children's clothing was her use of motifs, usually appliquéd though sometimes embroidered or crocheted, which she referred to as "stories" and believed "should be a part of [children's] imaginative lives," in keeping with Mearns's teaching strategies.[49] She repeatedly stressed the importance of understanding and

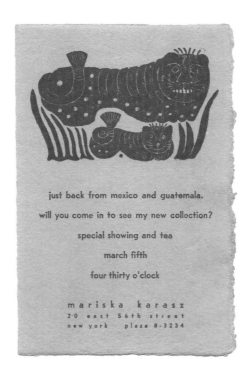

Announcement for spring
collection, ca. 1941
Unidentified designer
Ink on paper, approx. 6 x 3¾
inches
Cat. no. 115

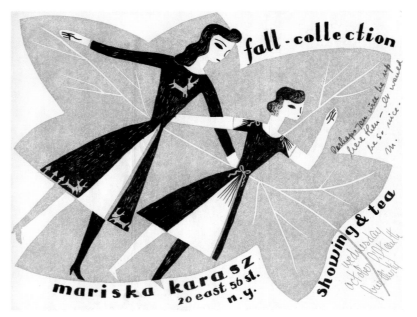

Flyer for fall collection, 1941
Unidentified designer
Ink on paper, 8½ x 10⅞ inches
Cat. no. 117

having affection for children when designing for them, characteristics appreciated by mothers, academics, and members of the press. Cotier notes that Mariska often "calculated [the decorative motifs] primarily to please their wearer," and Keyes credits her with tapping into the sense of delight in small details that children can feel about their clothing.[50] They and other writers enthusiastically reported on the enticing design themes of Mariska's clothing for children.

Keyes describes one dress with a gored skirt resembling an umbrella with a rainbow on the bodice, while Kay Austin, writing for the *New York World Telegram*, describes another dress, called *It Is Raining*, of navy gingham with an umbrella skirt and a top section of pale blue gingham with navy appliquéd raindrops.[51] Keyes enthuses about the sense of adventure created by "little fish [that] come right up out of the sea to swim across [one outfit's] yoke," and snowflakes that "cling tight to [the] lace collar," on another dress, "too happy to melt."[52] Cotier remarks on a playsuit with a single fastening, "a suspender over the shoulder which ends in a hook, to meet the ornamental fish on the front of the bodice," enjoying the fact "that every time the costume is fastened, the child has the delightful experience of 'catching a fish' at the same time."[53] Yet another writer describes a "Horse and Barn dress" of sheer linen with appliqué, noting that "the way the Horse ties to his Barn, at the neck, would give any child plenty to think about."[54]

Simple cotton outfits for children survive in Mariska's and Ilonka's families, demonstrating her use of entertaining appliqués. A small smock (Fig. 9) features a pocket watch appliquéd on the front with a band of Roman numerals around the waist,

suggesting "play time." Another dress or smock has daisies on the front pockets and a separate collar with white dots and a scalloped edge (Fig. 10). A hooded jacket's special detail is a snail on the front, whose shell serves as a pocket, (Fig. 11). The Smithsonian Institution's National Museum of American History owns, among other children's clothing, at least three fancier dresses with sheer linens and more intricate appliqués. Mariska also designed exquisitely appliquéd sheer scarves for her daughters, one with cats for Solveig and one with cupids for Rozsika (Fig. 21, p. 75), each with their name and her initials.

Mariska continued using her child-friendly motifs into the early 1940s, and drawings of dresses from the spring 1940 collection survive. For example, *Rose Leaves* was princess cut in pink linen with deeper pink sleeves that looked like roses when combined with appliquéd green stems running down the front and back (Fig. 12), and *Candy Stick* was a blue linen dress, also in a princess silhouette, with peppermint candy canes appliquéd on the front sides (Fig. 14).[55] In addition, this collection included *Watermelon*, a pale yellow linen dress with appliquéd watermelon slices and *spring-back*, which Mariska suggested for wear at the 1939–1940 New York World's Fair because it was designed for warm weather and vigorous activity.[56] The *New York Herald Tribune* printed descriptions of several other outfits from spring 1940:

> A pearl gray linen had a multicolored pinwheel appliqued on the bodice with the stick running down to the hemline. The sleeves were made of flat pieces of gray and pink linen which buttoned together to form a pinwheel. A little jacket dress

in gingerbread brown had a beige blouse piped in red and brown and a wide belt with the signs of the Zodiac squared off by red bands.

> A wool ensemble in a rich shade of green had a full length coat with a shirred skirt and a double-breasted panel down the front over a suspender dress with a white lingerie blouse. The sleeves were embroidered with red flowers. Also in wool was a red and gray plaid culotte suit with a jacket piped in red rickrack braid to match the piping on the gray chambray blouse.[57]

Women's Wear Daily also reported on the spring 1940 collection, noting in particular the "Easter suits," one of which was titled *Easter Parade* and was of deep blue tweed with a collarless jacket with colorful wool embroidery.[58]

Mariska warned against being too sentimental about clothing, as its primary function is to work, so she selected materials that are strong, easily washable, and colorfast.[59] She most frequently used linens and fine cottons, including gingham, denim, seersucker, organdy, georgette, calico, and batiste.[60] She incorporated some silks (crêpe de chine and mousseline de soie) and wools, and in 1938 she began using chambray, a woven fabric with a warp of one color and weft of another.[61] Other materials mentioned in regard to her clothing include India prints, ratinés, challis, gabardine, shantung, and windproof and water-repellent sailcloth.[62]

In 1935, Mariska designed a line of dresses for Saks Fifth Avenue using Pepperell cotton sheeting, which met her requirements of being colorfast, durable, and "easily tubbable."[63] The *New York Times* ran an advertisement for the Pepperell

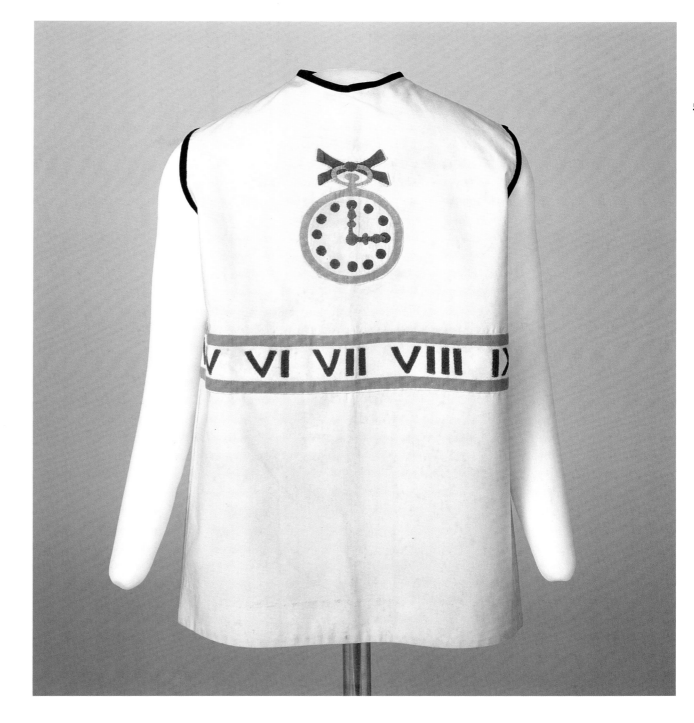

Figure 9
Smock with clock motif, n.d.
Cotton, length 20¼ inches
Collection of the Portas family
Cat. no. 70

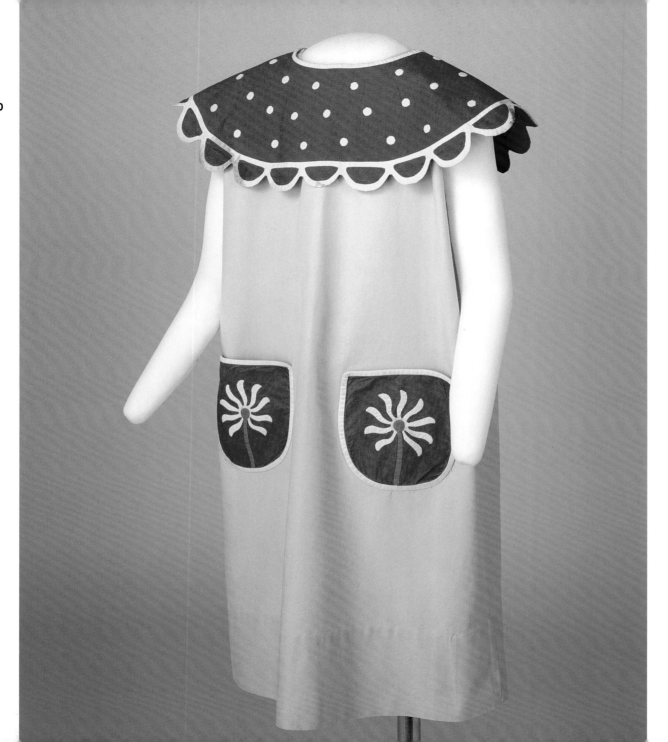

Figure 10
Dress with collar and daisy
pockets, n.d.
Cotton, length approx.
27½ inches
Collection of the Portas family
Cat. no. 69

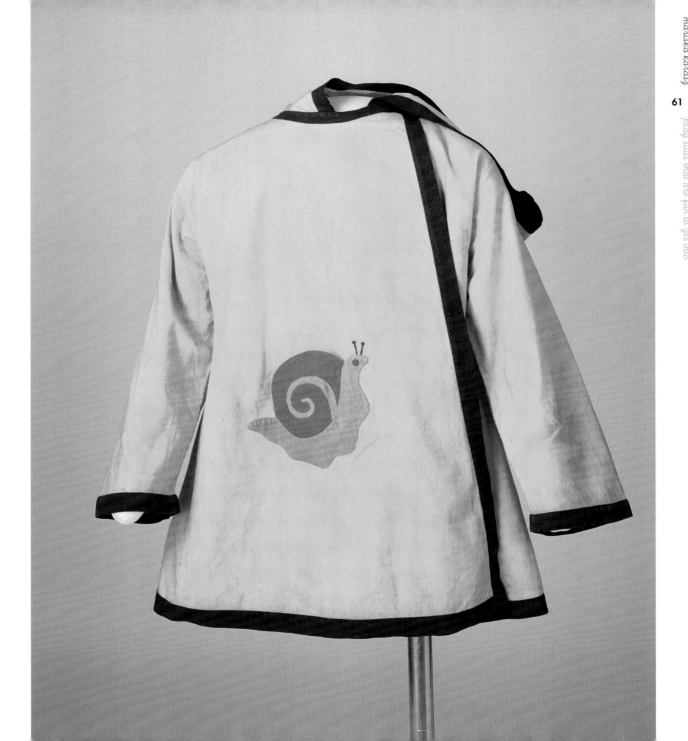

Figure 11
Jacket with snail pocket, n.d.
Cotton, length approx.
31 inches
Collection of the Portas family
Cat. no. 68

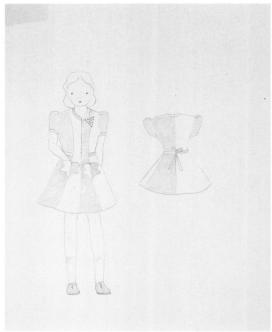

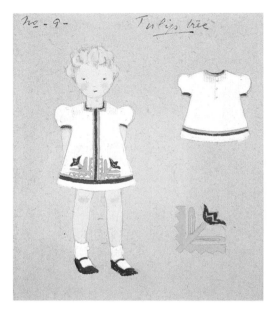

dresses, featuring Mariska's *Raindrops*, available in wineberry and rose or light blue and deep blue in sizes four to six.[64] The outfits featured images "that interest tots," and the dresses were "subtly educational," suggesting that Saks was actively engaged in the popular discussion of child development studies.[65]

Interesting and unusual color combinations continued to be a signature of Mariska's work when she shifted her focus from women's clothing to children's. For example, in 1939, she used unexpected combinations such as "cerise with lavender, lime yellow with royal," or multiple shades of one color together.[66] For her spring 1939 show, she featured two-color alliances, seen in the drawing in Figure 13 of a dress with grapes appliquéd near the neck and grapeleaf pockets on the front.[67] An undated clipping in Mariska's papers highlights the popularity of such two-color outfits, which were

gaining popularity both for custom wear and manufacturers.[68]

Mariska particularly was known for her playsuits and sunsuits, articles of clothing that acknowledged the increasing informality of modern life and reflected her belief that children's clothing should allow unrestricted movement. An announcement for one show features a large flower with the following text: "Play suits that are fun to get into/ Sun suits for the sun to get into/Aprons to make small girls beguiling/Help-Yourself-Clothes with/ grown-up styling" emphasizing the light-heartedness of her clothing as well as its educational aspects. Mariska also showed sunsuits with matching frocks to wear over them, often with square necklines in the back, "not too exposed for regular city wear, but . . . quaint and becoming."[69]

An article in *Women's Wear Daily* in April 1935 highlights Mariska's apparent fondness for capes

and aprons. The capes were "circular, nicely fitted across the shoulders and of waist or shorter than waist length."[70] Capes and other detachable elements, such as yokes or gilets (a sleeveless bodice with a decorative front, a vest), served a practical function in that for fancy outfits Mariska could place the decorative details on them so that they could be treated separately, thereby easing the cleaning process.[71] The spring 1938 collection included dresses with "wrist-length jackets or wrist-length capes" for play, day, or evening wear.[72] Aprons appeared both as actual aprons and as appliqués suggesting aprons, as seen in the fall 1941 collection's mother-and-daughter ensemble in blue wool challis with appliquéd green bands in an apron effect with printed apples on the "aprons."[73]

In addition to dresses, sunsuits, and playsuits, Mariska also sold bibs with bright appliqués, "supper pajamas" for children who wanted

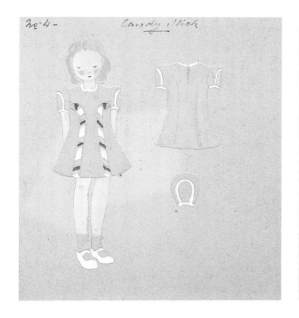

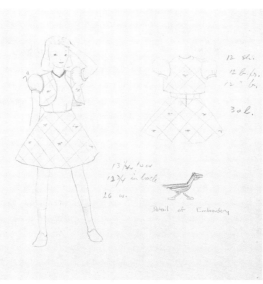

something dressier than their regular pajamas to wear to dinner, and snowsuits, a particularly popular item.[74] Both *Pictorial Review* (a general-interest publication) and *Woman's Day* featured snowsuits by Mariska on their January 1939 covers, and one writer noted that the snowsuits were in such demand that Mariska found it "impossible to keep one on her sample rack."[75] Mariska also offered ice skating costumes and accessories such as bonnets, hoods, and mittens, both woolen mittens and water-repellent sailcloth ones for use over the woolen ones.[76]

Another area of children's fashion design for which Mariska was particularly well known was related outfits for mothers and daughters, which were gaining interest in the fashion industry when she first presented them in her spring 1937 collection. *Women's Wear Daily* credited her a couple of years later with being one of the first

designers to endorse this theme, and in 1943 she claimed to have "pioneered in making mother-and-daughter fashions."[77] Mariska explained their popularity: "little girls like to dress like their mothers, and . . . mothers like to humor their daughters."[78] She used different silhouettes for mothers and daughters but related them via fabrics, colors, and details. She featured several dresses for mothers with the dirndl silhouette, with the daughter dresses matching in fabric and detail but not silhouette; she preferred the "gored Princess or straight-from-the-shoulder" silhouette for daughters.[79] Mariska, Solveig, and Rosamond sometimes wore mother-and-daughter ensembles, as seen in their matching outfits with aprons in red and blue in the photograph in Figure 17.[80]

Mariska's mother-and-daughter combinations in her spring 1937 collection ranged "from town cape costumes to summer beach coats of quilted

(opposite, left to right)
Figure 12
Rose Leaf, ca. 1940
Gouache and graphite on paper,
11 13/16 x 9 3/8 inches

Figure 13
Dress, ca. 1939
Graphite on paper,
11 11/16 x 9 3/8 inches
Cat. no. 81

Tulip Tree, ca. 1940
Gouache, graphite, and ink on folded paper; inside: metal straight pin with fabric sample,
6 x 5 1/2 inches (folded)
Cat. no. 82

(above, left to right)
Figure 14
Candy Stick, ca. 1940
Gouache, graphite, and ink on folded paper; inside: metal straight pin with three fabric samples, 6 x 5 1/2 inches (folded)
Cat. no. 83

Figure 15
Dress, ca. 1941
Graphite on paper, 10 7/8 x 8 3/8 inches
Cat. no. 87

Figure 16
Two dresses, ca. 1937
Gouache over graphite on paper, 12 1/4 x 9 1/8 inches
Cat. no. 74

cotton prints, including a diaphanous organdie evening frock with appliqued bandings and stars outlining the scalloped edges."[81] The *New York American* illustrated two mother-and-daughter ensembles in 1939. The first set was of plain navy challis with capes lined with a white-ground floral challis and complementary hats, the mother's in raffia and the daughter's in straw. The second set was for the beach, the mother wearing a dress of yellow linen with a bolero jacket with royal blue and yellow appliqués, and the child in a dress of similar design in turquoise linen and white linen, with royal blue linen appliqués.[82]

On the back of one of the copies of clippings from 1937 in Mariska's papers are lists of mother-and-daughter outfits with prices. The mother list includes outfits described as "Blue Linen tulip beach dress and jacket" for $55, "White evening white scrolls" for $110, "challis in black with rose coat" for $125, and "Blue wool emb. jacket on brick" for $35. The daughter list includes the corresponding "Tulip dres [sic] in blue" for $13.50 or $15 depending on the size, "Flesh muslin de soi [sic] scrolls" for $35, "challis in blue and short jacket" for $30, and "Blue + white emb. jacket" for $15.[83] Though high end, these prices are relatively moderate, considering that a custom-made adult's dress around that time might cost anywhere between $195 and $400.[84]

Women's Wear Daily noted that Mariska also made sets for big and little sisters, "often in reverse color combinations."[85] Though not in reverse, the dresses in Figure 16, with appliquéd pineapples along the waist and on the sleeves, probably represent this combination. Gertrude Bailey, writing for the *New York World-Telegram*, also addressed

this new "solidarity in the family wardrobe."[86] Bailey describes the step following mother-and-daughter or sister combinations in which "dad's necktie, junior's shorts, sister's dress and sun suit and mother's frock all match." She cites the example of one woman who asked Mariska to make related outfits for her family in checked linen and sailcloth. The mother's and children's outfits are illustrated and described in the article: "[Mother's] frock of blue and natural cross-barred linen has a gayest belt of bright blue sailcloth appliqued in rainbow colors. It matches the trimming on her little boy's sun suit (also of checked linen), and the collar of her little girl's checked linen princess frock." Though Mariska primarily focused on clothing for girls, she made some for little boys as well.

As the mother-and-daughter ensembles indicate, Mariska continued to design for women, though to a limited degree. For example, in March 1937, *Women's Wear Daily* featured illustrations of two women's outfits by Mariska, a military-styled striped linen housecoat "with wide revers and white cotton braid buttons and tabs" that could also be used for beachwear and an "exotic" chiffon "formal tea gown" in "royal blue with two tones of red" with appliquéd designs on the bodice suggesting peasant art.[87] Another *Women's Wear Daily* article about Mariska's clothing for women in the 1930s describes several chiffon dresses appropriate for resort wear: "a coral chiffon frock has yellow and lime green appliques; black chiffon is splashed with bright peasant colors in elaborate appliques and coral is trimmed with peach . . . one monotone costume is a crepe satin jacket ensemble in star-sapphire blue which makes use of the contrasting dull and shiny fabric surfaces, rather than color

Figure 17
Unidentified photographer
Mariska sewing with Rosamond
and Solveig, ca. 1939
Photograph, 9⅛ x 6¹¹⁄₁₆ inches
Cat. no. 111

contrasts."[88] One of Mariska's adult dresses appeared in the society pages of the *New York Herald Tribune* in September 1939: Mrs. Van Devanter Crisp, a noted golfer, was photographed attending a horse show at Piping Rock in Long Island with her children, Van Devanter, Peter, and Lucetta Crisp, wearing a dirndl-style dress with appliquéd peasant-style flowers on the front.[89]

The Georgia Museum of Art acquired a blue linen dress from this period by Mariska (Fig. 18) that features colorful abstract floral appliqués on the front of the skirt outlined with a red inverted scalloped border, suggesting an apron. This dress reflects the fine craftsmanship, peasant-influenced style, and skillful color combinations for which Mariska was known. The label, sewn inside the front waist, reads "Mariska Karasz/New York."

Parents' Magazine reported that Mariska quickly developed an "enviable clientele for her children's clothes," a fact clearly supported by surviving documents and clippings that reveal the names of numerous patrons, both for children's and women's clothing.[90] One writer, in fact, notes that Mrs. Gary Cooper was an enthusiast of Mariska's clothes and visited her studio when in New York.[91] An article in the *New York Times* further emphasizes the high reputation of Mariska's studio, describing it as to a child what "Patou or Schiaparelli is to a woman."[92]

Mariska's children's clothing often adorned social events attended by her well-to-do clients, certainly adding to its trend-setting status. *Women's Wear Daily* featured photographs of two young girls in 1937 at the Greentree Fair, a charity

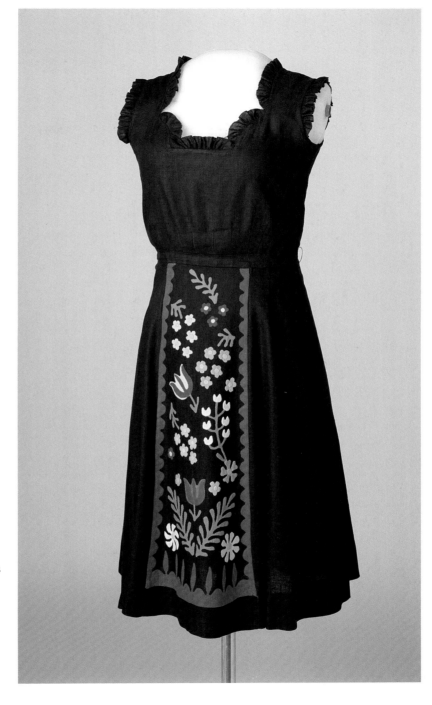

Figure 18
Dress, ca. 1938
Linen appliqué on linen with zipper, length approx.
40 inches
Georgia Museum of Art, University of Georgia; museum purchase
GMOA 2005.85
Cat. no. 9

affair at the country estate of Mrs. Payne Whitney in Manhasset, Long Island, attended by children from "the best families," wearing handmade dresses, "in the very high price bracket."[93] Though Mariska is not credited in the article, the clipping remained in her papers, and the dresses clearly match descriptions and photographs of her designs. One is a square-necked linen dress with appliquéd flowers on three godets (triangular inserts) in the front, worn by Ann Harkness, daughter of philanthropists Mr. and Mrs. William Hale Harkness (similar to the child's dress to the right in the center alcove of the photograph in Fig. 19); the other is a sheer linen dress with an embroidered collar and sash worn by Lili Knott, daughter of Mr. and Mrs. James Knott of the Knott Hotels Corporation.[94] Lili's dress matched her little brother's embroidered shirt that he wore with his two-piece suit. The following summer one of Mariska's dresses appeared on a young girl at the Sewickley horse show outside of Pittsburgh: Cordelia Scaife, who attended with her grandmother, Mrs. Richard Beatty Mellon, wore a two-color dress with appliquéd abstract leaves.[95]

Numerous receipts survive for Mariska's children's clothing, further documenting the names of her customers, her influences, and her prices.[96] The receipts include one for a blue wool coat and hat to Mrs. Mortiletto of New York in November 1937 for $35.70; another for a "Bittersweet linen dress" to Mrs. Stewart Beach, shipped to Miss Susan Gleaves, both of New York, in December 1937 for $8.16; and another for a yellow braid dress, size five, to Mrs. Warren Brewster of Long Island in January (probably 1938). Also documented by receipts are the purchase by Mrs.

A. A. Berle, Jr., of New York (the wife of Adolf Augustus Berle, Jr., who served as a member of Franklin Delano Roosevelt's Brain Trust and as Assistant Secretary of State for Latin American affairs from 1938 to 1944), of a "Queen's Costume" for her daughter Beatrice and a blouse for a jumper, a "costume of peasant woman 'mezőkövesd' Hungary," and a party dress for her daughter Alice in December (probably 1937).

Some receipts do not clearly indicate if the clothing was for a child or a woman, including two for jackets in December 1937, one for a red embroidered jacket to Mrs. Edward Darroll, Jr., of New York for $15.30, and the other for a quilted jacket for $25.50 to Miss Evelyn Carmey who lived on Gramercy Park in New York and wrote on the receipt, "The Jacket was very nice/Thanks very much best wishes." The prices suggest that the coats were for children.

Mariska's clientele extended well beyond New York, and she showed her clothing in other cities, including Philadelphia, Pittsburgh, and Washington, D.C.[97] In February 1941, Mariska wrote to a client in Midland, Texas, offering to send her original sketches of models from the current collection if the client did not expect to visit New York that season.[98] Mariska also sold an embroidered jacket and sailcloth mittens to Mrs. Birchall Hammer of Ellins Park, Pennsylvania, in January 1938, and a pink dress to Mrs. J. A. Harris III of Montgomery County, Pennsylvania, for $15 in January 1938.[99]

Hammer and Harris may have seen Mariska's clothing at the department store B. F. Dewees in Philadelphia, which first presented models of her clothing, allowing its shoppers to place custom orders, in March 1936.[100] The authors of an article

for the *Philadelphia Evening Public Ledger*, after seeing Mariska's children's clothing at Dewees, "decided that in [their] whole year and two months and two weeks of fashion trekking [they]'d never been so downright enthusiastic about *anything*."[101] They described spring outfits: "Little overalls in pink calico, with quilted dark blue patches at the knees so that tender skins will be protected from sandbox corners or a hard pavement upon which a tricycle has come to grief Little navy and red checked gingham aprons cut diagonally A delicate yellow linen frock embroidered in light-weight wool in beige tones with a little separate apricot-colored bolero." They noted that most outfits folded out flat for easy ironing and that Mariska would be in the store on March 16. At the end of the initial showing of her clothing at Dewees, Irene E. R. Nyland, the store's advertising manager, wrote to Mariska conveying her business's pleasure at having had the collection there and expressing her desire to continue their association.[102] The store set a goal of ten orders for the two weeks, and had achieved nine by the time of the letter.

The next year, spring 1937, the *Philadelphia Evening Public Ledger* again recorded that Mariska's clothing appeared at Dewees and acknowledged her renown: "B. F. Dewees window display of matching mother-and-daughter dirndl dresses is attracting considerable attention. . . . You've known about her children's clothing for ages, and you've probably seen the two children of Madame Karasz in a movie short showing what nice little boys and girls wear when they wish to look their cunningnest [sic]."[103] Mariska also presented at least one fall collection and possibly one collection in 1938 at Dewees.

Figure 19
Unidentified photographer
Dewees window, ca. 1936
Photograph, $7^{11}/_{16}$ x $9^{1}/_{4}$ inches
Cat. no. 93

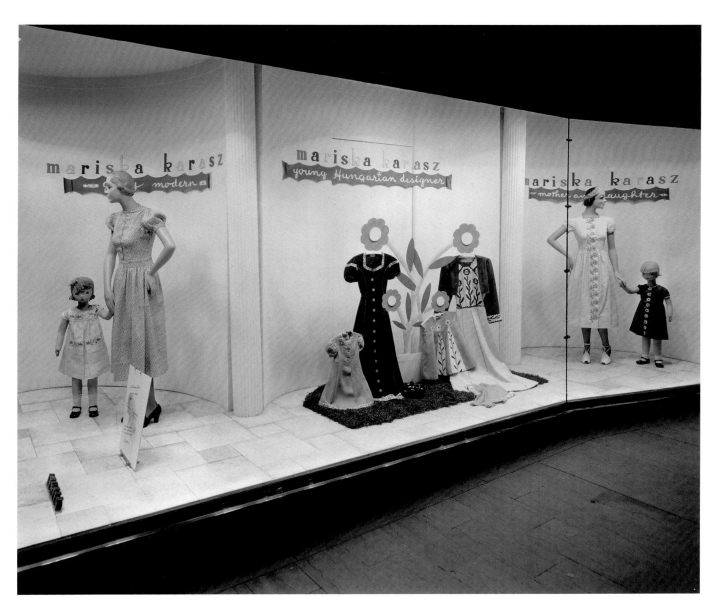

❈

In addition to custom designs, Mariska also developed children's clothing for manufacture. In fact, one of the earliest records of Mariska creating clothing for children is an agreement she signed in October 1933 with L. Bamberger & Co. in Newark, New Jersey, authorizing the department store to make copies of two original handmade girls' dresses. She allowed them to promote the copies for sale as designed by her and to use photographs of Solveig wearing the originals in the promotion.[104] (Solveig's costume in Figure 20 likely represents the style of clothing that Mariska provided to Bamberger and other manufacturers at this time.) Epstein records that there was "a great deal of excitement" about the clothing Mariska designed and Bamberger manufactured.[105]

In November 1934, Mariska signed an agreement with J. Markowitz & Son, Inc., to design and style its children's clothing line on a temporary basis.[106] The company was not to use her name in any way in the promotion of the garments, and it was understood that she would "not produce or style any garments in sizes one to six to be used by manufacturers." She promised three to five designs per week, working ten hours a week.

The following month Mariska agreed to design a line of overalls, sunsuits, and jackets for the American Romper Company for a trial period.[107] She promised to develop approximately thirty designs, working for about two weeks. She again requested that her name not be used in the promotion of the designs but allowed the company to mention it in correspondence on Nathan Krauskopf Company stationery.[108] In November 1935, she once more agreed to design for the American Romper Company, this time developing a line of about twelve to twenty sunsuits.[109] She continued her association with the company for several years, receiving a letter in September 1937 asking her to focus her work on sunsuits rather than playsuits or beach robes.[110]

Mariska enjoyed a favorable reputation within the industry, and when Mr. K. H. Bolen of the Ward-Stilson Company in Anderson, Indiana, wrote to Pacific Mills in New York in 1935 wishing to be put in touch with "a first-class designer of children's clothes who is well established," the company directed him to Mariska, describing her as the "best designer of children's clothes" and explaining that all of the leading stores in New York were using her designs, and that Saks Fifth Avenue had begun featuring her in its advertisements.[111] Despite success with mass production of her designs, Mariska preferred personal interaction with her clients and focused her efforts on her custom retail business.

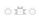

As mentioned previously, Mariska presented semi-annual shows of her children's fashion until at least fall 1941.[112] Documentation for her work in the early 1940s is limited, as is family discussion of this period of her life. Around Halloween one year in the early to mid-1940s, probably in 1941, a fire in Mariska's studio effectively ended her career as a fashion designer.[113] She lost existing work and documentation of earlier work, and much of the surviving ephemera and pieces of appliqué shows evidence of fire, smoke, and water damage. After the fire Mariska spent time in Brewster, and her daughters attended the one-room schoolhouse

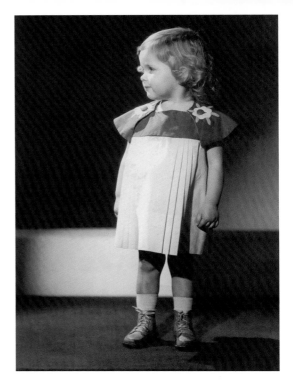

Figure 20
Unidentified photographer
Solveig wearing a sundress,
ca. 1933
Photograph, 8⅞ x 5⅝ inches
Cat. no. 90

there for half a year; she then traveled to Mexico, and her daughters spent half a year with a tutor in Florida.[114] Later they returned to New York, living at 95th Street and Central Park West, then moving to 310 Riverside Drive while the girls were in high school.[115]

In addition to losses resulting from the fire, Mariska also faced the stress of a deteriorating marriage and eventual divorce. Donald continued to be a part of her and her daughters' lives, though, and always lived nearby.[116] Further complicating these difficulties is the fact that this period of transition in Mariska's life was set against the backdrop of World War II, a particularly difficult time for her. The war affected her deeply, both personally, with Hungary and the United States on opposite sides, and professionally, since it limited her access to Hungarian craftsmen and likely limited American interest in Hungarian craftsmanship. Though the war years were the least productive for her artistically, Mariska did find a creative outlet in writing instructional books on sewing and design inspired by her daughters' growing interests and developing skills.

Frederick A. Stokes Company published, and *Good Housekeeping* sponsored, Mariska's first book, *See and Sew, a Picture Book of Sewing*, in fall 1943. *See and Sew* grew out of sewing classes she conducted for Solveig and Rosamond and neighboring children in Brewster and presents basic instruction in how to work with needle, thread, scissors, and fabric. Christine Engler, who taught art at the Birch Wathen School in New York, where Solveig and Rosamond studied, provided drawings for the book.[117] About its origins, Mariska stated, "Realizing how few children were learning to sew,

and knowing how necessary it is to know how to make things, particularly in wartime, I worked out the idea of the book."[118]

In the foreword to *See and Sew*, Mariska relates how when she was seven she learned to sew from the seamstress who made clothes for her family each year. Based on her personal experience of learning to sew and her observations of her daughters and their friends, she determined that young sewers like projects with pretty, colorful fabrics; projects that do something (such as a red stuffed horse Solveig created to replace the chair by the telephone table); and projects that do not come with boring, extensive instructions. She addressed the text to young readers and included humorous elements such as a dog drawn by the explanation of woof (or weft) and an illustration addressing how not to damage the sofa when cutting fabric. She provided simple projects such as making a pincushion, a skating cap, and a tray cloth, and, as with children's clothing, she sought to cultivate children's imaginations and encourage original expression through the projects.[120] *See and Sew* received wide promotion, and Solveig and Rosamond appeared with Mariska on the Martha Deane radio program, one of the first radio talk shows for women, to discuss the book in September 1943.[121]

Hughes Mearns wrote to Mariska praising *See and Sew* as "full of love, love for sewing and love for the eagerness of little children to create beautiful things of their very own," and credited her with being a "creative artist" as well as an "instinctive psychologist."[122] This commendation from Mearns reinforces Mariska's connection to modern issues of child development.

When her daughters outgrew *See and Sew*, Mariska wrote a second book, *Design and Sew*, published by J. B. Lippincott Company in 1946. Christine Engler again provided illustrations. *Design and Sew*, which was intended for teenagers, explains basic design principles and how to apply them to fashion.

Mariska and her daughters talked about *Design and Sew* on a program, probably for radio, with actress Glenda Farrell, and the discussion survives in the form of an undated typed transcript.[123] Mariska related that as a youngster she had always wanted to find a book that would help her learn to design but never could. Rosamond pointed out that her mother "had an awful time with patterns," which Mariska acknowledged, adding that she "was more concerned with color and the emotional qualities of designing." When discussing materials, Solveig stated, "Mother buys material, then hoards it till somebody needs a dress or a blouse"—an early indication of a collecting instinct Mariska cultivated more completely in the 1950s. Mariska also addressed individuality in fashion, urging women not to look like they had "been cut out by a cookie cutter." She added, "I've always warned my girls against apeing [sic] their classmates and looking like a rubber stamp. Your clothes should belong to YOU. Then you can be sure of certain style and individuality," themes she also promoted with her women's fashion in the 1920s.[124]

In conjunction with the publication of *Design and Sew*, J. B. Lippincott Company sponsored a national teenage dress design contest, capitalizing on Mariska's reputation even though she no longer worked as a fashion designer after the studio fire.

Mariska sewing with Solveig
and Rosamond (detail), ca. 1946
Conrad Eiger (American)
Photograph, 8⅛ x 10 inches
© The Eiger family
Cat. no. 122

Of the 315 eligible contestants, Joanne Sattler, a sixteen-year-old from Boonville, New York, won first place, receiving a $100 savings bond and having her design featured in *Calling All Girls*, an offshoot of *Parents' Magazine* for teenage girls. Eleanor Jo Martin, a seventeen-year-old from San Bernardino, California, won second place. The judges were actress Peggy Ann Garner, textile designer Pola Stout, Vyvyan Donner with 20th Century-Fox Movietone News, fashion editor Nancy Pepper, designer Edward Stevenson for RKO Pictures (the film studio), Helen Dean Fish of Lippincott, and Mariska.[125]

Mariska wrote another book in 1952, *How to Make Growing Clothes for Your Baby* (published by Pelligrini & Cudahy the same year), marking another momentous occasion in her private life, the imminent arrival of her first grandchild (David, Solveig's son). With the simple patterns in the book, she sought to allow new mothers to create "the perfect, individualized wardrobe for a comfortable, well-dressed baby." In the introduction she explains that she first conceived of the book when she was expecting Solveig, and though she did not write it immediately, she maintained "an unshakable belief that children's clothes are more important than any designer's latest collection." She acknowledges that expectant mothers are susceptible to a desire to make baby outfits, so with *Growing Clothes* she wanted to "pass along the ideal and the means of achieving success in this medium." Christine Engler again provided illustrations for the book and Ray Johnson (1927–1995), the eccentric collage artist especially known for incorporating the postal system into his art (mail art), designed the cover.[126]

In 1945, Beryl Williams Epstein wrote a book titled *Fashion Is Our Business*, which featured a chapter on Mariska as well as sections on ten other fashion designers, including Hattie Carnegie (1886–1956), Norman Norell (1900–1972), Claire McCardell (1905–1958), and Edith Head (1897–1981). Epstein claims that by 1945, children's fashion from Maine to California showed Mariska's influence. She writes,

> Every child who was brought to her was a stimulation and a challenge, and could be given the same individualized attention which an expensive couturier lavishes upon a beautiful woman. One thing the children especially loved about their Mariska Karasz clothes was the fact that each of them had a name. There was the "Lady Bug" dress, with huge replicas of its insect inspiration for pockets; the "Purple Cow," with an appliqué of that fabulous animal surrounded by flowers; "A-Tisket, A-Tasket," whose bloom-like buttons seemed to spill out of a flower basket; "It Is Raining," with long drops splashing diagonally from top to bottom; and the fascinating "Go Away" dress, on which coaches and an engine traveled a never-ending journey around the hem.[127]

Though published after Mariska's career as a fashion designer ended, Epstein's book attests to her stature in the field of fashion design and the widespread influence of her work. Mariska clearly played an important role in children's fashion in America in the 1930s, though the true extent of her influence is somewhat difficult to gauge because her work with fashion manufacturers was often anonymous. Keyes stated in 1935, "we owe a great deal that is good in the new trends to Mariska Karasz," a debt resulting from Mariska's resolve, in her own words, "to instigate a personal one-man revolution within the unexplored fashion world of infant's wear."[128]

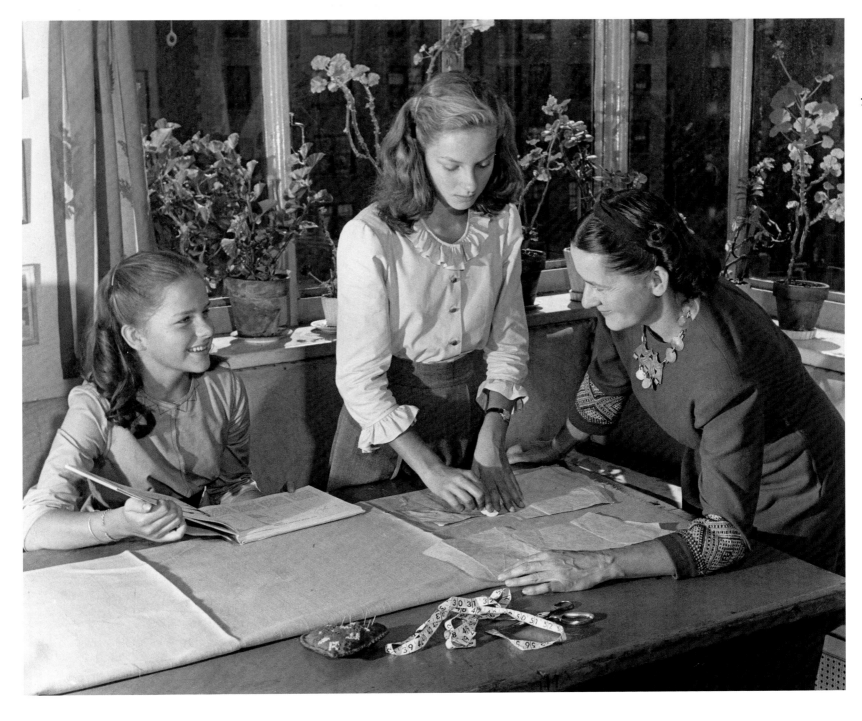

1 Hughes Mearns, New York, New York, to Mariska Karasz, Brewster, New York, September 27, 1943, collection of the artist's family.

2 Beryl Williams Epstein, *Fashion Is Our Business* (New York: J. B. Lippincott Company, 1945), 178. A photograph of Mariska with one of her baby daughters, probably Solveig (see image on page 50) documents her early designs for her family. The baby rests on a pillow and blanket with an appliquéd design of small repeated flowers and a scalloped border, similar in style to the clothing she designed for women.

3 Transcript of conversation, possibly for radio, between Glenda Farrell, Mariska Karasz, Solveig Peterson, and Rozsika Peterson, ca. 1946, collection of the artist's family.

4 Epstein, 181; and Betty Green, "Designed for You by Mariska Karasz, New York," *Parents' Magazine* 14 (February 1939): 88.

5 "New Things Seen in the City Shops," *New York Times*, November 20, 1938.

6 Virginia Cotier, "Designers of Today and Tomorrow," *Women's Wear Daily*, May 8, 1935.

7 "Tyrolean Success Inspires Designer to Open Salon," unidentified publication, date and page unknown, collection of the artist's family. Handwritten at the bottom of the clipping, which starts in the middle of the article, is "Women's Wear Daily / (March 8, 1934?)," but that citation is not accurate.

8 "Candy Sticks, Rose Leaves, Watermelon Motifs Adorn Girls' Frocks for Spring," *Women's Wear Daily*, February 5, 1940.

9 "A Touch of the European," unidentified publication, date and page unknown, collection of the artist's family.

10 "Mariska Karasz Turns Her Creative Talents to Designing of Children's Clothes," *Women's Wear Daily*, date unknown, collection of the artist's family.

11 Cotier; and Green, 89.

12 Email from Solveig Cox, September 18, 2005.

13 For more information on the history of scientific ideas about child development, see for example Alice Boardman Smuts, *Science in the Service of Children, 1893–1935* (New Haven, CT, and London: Yale University Press, 2006).

14 "Mariska Karasz Turns Her Creative Talents to Designing of Children's Clothes."

15 Announcement for fall show of Mariska's clothing at Dewees, undated, collection of the artist's family. Heinig wrote to Mariska in October 1935 asking if one of Columbia's students could observe Mariska's daughters for a dissertation project. Christine M. Heinig, New York, New York, to Mariska Karasz, New York, New York, October 8, 1935, collection of the artist's family.

16 P. R. F., "Shop Talk," *Child Study: A Journal of Parent Education* 14 (February 1937): 152; and "Practical Features Treated with Imagination by Young Designer," *Women's Wear Daily*, April 17, 1935. It is possible that Mariska showed her work more than once at the Lincoln School, which existed from 1917 to 1940.

17 Mariska Karasz, *How to Make Growing Clothes for Your Baby* (New York: Pelligrini & Cudahy, 1952), 6. Self-help clothing for children began appearing in the market around the time that Mariska began designing children's clothing. Smuts, 171.

18 "Hughes Mearns, Educator, Dead," *New York Times*, March 14, 1965; and Margaret Flenniken, "Creative Effort in Children," *New York Times*, May 25, 1930.

19 Cotier.

20 Ilonka designed a Bauhaus-inspired nursery in 1928 and continued to investigate that area of modern furniture design into the mid-1930s.

21 Epstein, 179. Dresses by Mariska appear with Ilonka's nursery furniture in Hanna Tachau, "Modern Ideas for Very Young Moderns," *American Home* 14 (September 1935): 259–61, 292. One of the dresses features an appliquéd stem with leaves running up the front, ending in a scalloped-edged, flower-like collar. Most of the promotion focused on Ilonka's nurseries.

22 Zilpha Carruthers Franklin, New York, New York, to Mariska Karasz, New York, New York, May 7, 1935, collection of the artist's family; and P. R. F., 152. Ilonka also worked with the Child Study Association.

23 Smuts, 171; and Green, 84.

24 The patterns were featured in the February 1939 issue.

25 Evelyn Boatwright, "Through a Child's Day," *The New York Woman*, ca. spring 1937, collection of the artist's family.

26 "Mariska Karasz Turns Her Creative Talents to Designing of Children's Clothes."

27 Ibid. This collection also included sunsuits for the Brohman Co. *Women's Wear Daily* misspells Weidhaas's name as Weldhaaf. For more on him see "At Last, Something New," *New York Times*, July 15, 1928; and "Gustav A. Weidhaas," *New York Times*, August 23, 1938.

28 "Mariska Karasz Designs for Children Have a Refreshing and Imaginative Quality," *Women's Wear Daily*, March 14, 1934.

29 "Mariska Karasz—A Name to Watch," unidentified publication, ca. 1934, page unknown, collection of the artist's family.

30 *McCall's* also offered for sale the patterns for these and other dresses and noted that they would be lovely in many different fabrics. McCall's Printed Pattern with Transfer, collection of the artist's family; and Elisabeth Blondel, "Daughters of the Sun" *McCall's* 61 (May 1934): 133.

31 "Colorful Appliques Identify 'Dateless' Princess Frocks," *Women's Wear Daily*, October 20, 1937.

32 "Central European Peasant Inspires Spring Collection by Mariska Karasz," *Women's Wear Daily*, March 2, 1938.

33 "Chambray Appliqued in Gayest Contrasts in Custom-Made Group," *Women's Wear Daily*, October 26, 1938.

34 Margery Rae, "A Sunday in Mezőkövesd," *National Geographic* 67 (April 1935): 497. Thanks to Rosamond Berg Bassett for bringing this article to my attention.

35 "Tyrolean Success Inspires Designer to Open Salon"; and P. R. F., 152.

36 "Practical Features Treated with Imagination by Young Designer," *Women's Wear Daily*, April 17, 1935; and "All of a Summer's Day—Be It Party or Play," *Good Housekeeping* (date unknown): 58, collection of the artist's family.

37 Boatwright. In the spring 1938 collection, Mariska included a dress with "hand-blocked linen in a tiny peasant pattern with banding of peasant braid." "Chambray Appliqued in Gayest Contrasts in Custom-Made Group."

38 "Mariska Karasz Turns Her Creative Talents to Designing of Children's Clothes."

39 Ibid.

40 "Made-to-Order Easter Clothes for the Growing Miss," *Evening Public Ledger* (Philadelphia), March 12, 1940.

41 "Mother-and-Daughter Theme Gains Momentum for Exclusive Trade," *Women's Wear Daily*, March 17, 1937.

42 "Windsor, Told to 'Hurry Up,' Speeds to Reunion Today," *New York Times*, May 4, 1937. Thanks to Madelyn Shaw for pointing out the connection between dirndls and Mrs. Simpson.

43 "Central European Peasant Inspires Spring Collection by Mariska Karasz."

44 Informal interview with Solveig Cox, June 8, 2004; and informal interview with Rosamond Berg Bassett, March 16–17, 2006.

45 Though none of the clippings or ephemera related to Mariska's Guatemalan- and Mexican-inspired clothing is dated, the article "Park East Shopper," cited below, contains details that clearly indicate a date of April 1941, in particular an advertisement for a sale at Parke-Bernet Galleries that corresponds to an advertisement in the *New York Times* from April 12, 1941.

46 "Appliqued Yoke and Bolero Themes in Latin-American Embroideries for Girls' Frocks," unidentified publication, date and page unknown, collection of the artist's family; and "Park East Shopper," unidentified publication, ca. April 1941, page unknown, collection of the artist's family.

47 See, for example, the advertisement for John Wanamaker in the *New York Times* on March 3, 1941. This influence continued for several years, and in 1943, Saks presented a mother and two daughters with the children wearing clothing of "peasant fashion with fascinators for each" and a Guatemalan coatdress. Virginia Pope, "Six Stores Exhibit Summer Fashions," *New York Times*, April 28, 1943.

48 Program for a spring collection of Mariska's children's clothing, undated, collection of the artist's family. The card notes that the costumes are from Sololá, Santiago-Atitlán, Palin, Mixco, and Coban.

49 Helen Johnson Keyes, "Clothes and the Child," *Christian Science Monitor*, November 21, 1934.

50 Ibid. and Cotier.

51 Keyes, "Clothes and the Child"; and Kay Austin, "Little Dresses Appeal to Hearts of All Women," *New York World-Telegram*, January 8, 1935.

52 Keyes, "Clothes and the Child."

53 Cotier.

54 "Park East Shopper."

55 "Candy Sticks, Rose Leaves."

56 Ibid.; and "Mariska Karasz Shows Children's Spring Garb," *New York Herald Tribune*, February 2, 1940.

57 "Mariska Karasz Shows Children's Spring Garb."

58 "Candy Sticks, Rose Leaves."

59 Keyes, "Clothes and the Child."

60 Ibid.; "Mariska Karasz Does Apron and Petticoats By Color Contrasts," *Women's Wear Daily*, March 2, 1939; and "Dresses for Children," unidentified publication, date and page unknown, collection of the artist's family. A writer in 1937 noted that for some dresses Mariska used hand-woven linens with a rustic feeling. "Mother-and-Daughter Theme Gains Momentum for Exclusive Trade."

61 "Mariska Karasz Does Apron and Petticoats By Color Contrasts"; "Dresses for Children"; and "Chambray Appliqued in Gayest Contrasts in Custom-Made Group."

62 Keyes, "Clothes and the Child"; "Chambray Appliqued in Gayest Contrasts in Custom-Made Group"; "All of a Summer's Day—Be It Party or Play"; and "A Navy Blue Coat Over a Print Frock Makes a Smart Spring Ensemble for the Small Girl," *New York Herald Tribune*, March 24, 1937.

63 Keyes, "Clothes and the Child."

64 Advertisement, *New York Times*, October 2, 1935.

65 Helen Johnson Keyes, "Clothes to Express the Child," *Christian Science Monitor*, November 15, 1935.

66 "Still Present—the Peasant Theme in an American Mood," *Women's Wear Daily*, December 21, 1938; and Green, 89. Mariska also employed, by 1938, "shocking pink," which Elsa Schiaparelli introduced in 1936. Margaret Walch, *Living Colors: The Definitive Guide to Color Palettes Through the Ages* (San Francisco: Chronicle Books, 1995), 105. This color appeared both in a full-length coat over a dress of floral challis and combined with teal blue in another coat. "Central European Peasant Inspires Spring Collection by Mariska Karasz" and "Mariska Karasz Does Apron and Petticoats By Color Contrasts."

67 "Mariska Karasz Does Apron and Petticoats By Color Contrasts."

68 "Half and Half Tonic for Juveniles," unidentified publication, date and page unknown, collection of the artist's family. Mariska's name is not mentioned in the article, but the clipping remained in her papers and the illustrations resemble her clothing.

69 "Mother-and-Daughter Theme Gains Momentum for Exclusive Trade."

70 "Practical Features Treated with Imagination by Young Designer."

71 Mary Brooks Picken, *A Dictionary of Costume and Fashion, Historic and Modern* (Mineola, NY: Dover Publications, 1985), 148; and Keyes, "Clothes and the Child."

72 "Central European Peasant Inspires Spring Collection by Mariska Karasz."

73 "Appliques Suggest Suspenders and Apron Effects in Karasz Custom Designs," *Women's Wear Daily*, October 29, 1941. Sometimes hats accompanied Mariska's outfits, often provided by Maria Constantine, about whom more research remains to be conducted. See, for example, "Chambray Appliqued in Gayest Contrasts in Custom-Made Group."

74 "Tyrolean Success Inspires Designer to Open Salon."

75 Ibid.

76 P. R. F., 152.

77 "Mariska Karasz Does Apron and Petticoats By Color Contrasts"; and Barbara E. Scott Fisher, "Children Should Have Taste, Too," *Christian Science Monitor*, October 13, 1943. A press release from 1943 also credits Mariska as the "originator of the Mother and Daughter dress fashions." *See and Sew* press release from Lippincott, October 9, 1943, collection of the artist's family.

78 "Dresses for Children."

79 "Mother-and-Daughter Theme Gains Momentum for Exclusive Trade."

80 Green, 89.

81 "Mother-and-Daughter Theme Gains Momentum for Exclusive Trade."

82 Prunella Wood, "Little Girls' Garb Grows Up For Mothers," *New York American*, April 30, 1937.

83 These lists, which include several other matched outfits, are handwritten on the back of a copy of a clipping from *Child Study: A Journal of Parent Education* 14 (February 1937), collection of the artist's family.

84 See Madelyn Shaw, "American Fashion: The Tirocchi Sisters in Context," 126, in Susan Hay, ed., *From Paris to Providence: Fashion, Art, and the Tirocchi Dressmakers' Shop, 1915-1947* (Providence, RI: Museum of Art, Rhode Island School of Design, 2000). According to the inflation calculator on the website of the Bureau of Labor Statistics (http://data.bls.gov/cgi-bin/cpicalc.pl), the price for the scrolls outfits, $110 and $35, would equal about $1,550 and $500 in 2006 (accessed June 23, 2006).

85 "Mother-and-Daughter Theme Gains Momentum for Exclusive Trade."

86 Gertrude Bailey, "Families Go In For Matching Up Their Wardrobes, Even to Dad's Tie," *New York World-Telegram*, May 1, 1937.

87 "Military and Exotic Themes Developed in Summer Negligees by Uptown Designer," *Women's Wear Daily*, March 25, 1937.

88 "Colorful Appliques Identify 'Dateless' Princess Frocks."

89 "Families of Society to Take Part in Piping Rock Horse Show," *New York Herald Tribune*, September 24, 1939. A similar dress appears in a photograph of a display of Mariska's clothing at Dewees with a matching child's dress next to it. Photocopy, collection of the artist's family.

90 Green, 88.

91 "Park East Shopper."

92 "New Things Seen in the City Shops." This article, which remained in Mariska's papers, does not mention Mariska by name, but clearly is about her, and is referenced in the inside flaps of *How to Make Growing Clothes for Your Baby*.

93 "'Youngest Set' Wears Expensive Handmades at Recent Outdoor Event," *Women's Wear Daily*, June 23, 1937. Another article, however, describes the prices for Mariska's dresses as "extremely moderate." "Tyrolean Success Inspires Designer to Open Salon."

94 Lili's full first name was Lilias.

95 Clipping, unidentified publication, June 4, 1938, collection of the artist's family. The dress is not indicated as by Mariska, though the clipping remained in her papers and the dress clearly resembles her designs. The reclusive Scaife, heiress to the Mellon fortune and a respected philanthropist, died in 2005.

96 All of the receipts are on Mariska's letterhead and are in the collection of the artist's family.

97 P. R. F., 152.

98 Mariska Karasz, New York, New York, to Mrs. W. Penn, Midland, Texas, February 24, 1941, collection of the artist's family. Mariska states that a Miss Hula Myers was no longer representing her, and invites Mrs. Penn to deal with her directly when considering dresses for her daughter.

99 One of Mariska's address books from the 1930s includes many names of people documented as customers, including Mrs. Van Devanter Crisp, Mrs. Gary Cooper, Mrs. A. A. Berle, Mrs. William Hale Harkness, and Mrs. Birchall Hammer, suggesting that others in the list may have been clients as well and at least were associated closely enough to Mariska to warrant her listing them in her address book. Other names included: Mrs. H. H. Flagler, Mrs. Frederick C. Havemeyer, Mrs. Paul G. Mellon, and Mrs. James Roosevelt, Jr., again emphasizing that she catered to an extremely affluent and influential clientele. Collection of the artist's family.

100 Mariska agreed not to sell children's clothing to any other outlets in the Philadelphia area while she was working with Dewees. Contract between Mariska Karasz and B. F. Dewees, March 3, 1936, collection of the artist's family.

101 Untitled, *Philadelphia Evening Public Ledger*, March 12, 1936.

102 Irene E. R. Nyland, Philadelphia, Pennsylvania, to Mariska Karasz, New York, New York, March 21, 1936, collection of the artist's family.

103 Untitled, *Philadelphia Evening Public Ledger*, March 4, 1937. An undated letter from Mariska to Dorothy Peterson in the collection of the artist's family mentions that the girls were in a movie about toys

(Fox Movietone News, ca. December 1936, vol. 18, no. 25). Thanks to Andrew Murdoch at the University of South Carolina's Newsfilm Library for sharing that the movie was story 27-55, titled "Fashions."

104 Agreement between L. Bamberger & Co., Newark, New Jersey, and Mariska Karasz, October 20, 1933, collection of the artist's family.

105 Epstein, 179. Correspondence survives with several other manufacturers about possible opportunities: George Hecht, president of *Parents' Magazine*, wrote to Max Herzberg at *Pictorial Review* introducing Miss Mary Wilder, Mariska's representative, and stating that Mariska had "some of the most charming designs for children's clothes" that he had ever seen; he suggested that Herzberg "might be interested in buying some of her designs," and added that he would be happy to have them offered to readers of *Parents'*. George J. Hecht, New York, New York, to Max Herzberg, New York, New York, March 14, 1934, collection of the artist's family. Also, the president of the Barbara Coat Company, a New York manufacturer of coats for girls and juniors, wrote to *Women's Wear Daily* inquiring about the possibility of Mariska designing coats for them. Winifred J. Oritte (?), New York, New York, to Mariska Karasz, New York, New York, May 13, 1935, collection of the artist's family.

106 Mariska Karasz, New York, New York, to J. Markowitz & Son, Inc., New York, New York, November 22, 1934, collection of the artist's family. More research remains to be done on J. Markowitz & Son, which continued manufacturing children's clothing at least until 1946. "Advertising News and Notes," *New York Times*, April 30, 1946.

107 Mariska Karasz, New York, New York, to Mark Silverberg, New York, New York, December 29, 1934, collection of the artist's family. The factory was in Stanford, Connecticut, but correspondence went through the New York office of Nathan Krauskopf Company. Little is known about the American Romper Company and Nathan Krauskopf Company, though vintage children's clothing by Krauskopf is readily available online.

108 Nathan Krauskopf Company, New York, New York, to Mariska Karasz, New York, New York, January 7, 1935, collection of the artist's family.

109 Nathan Krauskopf Company, New York, New York, to Mariska Karasz, New York, New York, November 7, 1935, collection of the artist's family. Also in 1935, she agreed to make twelve original models suitable in "SISTER and BROTHER styles" for Kiddies Pal, Inc., of New York, New York, manufacturer of Kiddies Pal Infant Wear. Kiddies Pal, Inc., New York, New York, to Mariska Karasz, New York, New York, March 15, 1935, collection of the artist's family.

110 Mark Silverberg, Nathan Krauskopf Co., New York, New York, to Mariska Karasz, New York, New York, September 23, 1937, collection of the artist's family.

111 Cleartha E. Dodson, New York, New York, to Mariska Karasz, New York, New York, December 9, 1935, collection of the artist's family, and Sales Promotion Manager to Mr. K. H. Bolen, Anderson,

Indiana, December 9, 1935, collection of the artist's family. Dodson also wrote to Mariska in November 1936, expressing her admiration: "I should like to tell you again what a genius I think you are in the clothes field and how thoroughly I enjoyed your opening." Cleartha E. Dodson, New York, New York, to Mariska Karasz, New York, New York, November 6, 1936, collection of the artist's family.

112 The latest article located thus far about Mariska's children's fashion design is "Appliques Suggest Suspenders and Apron Effects in Karasz Custom Designs," from 1941.

113 An exhibition proposal, "Ilonka and Mariska Karasz (1896-1981) (1898-1959 [*sic*]): Sisters in Design," n.d., in the files of the Cooper-Hewitt, National Design Museum, Smithsonian Institution, lists the date of the fire as 1941.

114 Informal interview with Rosamond Berg Bassett, March 16–17, 2006.

115 Informal interview with Solveig Cox, June 8, 2004.

116 Ibid.

117 Engler also assisted Mariska by helping with her daughters, including accompanying them by taxi to school. Informal interview with Rosamond Berg Bassett, March 16–17, 2006; and email from Solveig Cox, April 18, 2006.

118 Fisher.

119 Mary Wells Ridley, "Sew a Fine Seam, Darling Daughter!" *New York World-Telegram*, September 20, 1943.

120 Ibid.

121 The host of the Martha Deane show at the time, Marian Young, wrote to Mariska that her sister threatened to steal her autographed copy of the book for her own young daughter and that both her mother and sister had expressed to her that the book was "one of the finest sewing books" they had ever seen. Marian Young, New York, New York, to Mariska Karasz, September 27, 1943, collection of the artist's family. See also the Library of Congress's Recorded Sound Section's information on the WOR Collection at http://memory.loc.gov/ammem/awhhtml/awrs9/wor.html, accessed June 18, 2004.

122 Hughes Mearns, New York, New York, to Mariska Karasz, Brewster, New York, September 27, 1943, collection of the artist's family.

123 Transcript of radio conversation. Farrell had a home in Putnam County, where Brewster is located. Email from Solveig Cox, June 2, 2006.

124 Ibid.

125 Press release, Girls From New York State and California Win Awards in National Teen-Age Dress Design Contest, J. B. Lippincott Company, for release on or after June 24, probably 1946, collection of the artist's family.

126 Johnson included Mariska in some of his mailings, sending her both his photocopied drawings and collages as well as an original collage incorporating her initials.

127 Epstein, 180–81.

128 Keyes, "Clothes to Express the Child"; and Karasz, *How to Make Growing Clothes for Your Baby*, 6.

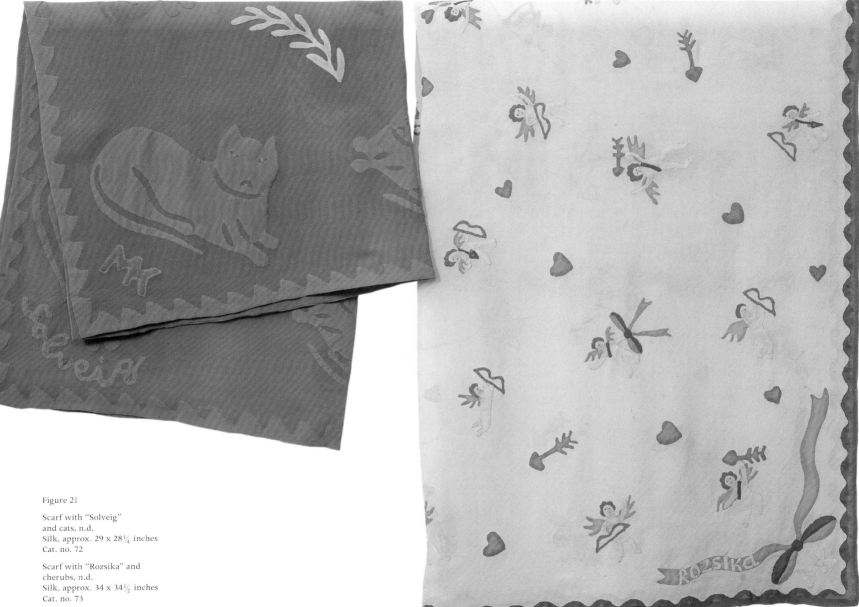

Figure 21

Scarf with "Solveig"
and cats, n.d.
Silk, approx. 29 x 28¼ inches
Cat. no. 72

Scarf with "Rozsika" and
cherubs, n.d.
Silk, approx. 34 x 34½ inches
Cat. no. 73

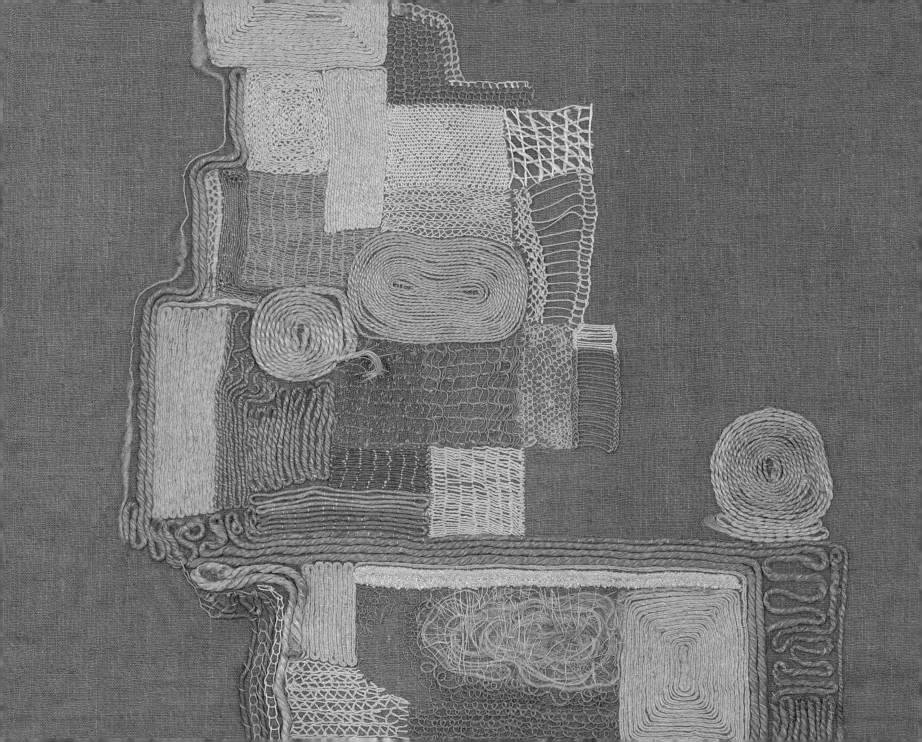

Abstract Stitches: Embroideries by Mariska Karasz

In Hungarian, embroidery is called Kézimunka, which, literally translated, means handwork. By and large, embroidery has become just that. Handwork . . . done with the hand, but not with the heart; worked without thought or emotion. And this should not be so, for the beauty of fabrics and fibre, their thinness or thickness, smoothness or coarseness; those endless varieties of color in harmony or dissonance deserve to be brought together with more than just the work of the hand. The relating of background to thread and stitches can become not just an exercise in manual skill, but an exciting expression in texture; an expression of mind, emotion and inner joy.

—

MARISKA KARASZ, 1950[1]

MARISKA'S FIRST TWO BOOKS on sewing led her to plan a book on embroidery, an important element in her earlier fashion designs and a topic she addressed briefly in *Design and Sew*. In revisiting embroidery in preparation for the publication, she became enchanted with stitches and temporarily set aside the book to begin a new phase of her career. Using embroidery, she created works of art that were shown in galleries, museums, and interiors across the country. They primarily took the form of wall hangings, both framed and unframed (with slats or rods at the top and bottom) as well as a few freestanding room dividers. The earliest works were laboriously stitched, often whimsical, representational images in commercially available cotton threads, but her style soon evolved into more spontaneously stitched abstractions incorporating a wide assortment of materials. Mariska made these works during the time of the Abstract Expressionists and the rise of the Studio Craft Movement in the mid-twentieth century, and her embroideries belong, in part, to both worlds. Through her exhibitions (she had more than sixty solo shows between 1947 and 1960), lectures, publications (including the book *Adventures in Stitches* in 1949 and a series of needlework lessons for *House Beautiful* in 1952 and 1953), and teaching, Mariska influenced artists, designers, craftsmen, and hobbyists throughout the United States for several decades. She broke new ground for the artist/craftsman and significantly contributed to an increase in the domestic popularity of embroidery. Another stitcher, Nik Krevitsky (1914–1991), later recognized the complex mix of innovation and tradition in Mariska's interpretation of embroidery, writing, "In retrospect [Mariska] now represents both a link with the past and a bold break from it."[2]

During the late 1940s and 1950s Mariska continued to divide her time between New York City and Brewster. By 1950, after her daughters graduated from high school, Mariska moved to 170 Lexington Avenue, near 31st Street, and by 1956 she was at 806 Lexington Avenue, near 62nd Street.[3] Her social circle included numerous artists and craftsmen as well as people affiliated with galleries, advertising, and publishing. She was friends with many of the Abstract Expressionist artists and regularly attended shows in the galleries along 57th Street.[4] Writer William Maxwell (1908–2000), who worked as an editor at *The New Yorker*, was a close family friend and used some family events, including the studio fire, in his short stories.[5] Mariska's neighbors and friends in Brewster, besides her sister, included artist Will Barnet (b. 1919) and textile artist and designer Pola Stout (1902–1984) whose fabrics Mariska often used in her embroideries.[6] Another friend and textile artist, Dorothy Liebes, also provided her with materials, (giving her thrums—leftover warp ends from weaving), as did Jack Lenor Larsen (b. 1927), who helped her acquire Haitian cotton, in particular.[7] Mariska especially enjoyed the company of weavers and dyers, both artists and craftsmen, some of whom she met on travels to the South and to California, because of their appreciation for materials and processes, stating, "I find it rewarding

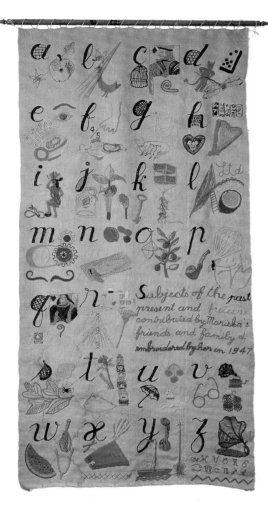

Figure 1
Alphabet, ca. 1947
Mixed fibers, metal wire, and
plastic on linen with wooden
dowel, approx. 53 x 26¼ inches
Cat. no. 135

to go among people who speak my language."[8] She also was immediate friends with most of the Hungarians she met, including painter Zoltan Sepeshy (1898–1974).[9]

The image of Mariska that emerges from this period is of an intelligent, generous, energetic artist. One writer described her as "a small, modishly, but inconspicuously dressed woman," and she toyed with the use of contemporary slang, stating in 1947 that she was "hipped (is the word hipped or hepped?) over the idea of creative embroidery for women."[10] Unlike her sister Ilonka, who maintained a serious demeanor and rarely spoke publicly about her work, Mariska was vibrant, outgoing, and eager to share her love and knowledge of embroidery and materials with others. Also in contrast to Ilonka, Mariska embraced abstraction. She traveled widely and collected materials and influences from around the world, though she remained firmly tied to New York's art scene.

✧✦✧

With her earliest embroideries, made probably in 1946 and early 1947, Mariska drew the images to be stitched and then transferred the designs to the support materials with carbon paper.[11] She filled the canvases with carefully shaded stitches using DMC-brand cotton threads in a spectrum of hues; one reviewer noted that due to Mariska's detailed shading, some works looked like paintings from a distance.[12] Her embroideries often reflect her sense of humor, as in *Alphabet* (Fig. 1), in which she stitched images for each letter, including goose, gas, and generations for *g* and lily-of-the-valley, ladder, lime, and "Ltd." for *l*.

The goats living in the pasture near her home in Brewster provided one of Mariska's first subjects for embroidery, and she created several "goat-scapes." In *Goat Tree* (Fig. 2), for example, Mariska presents a family tree of the goats, each identifiable by characteristics such as a big belly or bowed legs.[13] A neighborhood child, Gertrude, requested that Mariska make a picture of her like the ones of the goats, leading Mariska to the first of her embroidered portraits.[14] Drawings made by her daughters, including a poodle tamer created by Rosamond and an image of the family's home in Brewster (Fig. 5) drawn by Solveig, provided yet another source for imagery to embroider.[15] The brightly colored depiction of Brewster shows their modern white house surrounded by gardens and goats and has Mariska's initials in the lower right on the mailbox.[16]

Mariska soon—even before her first exhibition—discontinued her exclusive use of DMC cotton threads and her practice of covering nearly the entire surface of her work with stitches. She moved toward fewer stitches, seen in *Tequila Trip* (Fig. 4), a small, humorous early embroidery depicting a Mexican man riding on a horse through the desert in the rain, and more abstract images, such as *Beacon Light* (Fig. 3), with a stylized lighthouse, ship, and wavy sea. She described her transition to abstraction as a gradual inner change, demonstrated more completely in such nonrepresentational works as *Hieroglyphics* (Fig. 6), *Babble* (Fig. 7), and *Dawn* (Fig. 8).[17]

Mariska developed a near-obsessive desire to collect unusual materials for her work and repeatedly expressed that in order "to be a good designer one must also be a good collector."[18] She gathered

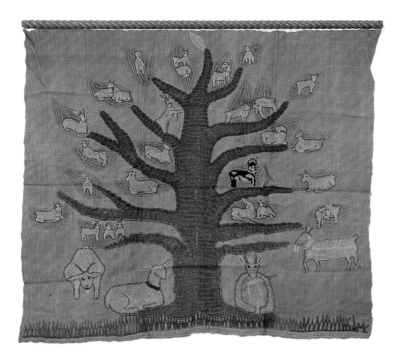

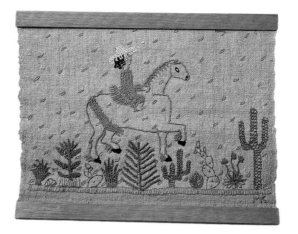

(left)
Figure 4
Tequila Trip, ca. 1947
Cotton on unidentified
handwoven fiber with wooden
slats, approx. 12¾ x 15¼
inches
Cat. no. 134

(below)
Figure 5
Gage Hill, ca. 1947
Multicolored cotton embroidery
on cotton, 30 x 25½ inches
Cat. no. 131

(above)
Figure 2
Goat Tree, ca. 1947
Mixed fibers on unidentified
four-selvage vegetal fiber with
wooden dowel, approx. 43 x
47½ inches
Cat. no. 136

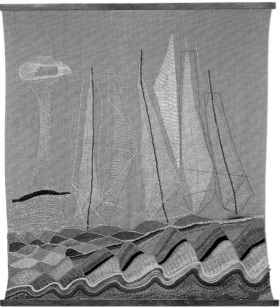

(left)
Figure 3
Beacon Light, ca. 1958
Mixed fibers on linen with
wooden slats, 61 x 54⅝ inches
Georgia Museum of Art,
University of Georgia; museum
purchase with funds provided
by the Virginia Y. Trotter
Decorative Arts Endowment
GMOA 2003.14
Cat. no. 152

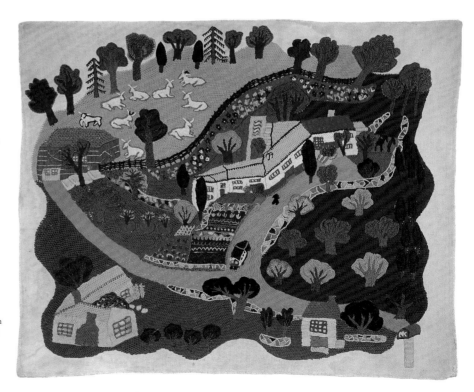

Figure 6
Hieroglyphics, 1960
Mixed fibers on mixed fibers
with wooden slats, Approx. 66
x 55⅛ (slat) and 48 to 50
(textile) inches
Cat. no. 154

80

an impressive range of items—unexpectedly commonplace, technologically innovative, and delightfully handmade—most anything that could be threaded through a needle. Mary Moore, writing for *Craft Horizons,* explains that Mariska viewed design, texture, and fabric as inextricably linked and therefore found "a horde of beautifully textured, curious, unlikely, as well as traditional materials to be found anywhere and everywhere" to be "indispensable" to her creative process.[19]

Mariska's description of *Ropes on Red* (Fig. 9) reveals some of her approach to materials and design: "I treasured ropes, twines and string that came tied around packages and I collected them from my friends. To me they had particular relations to each other, the forms they suggested were simple. It is enough to take a round form and tie it together and make a linear something else near it, bringing out its own special excitement."[20] The following description by Mariska, though it does not mention the subject by name, likely also applies to *Ropes on Red:* "One background . . . was a design in itself. A weaver and new friend, Mary Helen von Wahlde, was inspired by the pattern and color of a brick wall to weave a tweedlike piece in rich brick-red. She sent it on for whatever it might mean to me. Here the materials applied—sand-colored twines and ropes, beige handwoven fabrics—had to be neutral and quiet instead of the background."[21] When Mariska worked, she considered the weight, color, and texture of both the background material and the threads, often contrasting humble materials with elegant ones, mixing dull colors with sparkle.[22]

Mariska's friends and peers recognized and fostered her passion for collecting, and several

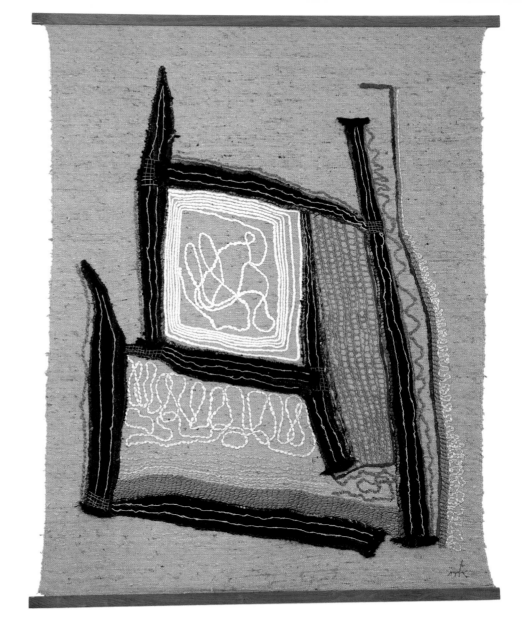

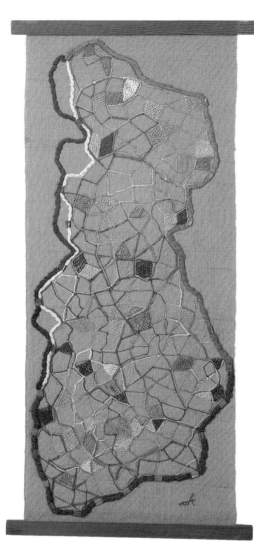

Figure 7
Babble, ca. 1955
Mixed fibers and metal on
mixed fibers with wooden slats,
approx. 35¾ x 16½ (slat) and
14⅜ (textile) inches
Cat. no. 144

Figure 8
Dawn, ca. 1955
Mixed fibers on mixed fibers,
approx. 54½ x 18⅛ (slat) and
16 (textile) inches
Cat. no. 145

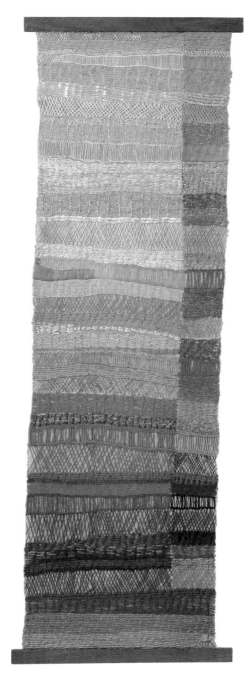

stories survive of her crafty acquisition of materials.
Ann Pringle, writing for the *New York Sun*, relates
that Mariska "persuaded some friends to take down
their russet burlap curtains and give the material to
her."[23] Another friend sent Mariska "holy patches"
in 1959 that he saved from his experience teaching
painting at the Convent of the Sacred Heart. He
did not know the history of the ones he sent her,
but he had two others, which he had misplaced,
that were given to him when he asked for rags for
the painting class; he thought they were "lovely
rags, patched with the most exquisite patches."[24]
Yet another friend brought her black horsehair from
a trip to Switzerland.[25] Solveig remembers an
instance when Mariska visited her in Germany,
where she and her husband lived for several years,
in which her mother became intrigued by the dark
brown fabric of a monk's habit; she began
following him, and Solveig feared she was going to
catch him and ask for a robe.[26] Solveig also recalls
her mother picking up a piece of string from the
sidewalk and marveling, "look at this texture," and
that she would request extra string from the
butcher when ordering meat.[27]

Mariska's materials also included: Mexican
horsehair cloth, post office string, "scraps from the
knitting bags of friends," clothesline, shoelaces,
cello string, "obscure samples left at fabric
dealers," burlap ("found protecting imported items
ranging from jewels to marble statues"), sacks used
to ship bananas, grass-cloth from the Philippines,
ribbons from Salvation Army outlets, hand-dyed
and handspun wools from the South, tailor's
canvas, open-mesh pineapple cloth, twine, cord,
leather, hair, feathers, sequins, tinsel, and silk and
woolen yarns (some from the Yarn Depot in San

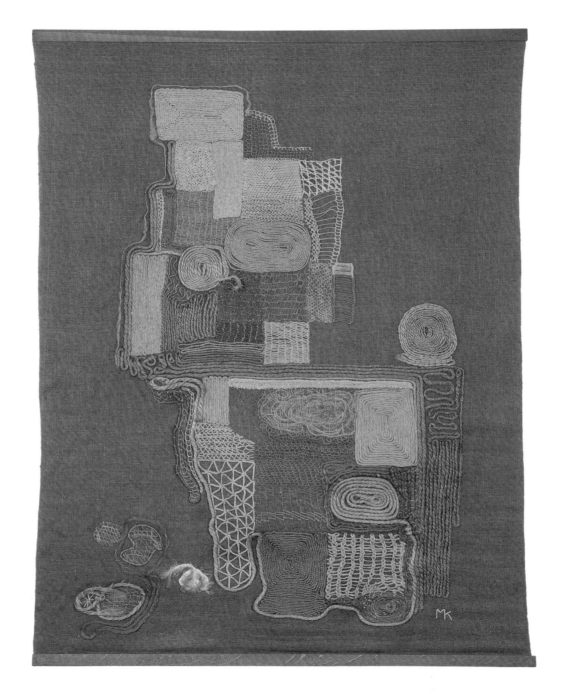

Figure 9
Ropes on Red, ca. 1952
Mixed fibers on linen with
wooden slats, approx. 62½ x
47¾ inches
Cat. no. 138

Color Range II, ca. 1956
Mixed fibers on mixed fiber
(probably linen and rayon
blend) with wooden slats,
approx. 57⅛ x 82¾ inches
Cat. no. 149

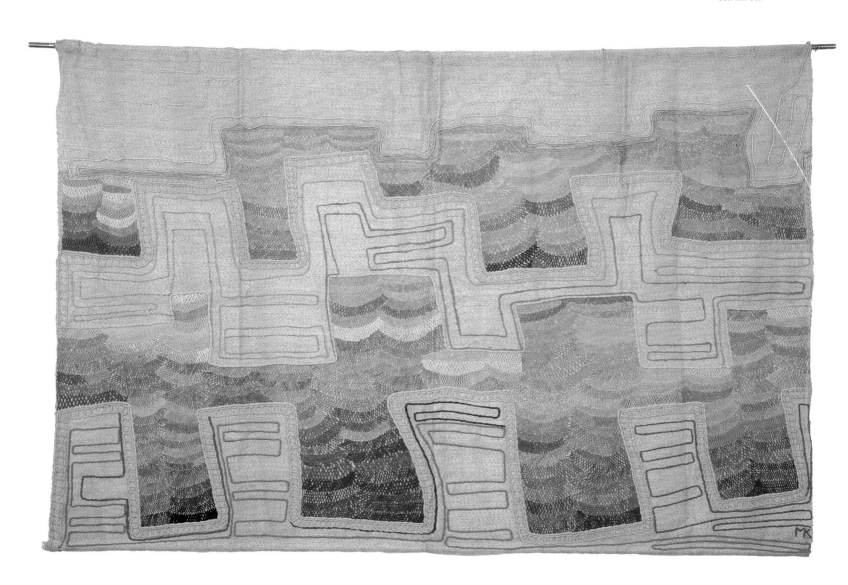

84

Francisco).[28] One of the materials she mentioned most enthusiastically and frequently was asbestos, which she described thusly:

> It was white; it was without sheen or shimmer, and I knew as soon as I'd held a few square inches in my hand how marvelously pliable and workable it would be. That was last winter, when I visited a textile school in South Carolina, and then I found it at last, sold by the yard, in downtown New York found it through an engineer! The fabric that pleased me so was asbestos, and it forms the background for [*What Goes Up Must Come Down*, ca. 1951]. Into it, I worked a score of lovely black yarns, natural linen threads, and a bit of waxed fishline; some handspun wool, and a strong, grayed string. To these, I added dressmaker's cord, a pair of new shoestrings, an old, half-browned one, and one of leather; next, a superbly grayed strand of Guatemalan cotton; then hair, mohair, chiffon, and nylon. The fibres range from aged to agelessness, my stitches are few and far between, surely one can no longer think of the result as embroidery![29]

Mariska's passion for asbestos, expressed at a time when its carcinogenic quality was not widely known, underscores her interest in experimenting with new materials. Mariska's friends and colleagues helped her procure experimental materials by sending her samples and suggestions as they learned of innovations.

Julia Lukas, an interior designer with whom Mariska was associated in the late 1950s, sent her two samples of asbestos fabrics made by the manu-

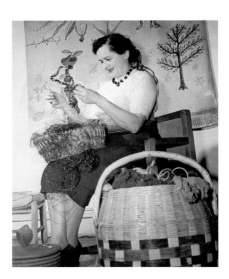

facturing company Johns Manville, noting in her letter that she agreed with Mariska "that they show[ed] great promise for development."[30] Lukas also expressed interest in having an embroidery incorporating "Darlan, the Goodrich fiber," but added that it might be some months before there were "enough interesting Darlan yarns worthy of [Mariska's] hands."[31] In 1958, Mariska's friend W. E. Dempster of Calkins & Holden, an advertising firm, wrote her to ask if she had ever worked with synthetic yarns such as Acrilon, Chemstrand, or Chromspun; while he did not think that they had been made for sewing threads, they did come in many sizes, so it seemed feasible to him that she could work with them.[32]

Though Mariska's first works took weeks to complete, in later years she accomplished an embroidery a week and sometimes more.[33] She stitched while she talked, sitting on the couch or

chair with her materials in open baskets around her.[34] She sometimes worked outdoors, where birds carried off bits of thread for their nests.[35] She no longer drew her designs; rather, she created them in response to her materials as she progressed. Mariska explained that she took numerous breaks while working, stating, "By stopping frequently to evaluate I remain free to change my attitude and to grow."[36] Her continual response to and expression of inward changes correspond to developments in painting at the time.

Mariska often looked to, and recommended to others, nature as a source of inspiration, and slides she took of her work outdoors capture the similarities of color and form between her work and the natural setting (Figs. 10–13). In 1953, Mariska wrote about observing nature, noticing the changes in the landscape after a rain, seasonal changes, and the effect of light on foliage at different times of the day, and emphasized the importance of being aware of these experiences.[37]

Mariska preferred to have the mountings for her work as simple as possible.[38] Her brother Steve often made the frames and slats for her embroideries, and her method of hanging embroideries between two thin wooden slats at top and bottom allowed for simple transportation because works could be shipped rolled, resulting in minimal creasing.[39] In the many lists of her art that survive in her papers, primarily handwritten or typed checklists for exhibitions, she often divided works by size (small, medium, or large) or by format (frequently using the categories of pictures, hangings, scrolls, and wall separations). The prices for her work remained fairly consistent during the 1950s, generally ranging from $100 to $700, with

(top)
Figure 10
Kodachrome slide, n.d.

(bottom)
Figure 11
Kodachrome slide, 1959

(top)
Figure 12
Kodachrome slide, 1958

(bottom)
Figure 13
Kodachrome slide, 1958

mariska karasz

abstract stitches

85

the most costly objects being the screens and size being the primary factor in price.[40]

While Mariska created most of her work for exhibition, she did complete some commissions.[41] For example, she wrote to Jane Christian, of Jane Christian Interiors, in 1959, to discuss fabric samples, including prices and measurements for different fabrics for a custom project. She expressed hope that the proposal would meet with Christian's and the client's approval, adding, "The rough sketch I will have in your office middle of this week but please explain it is a real rough as I do not really sketch. My work makes up for it, I hope."[42] Mariska also created an embroidery, built into a teak cabinet over a speaker, for Mr. and Mrs. Herbert Shapiro in Beach Haven, New Jersey, in 1957.[43] Mr. Shapiro recalls that the work, titled *Ebb Tide*, "had the flow and feeling of movement of the water, the sky and the sand of our island." Abraham W. Geller, the architect who designed the modern house, brought Mariska there so that she could consider the site when creating her commission, and the Shapiros felt that she "had fully captured the feeling of the locale" in the embroidery.[44]

Letters in Mariska's papers record her advice regarding care of her embroideries. In 1960, she wrote to James Whitehead, who was organizing an exhibition including her work, "It would be well to gently direct a dusting brush over the surface of your piece, and air it. Thereafter, spraying it on both sides with an anti-moth spray should take care of it satisfactorily. Should you have it cleaned, pick the best and most reliable cleaning establishment you can find, one accustomed to handling fine textiles. Assure yourself in advance that the handling will be reliable, and that the company assumes responsibility."[45] In another letter, to "Bea," in 1959, she requested that Bea press the works Mariska sent her if they were crumpled during shipment but to press from the back using a cloth so that the iron did not catch the stitches.[46] Another method Mariska used to flatten works was to store them under rugs in her home.[47] In a surprisingly relaxed approach to her art, sometimes when asked by owners of her embroideries what to do about loose threads, Mariska simply instructed them to snip off any that were sticking out.[48]

Mariska's embroideries defy easy classification. For example, Margaret Breuning, writing for *Art Digest*, described her work as "quite *sui generis*," noting that it had "no connection with embroidery, except through the use of a needle in its production."[49] Though her technique and medium placed

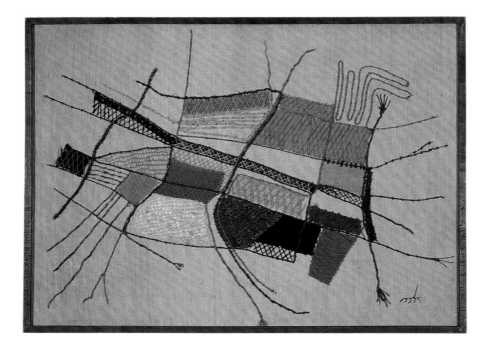

Figure 14
Alternate B, ca. 1955
Mixed fibers on linen,
17 x 22¹⁵⁄₁₆ inches (framed)
Cat. no. 147

her embroideries in the realm of studio craft, in terms of format and expression her work clearly relates to modern painting.[50] Though not the only artist at the time to straddle these disparate forces, Mariska did so with remarkable success, resulting in a tension that makes her work particularly interesting and engaging.

Critics often described Mariska's embroideries in terms of modern abstract painting. In fact, an often-told story about how Mariska began her work with embroidery starts with a painter: she went to her friend the artist Hans Hofmann (1880–1966) and expressed a desire to paint with thread, to which he replied, "My dear, Just do it!"[51] Mariska frequently described her work using wording similar to that of the Abstract Expressionists, emphasizing individual expression, emotional understanding, and a spontaneity appropriate to contemporary life.[52] Also, Mariska presented some works framed

like paintings (such as *Alternate B*; Fig. 14), was associated with galleries that showed paintings and sculpture, and maintained a two-dimensional emphasis in her work. Her use of fiber and texture, though, deviated from the flat picture plane advocated by critic Clement Greenberg. Newspaper reporter Dustin Rice, after seeing a show of her embroideries in 1956, stated that she was "completely in control of the modern painting idiom which she so inventively translates with thread, cloth, yarn, gunnysacking, or almost anything pliable, into abstractions that can be hung on the wall like pictures," emphasizing the relationship between her embroideries and paintings.[53]

Mariska particularly admired the work of artist Paul Klee (1879–1940), and critics repeatedly recognized an affinity between their work.[54] The qualities reviewers observed as sympathetic between the artists were "visual wit," "surrealist

overtones," and "inner-world imagery," and a reviewer in 1956 noted that, "in some of the best pieces [by Mariska] . . . one senses the kind of mood evoked by Paul Klee's canvases," though the reviewer added that Mariska's work was "highly original" and not derivative.[55]

Concurrently, Mariska's involvement with the American Craft Council, founded in 1943 in order to raise public awareness, appreciation, and understanding of contemporary craft, firmly ties her to the craft tradition.[56] The council included Mariska's work in an exhibition in 1953 of contemporary American handicrafts for the Department of State to circulate internationally as well as in a show of American crafts for the U.S. Pavilion at the Brussels World's Fair in 1958.[57] Mrs. Vanderbilt (Aileen Osborn) Webb (1892–1979), who founded the council, was particularly fond of Mariska, and Jack Lenor Larsen invited Mariska to be on the

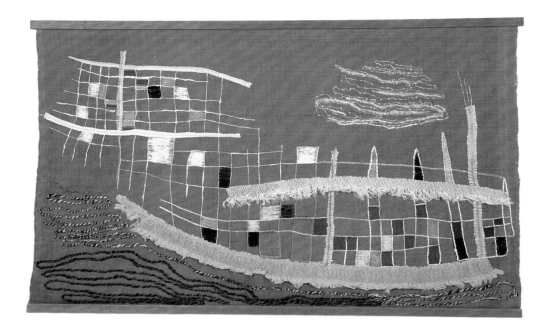

Figure 15
Split Level Ark, 1960
Mixed fibers on handwoven
wool with wooden slats,
approx. 37¼ x 60 inches
Cat. no. 153

membership committee of the council in late 1959, shortly before the onset of her fatal illness.[58] Mariska also exhibited at America House, a New York retail outlet for craft founded by a predecessor to the council, the Handcraft Cooperative League of America, and at the Museum of Contemporary Crafts (later the American Craft Museum and presently the Museum of Arts and Design), which the council opened in 1956.

The Museum of Contemporary Crafts included Mariska's embroidery *Tree Tops* in its inaugural exhibition, titled *Craftsmanship in a Changing World.* In the foreword to the exhibition's brochure, Webb wrote that the opening of the museum marked an important milestone "in the cultural . . . life of the people of the United States" because it was an "assertion that the crafts are . . . part of the total art picture."[59] Other artists, craftsmen, and designers featured included Alexander Girard (for

Herman Miller; 1907–1993), Ralph Higby (for Dorothy Liebes Studio), textile artist Lenore Tawney, ceramicists Gertrud and Otto Natzler (1908–1971 and b. 1908, respectively), and silversmiths John Prip (b. 1922) and Adda Husted-Andersen (d. 1990).[60] Mariska's work again appeared at the Museum of Contemporary Crafts in 1957 in the museum's fifth exhibition, *Wall Hangings and Rugs,* presented in recognition of textile artists' responses to modern architectural spaces. The show included sixteen craftsmen and seventy-nine works, and *Craft Horizons* selected Mariska's *Rectangles* to illustrate an article on the exhibition.[61] Other artists represented included fiber artist and educator Trude Guermonprez (1910–1976); influential textile designer, artist, and collector Jack Lenor Larsen; multimedia artist and tapestry weaver Jan Yoors (1922–1972); abstract fiber collage artist Eve Peri (1897–1966); weaver

and textile designer Marianne Strengell (1909–1998); ceramicist Toshiko Takaezu (b. 1926); Lenore Tawney; and fiber artist Fritz Riedl (b. 1923).[62] Mariska's work also appeared in the museum's exhibition *The Patron Church* in 1957–58, which featured contemporary church architecture, ceremonial objects, vestments, and appointments.[63] The Museum of Arts and Design now holds one of the most significant collections of Mariska's embroideries, primarily through gifts from her daughters.

Mariska enjoyed extensive coverage by *Craft Horizons* magazine, which the American Craft Council took over in 1960 and continues to publish under the name *American Craft*.[64] Mary Moore wrote a substantial and well-illustrated article on Mariska for *Craft Horizons* in 1949, emphasizing her stature in the burgeoning field of American postwar studio craft. Moore referred to Mariska as

Figure 16
Unidentified photographer
Photograph of *Night and Day* (detail),
ca. 1949
Photograph, 8¹⁄₁₆ x 9¹⁵⁄₁₆ inches
Cat. no. 166

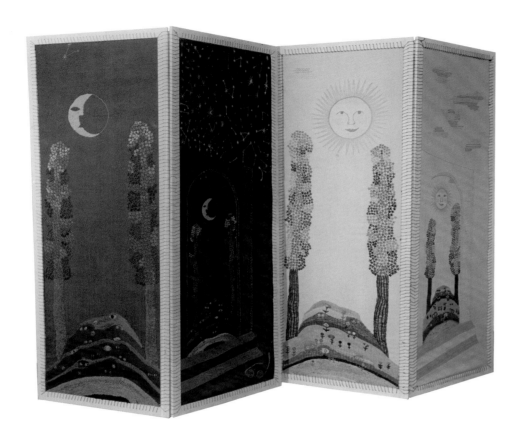

Though Mildred Constantine and Jack Lenor Larsen classified Mariska's work as "Art Fabric" in their 1972 study of the modern history of artists working with fiber, Mariska's embroideries predate much of the activity in that area.[68] Constantine and Larsen refer to embroidery as a "decorative" technique, a pejorative term throughout much of the mid-twentieth century, and focus their book instead on structural and aesthetic characteristics, indicating the presence of a bias against embroidery by the early 1970s.[69] What elevated Mariska's work above this prejudice was the freedom and expression evident in her approach and likely the fact that she did not simply use stitches to make an image, but that she considered and understood the structures of her stitches and the aesthetics of her materials.[70] Unlike the younger generation of artists working in fiber who were gaining prominence at the time, such as Lenore Tawney and Ed Rossbach, Mariska was not a weaver and did not move toward a sculptural, three-dimensional approach to her medium, though perhaps only because of her premature death. So although Mariska participated in the early years of the studio craft movement and was one of the artists who helped blur the distinction between fine art and craft, she is somewhat separate from the dominant historical trends of artists working with fiber.

Further complicating any classification of Mariska's work is its suitability to mid-century interior design, which sometimes placed it in the undesired role of decoration rather than art but certainly contributed to its popularity. As recognized by the Museum of Contemporary Crafts and celebrated through its exhibition of wall hangings and rugs in 1957, modern architecture of mid-

"a painter in thread" and praised the freedom of her approach and her abilities in original and creative design, in technical perfection in execution and selection of materials, and as a "master collector."[65] In 1953, *Craft Horizons* again featured Mariska's work, this time including an article by her titled "Abstract Stitches," in which her passion and openness are evident. In this well-illustrated article she writes compellingly about abstraction, collect-ing materials, and creating embroideries. As its cover for this issue, *Craft Horizons* used a detail from one of Mariska's embroideries, *Alchemy*, in which she recycled a "worn but treasured Chinese kimono" and combined it "with strong, delicate yarns of Pola Stout's."[66] The Cleveland Museum of Art recognized her contribution to the area of "fiber art" in the introduction to its catalogue for the exhibition *Fiberworks* in 1977.[67]

twentieth–century America, with its expanses of unadorned walls and long, open spaces, provided an ideal canvas for artists working with fabric. Mariska believed that her work was appropriate for modern houses, "where flat walls need more than a painting," and that there was a need "for something colorful and warm" in these spaces dominated by "so much glass, shine and metal."[71] Reviewers frequently noted the appropriateness of her work for contemporary architecture, *Art News* suggesting in 1956 that her embroideries "might do much for the bare walls of good-design apartments," and the *New York Times* describing them in 1950 as suitable for a modern home.[72] Marjorie Montgomery, reporting on a lecture Mariska presented in Dallas, indicates that design-conscious homeowners heeded such advice, writing that her works were "used as wall hangings in high-styled residences of the nation."[73] Mariska even references modern architecture in the title of *Split Level Ark* (Fig. 15) and in its use of primary colors and rectilinear forms, which suggest windows and repeated units. The few freestanding screens that Mariska created also worked well with modern architecture, providing a flexible means of dividing open floor plans. Mary Moore described Mariska's *Night and Day* (Fig. 16), a two-sided work on wool and mohair created by Pola Stout, now in the collection of the Museum of Arts and Design, as "extremely muted in color and design and very modern, though not abstract, in style."[74]

The promotion of her work as a design element was not always appealing to Mariska. In part of a carbon copy of a letter from Mariska in late 1959 to an unidentified recipient, possibly Julia Lukas, she wrote, "Once Bertha lent a show to a

new department store and I did not like it one bit, just because they paid the fee. It will take a long time to get back to museum caliber shows after that kind of thing. So I hope you are wise enough to watch, how this should go. I am not sure Herman Miller is the place, but you are there, and can see for yourself. Sometimes interiors just use you for props and thats [*sic*] the end."[75] (Figure 17 shows Mariska's work in what appears to be a department store setting.) Such hints of bitterness rarely surface in Mariska's writing, at least as reflected in her surviving papers, and her sentiments expressed above underscore that she considered her work art and that museums and galleries were her venues of choice.

Mariska's first exhibition of embroideries took place in April 1947 in the prestigious gallery district along 57th Street in New York. Bonestell Gallery,

located at 18 East 57th Street, presented her work in an installation designed by photographer and designer Robert Allison.[76] The brochure for the exhibition at Bonestell includes a quotation from the vice president of Lord and Taylor, Alieda van Wesep, saying that Mariska "recreated a spirited art form," bringing to it "a lively and sensitive intelligence—improvising new techniques to give depth, focus and brilliance to her counterplay of color and texture."[77] Van Wesep's statement addresses Mariska's embroideries as fine art, a quality emphasized by their presentation in a fine arts gallery.

In addition to *Goat Tree, Gage Hill*, and *Tequila Trip*, discussed previously, the embroideries in this exhibition included portraits of her daughters and herself. The portraits of the girls (Figs. 18 and 19) are typical of Mariska's earliest embroideries in their use of a single material for stitching, near coverage of the support surface, and representative imagery.[78] Mariska manipulated the stitches so that they highlight the contours of the girls' faces, creating a slight relief in areas such as the cheeks, demonstrating that she had a thorough understanding of her technique.[79] In these portraits, Solveig wears a necklace with a ceramic heart made by one of Mariska's friends, and Rosamond wears a dress with embroidery on the shoulders, referencing Mariska's earlier incorporation of that element in her fashion designs.[80] While the portrait in Figure 20 may or may not be the embroidery titled *Me* that appeared in the show at Bonestell, it does represent Mariska's work from this period. In this self-portrait, Mariska still uses small, controlled stitches, but the image is simpler, with outlines replacing areas covered with stitches. Though she

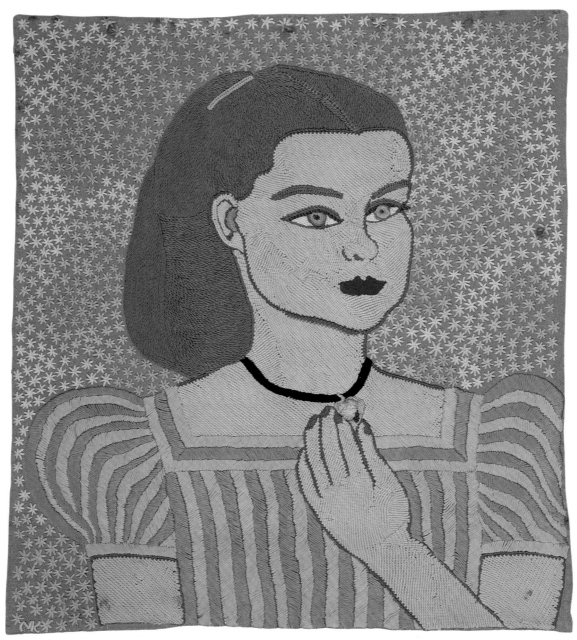

Figure 18
Solveig, 1947
Multicolored embroidery on
cotton, 23⅜ x 20½ inches
Cat. no. 126

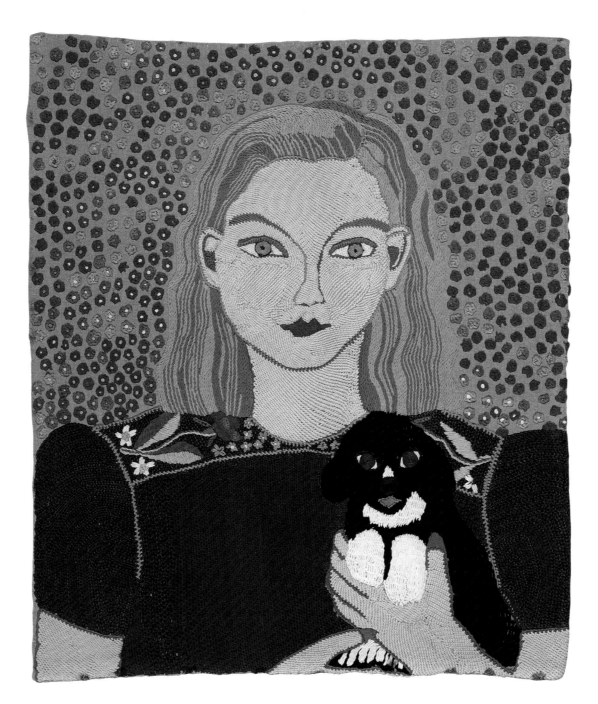

Figure 19
Rozsika, 1947
Multicolored embroidery on
cotton, 23^{13}/$_{16}$ x 19^{5}/$_{16}$ inches
Cat. no. 127

Figure 20
Self-portrait, ca. 1947
Embroidery on linen,
22 x 15½ inches
Cat. no. 132

Figure 21
Kodachrome slide of
Monochrome in Red, n.d.

used her maiden name almost exclusively professionally, in this work she signed her initials "MKP."

Two other works from Mariska's first exhibition are now in the collection of the Museum of Arts and Design, *Nuala* and *Pennsylvania Airscape,* now titled *Elsa de Brun* and *Harlem Valley from the Air.* Elsa de Brun (1896–1988), who went by Nuala, her Gaelic nickname, professionally, was a friend of Mariska's and began her career as an artist about the time her portrait was shown.[81] *Pennsylvania Airscape* (or *Harlem Valley from the Air*), dated 1946, presents a view from the window of a Pan American airplane, with the walls and curtains on either side of the window in the traditional color scheme of that airline.[82] Both works feature extensive stitching and DMC cotton threads.

Mariska's first exhibition at the Bertha Schaefer Gallery, her representative for many years, occurred in November and December 1948.[83]

Bertha Schaefer (1895–1971), who opened her gallery at 32 East 57th Street in New York in 1944, worked as an interior designer and a gallery owner, operating a fine arts gallery and making little distinction between fine and applied art. Some of the other artists she represented were painters William Halsey (1915–1999), Wallace Mitchell (1911–1977), Angelo Ippolito (1922–2002), Will Barnet, and Charles Cajori (b. 1921); collage artists Ilse Getz (1917–1992) and Sue Fuller (1914–2006); painter and designer Boris Aronson (1900–1980); furniture designer Wharton Esherick (1887–1970); and Jack Lenor Larsen, who credits her with discovering him.[84]

Schaefer presented solo exhibitions of Mariska's embroideries in 1950, 1952, 1954, and 1956 and included her in group summer shows, usually titled *Fact and Fantasy,* in 1952, 1955, 1956, 1957, and 1959.[85] Schaefer also included Mariska's work in a group show titled *Modern Tapestries* in fall 1957 along with work by Alice Adams (b. 1930) and Trude Guermonprez, among others. Through these solo and group exhibitions, Mariska maintained a regular presence in the gallery scene in New York.

The New Yorker carried a review of Mariska's first exhibition at Bertha Schaefer Gallery, stating, "It is hard to give you an idea of the charm and originality of these pieces, the designs of which, whether they are conceived with naïve simplicity or ironical subtlety, are always executed with easy, self-confident expertness." Many of the works were shown in shadow box frames, while a larger embroidery, measuring 50 by 65 inches, of "an abstract design of the four seasons worked on burlap" was unframed.[86]

The press release for Mariska's second show at Bertha Schaefer, titled *Abstractions with Thread,* begins with a quotation from Frederick Kiesler: "The painter uses brush and colors—Mariska Karasz uses thread and needle to create a new plastic entity," again relating her work to modern painting. The release notes that though it had been fashionable for some time to talk about texture in regard to paintings, Mariska did not simulate or approximate texture "as in paintings"; rather, she included real texture. The release continues, "the result can hardly be classed as handicraft but must be recognized as a definite—and as yet unnamed—form of art," again revealing the difficulty of classifying her work. The show contained approximately thirty embroideries, with the most recent being "non-objective textural expressions of form and color."[87] Margaret Breuning reviewed the exhibition for *Art Digest* and praised Mariska's

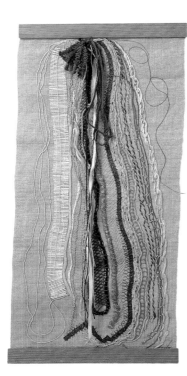

Figure 22
No Strings Attached, ca. 1954
Mixed fibers, leather,
plastic, and wood on
unidentified fiber with wooden
slats, approx. 29 x 14 inches
Cat. no. 143

Figure 23
Title uncertain, probably
Strata (Pinks), ca. 1956
Mixed fibers on cotton with
wooden slats, approx. 83¼ x 14
(slat) and 13¼ (textile) inches
Cat. no. 148

"fecundity of invention" and her impressive use of color, texture, and form, adding, "the wall hangings are actually magnificent, not only in terms of area, but in terms of largeness and freedom of their designs."[88]

In the exhibition at Bertha Schaefer in 1952, Mariska introduced a series she called "monochromatic textures," works in which she limited her palette but not her materials, as seen in *Monochrome in Red* (Fig. 21). With the October 1954 show at Bertha Schaefer, Mariska introduced embroideries she categorized as "scrolls," such as *No Strings Attached* (Fig. 22).[89] A reviewer for *Art Digest* wrote about the exhibition, "It would take a hard heart indeed to resist Mariska Karasz' woven decorations. Their abstract surfaces, neither tortured nor dogmatic, seem gently petted into well-being: textile, string, rope, even bits of metal unite into varied, flowing compositions whose

modest grace never descends to empty charm or prettiness."[90] When Mariska exhibited at Bertha Schaefer in 1956, she included some "enormously long, narrow" works, possibly such as Figure 23, which measures approximately 83¼ by 14 inches, and some works reflecting her recent visits to Mexico and Haiti.[91] A review in the *New York Times* described the works in this show as "done with considerable ingenuity and cunning."[92] Mariska enjoyed working on narrow widths of handwoven fabrics but found them difficult to locate, so she persuaded weavers to create custom cloth for her, often providing them with the materials.[93]

Mariska's exhibitions at Bertha Schaefer typically traveled to museums and galleries throughout the country after their initial showing in New York.[94] Mariska replaced or exchanged works on the checklists as they sold or were needed for other projects and as she made new ones. The shows often included a copy of *Adventures in Stitches,* and Mariska frequently presented slide-illustrated lectures in conjunction with the exhibitions. The venues for Mariska's exhibitions from 1951 to 1960 included the University of California, Los Angeles; Philadelphia Art Alliance; Art Institute of Chicago; M. H. de Young Memorial Museum in San Francisco, California (which included *Glorified Lemon Bag* (Fig. 26), priced at $125, equal to approximately $955 in 2006); Taft Museum of Art in Cincinnati, Ohio (which included *Moses I* and *Moses II,* Fig. 24);[95] Cleveland Museum of Art; Clarke College in Dubuque, Iowa (which included *Trailer House,* Fig. 25, for $175, equal to approximately $1,320 in 2006); Cranbrook Art Museum in Bloomfield Hills, Michigan; Baltimore Museum of Art; and Montclair Art Museum in Montclair, New

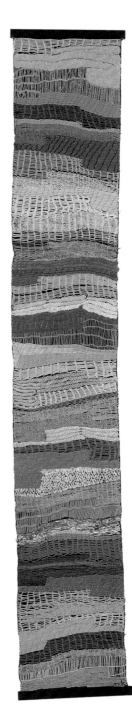

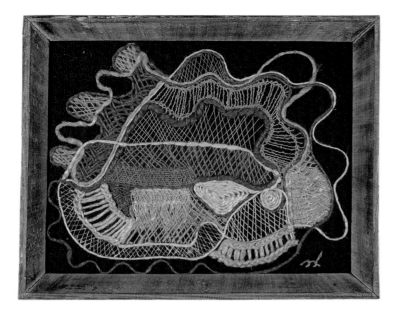

Exhibition, ca. 1953
Unidentified photographer
Photograph, 8 x 10 inches

Figure 24
Moses I or *Moses II*, 1953
Mixed fibers on linen (?),
Approx. 12¼ x 15 inches
(framed)
Cat. no. 140 or 141

visitors."[97] The curator of decorative arts at the de Young, Elisabeth Moses, wrote to Mariska describing a similar enthusiasm among her museum's visitors.[98] When the Oregon Ceramic Studio (now the Contemporary Crafts Museum and Gallery) presented Mariska's work in 1953, it sold all fifty copies of *Adventures in Stitches* that it had ordered, and a representative of the studio wrote Mariska that attendance was "splendid" during the exhibition and that many teachers brought classes to see the show.[99]

In reporting on the exhibition of Mariska's work at the Baltimore Museum of Art in 1957, Alice Price stated, "Women who have come in to see the display have remained to study [the works], say museum staff observers."[100] One of these lingering visitors may have been Mrs. Robert Heller, whose "yarn paintings" the *Christian Science Monitor* featured in 1963 in an article that stated, "After attending an exhibition of stitchery by the famous Hungarian, Mariska Karasz, at the Baltimore Museum of Art, Mr. Heller urged his wife to convert her enthusiasm into a panel for their living room." Heller went on to win several prizes in craft shows and exhibited widely.[101]

Other textile artists took note of Mariska's exhibitions, and in 1957, Marianne Strengell, the artist-in-residence in the textile department at Cranbrook Academy of Art, wrote to Mariska praising her show at Cranbrook as "beautiful" and noting that she had seen her work on many other occasions. Strengell wrote that she and her husband, architect Olav Hammarstrom (1906–2002), were planning an international lecture tour on architecture, interiors, and crafts and hoped to obtain slides of Mariska's work to include.[102]

Jersey. The more complete list in Appendix II suggests how accessible Mariska's work was across the country and indicates through the prestige of the venues the high regard in which her work was held.

When Mariska exhibited at the University of California, Los Angeles, in March 1951, Arthur Millier, writing for the *Los Angeles Times*, described her exhibition as one of the two best solo shows of the season (the other, in his opinion, was by realist painter John Koch), remarking that her work formed "a welcome addition to design for living."[96] The Currier Gallery of Art in Manchester, New Hampshire, which also presented Mariska's work in 1951, arranged to host the exhibition because of a lively interest in needlework in New Hampshire and because of the strong tradition of craftsmanship there, and a writer for Manchester's *Union-Leader* noted that Mariska's embroideries "entranced

Figure 25
The Trailer House, ca. 1953
Mixed fibers on chenille with
wooden slats, approx. 27½ x
21½ inches
Cat. no. 139

Figure 26
Glorified Lemon Bag, ca. 1950
Mixed fibers, straw, and paper
with wooden slats, approx.
20½ x 16¼ inches
Cat. no. 137

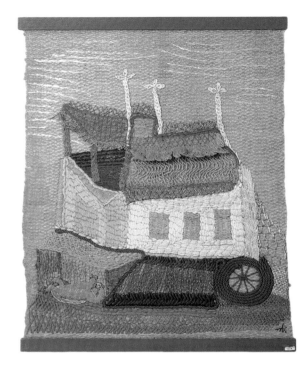

Another textile artist, Lydia Bush-Brown, wrote to Mariska in 1957, "I wish so much that I might go to your studio in Brewster and see more of your work. I always love it whenever I see it."[103] Bush-Brown invited Mariska to participate in an upcoming exhibition of handicrafts to be presented by the Pen and Brush Club, New York, founded in the late nineteenth century and comprising women active in the literary, visual, and performing arts. With this club, Mariska participated in handicraft exhibitions at least in 1948, 1950, and circa 1952 and lectured in 1949.[104] During the exhibition in 1950, judged by Richard F. Bach from the Metropolitan Museum of Art, architect Francis Keally (1889–1978), and painter and ceramicist Maud Mason (1867–1956), Mariska won the Founder's Prize.[105]

Mariska also participated in numerous group exhibitions, including *10 Women Artists* at the Riverside Museum in 1954, along with sculptor Doris Caesar (1892–1971), mosaicist Jeanne Reynal (1903–1983), and abstract painters Ethel Schwabacher (1903–1984) and Anna Walinksa (1906–1997); *ART:USA:59* in 1959 at the Coliseum in New York, in which her entry, *Transcendence*, won a blue ribbon[106]; and *Contemporary Textiles* at the Grand Rapids Art Gallery in 1960, in which other artists represented included Lili Blumenau (1912–1976), Ed Rossbach, Lenore Tawney, and Robert Sailors.[107]

In addition to creating and exhibiting art, Mariska often engaged others in her passion for materials and stitches through lecturing. In the 1950s she frequently presented well-received slide-illustrated lectures or demonstrations. Titles for her talks included "You Are More Creative Than You Think," which she presented at the Cleveland

Museum of Art, circa 1952, and "Texture in Our Homes," which she presented at the DeCordova Museum in Lincoln, Massachusetts, in 1954.[108] In a slide-illustrated talk to the South Congregational Women's Guild in Springfield, Massachusetts, in 1952, Mariska discussed the progression of her style, "beginning with the first experimentation with stitches, to simple pictorial designs, and finally, abstract creations with a definite feeling for contemporary art."[109] Alberta Dickinson, writing for the *Utica Observer-Dispatch*, noted that Mariska spoke "as vividly and convincingly as she stitches and writes about stitching."[110] The education director at the Syracuse Museum of Fine Arts wrote to Mariska after she lectured there to inform her that the museum had received "numerous wonderful comments" about her lecture, adding that she could not "remember a comparable exuberance following a lecture."[111]

In a talk at the Currier, Mariska stressed the importance of originality, encouraging potential stitchers not to waste stitches on someone else's pattern or be hampered by a fear of criticism. She also told the stories behind several of her works: *New Potatoes* was inspired by a bag of potatoes that had gone to seed in her cellar, while *Map Mixed with Territory* began as an autumn landscape and evolved into a map to her home in Brewster. A visit to a sculptor friend inspired another work, *Look*, which featured eyes and blocks in an abstract design. Manchester's *Union-Leader* recorded: "There she found a piece of cloth used to cover clay which she took home with her, made a design in thick Mexican yarn, darned the holes in the cloth, and covered them with eyes, producing a handsome design." Mariska ended this lecture by quoting the New Hampshire state motto, "Live free or die," which she saw as particularly applicable to craft work.[112]

After her first few exhibitions, Mariska completed her book on embroidery, *Adventures in Stitches: A New Art of Embroidery*, which Funk & Wagnalls released in fall 1949; Christine Engler again provided illustrations based on Mariska's drawings. The book was launched at an exhibition of Mariska's work at America House.[113] In *Adventures in Stitches*, Mariska discusses materials and explains basic stitches with step-by-step diagrams and examples of her work. The book received favorable reviews in publications across the country, with many writers expressing an eagerness to try embroidery after encountering it, which was one of Mariska's goals for the book. Furniture

designer T. H. Robsjohn-Gibbings (1905–1976) even admitted in a letter to Mariska a desire to stitch after reading her book, thanking her for sending him a copy and stating, "I am amused to see that the frontispiece is one of the designs which I thought were your best."[114]

When Mariska returned to her book years later, she reevaluated her embroidery and found it dull. Perfect stitches and representational images no longer excited her, so she revised and expanded the book, which Funk & Wagnalls republished in 1959 as *Adventures in Stitches: A New Art of Embroidery and More Adventures—Fewer Stitches*. The book again debuted with an exhibition of her work at America House.[115] In the introduction to the new section (she added about thirty pages), she describes her new stitches as "liberated" and expects them to be welcomed by stitchers ready for more contemporary approaches.[116] *Adventures in Stitches*, in both the original and revised versions, remained an influential publication for decades, and a writer for the *Washington Post* in 1975 still considered Mariska's book "the best . . . on the market for those who aspire to do creative work."[117]

Mariska apparently planned to write another book, indicated by copies of a questionnaire she prepared to solicit feedback about her ideas. In the introduction to the undated questionnaire, she explains that she "had been trying to gather material for a new book to take the place of lectures." When facing the question of whether the new book should be a "how to" book or an art book, she settled on the latter. She asked respondents to list their three favorite contemporary painters, inquired about their familiarity with the work of Paul Klee, and posed numerous questions

about instructional formats and book layouts. She also asked, "Are you interested in sources of inspiration?"—a frequent topic in her lectures.[118]

In addition to books, Mariska also wrote a series of eight needlework lessons, each offering illustrated instruction on particular stitches and related projects, for *House Beautiful*, which engaged Mariska as guest needlework editor from 1952 to 1953.[119] The easy-to-follow lessons always included photographs of Mariska's work and began with encouraging text. The projects primarily focused on adding decorative embroidery to household items such as curtains, bedspreads, placemats and napkins, chair cushions, and lampshades. Sometimes Mariska suggested that embroidered motifs be inspired by other details in the home, such as wallpaper patterns, and sometimes she instructed readers to look to nature, showing a placemat and napkin she had decorated inspired by the shape of a seashell. Before preparing the lessons, she gave a series of needlework classes to a group of "average women" (Fig. 27), and the magazine included photographs of their work with Mariska's first lesson to demonstrate how readily readers could learn and use needlework skills.[120] The lessons caught on especially well in-house, and Alberta Dickinson in the *Utica Observer-Dispatch* relates that everyone at *House Beautiful*, "from editors to secretaries," took up Mariska's "conception of embroidery."[121] In 1973, Sarah Booth Conroy noted in the *Washington Post, Times Herald* that "many people interested in stitchery credit the resurgence of interest in the art to articles written by Mariska Karasz which ran in *House Beautiful* in the 1950s."[122] More than thirty years after the lessons were originally published,

Figure 27
James Abbé, Jr. (American,
1883–1973)
Sewing group, ca. 1952
Photograph, 9⅜ x 9½ inches
Courtesy of *House Beautiful*
Cat. no. 162

Mary Carroll Nelson, in the magazine *American Artist*, still remembered the lessons and credited Mariska as "the catalyst for a ferment of innovation among men and women whose medium is stitchery."[123]

In addition to highlighting Mariska's work through her needlework lessons, *House Beautiful* also featured it in several of its Pace Setter Houses. By the mid-1950s, many home magazines presented annual model homes, such as *House Beautiful*'s Pace Setter House, with influential exterior and interior designs.[124] *House Beautiful* described the Pace Setter as "a home which is perfect and complete to the smallest detail, and which represents the best current values" and, by including Mariska's embroideries, positioned them as desirable before a vast domestic audience.[125]

House Beautiful's Pace Setter House for 1951, which was in Dobbs Ferry, New York, symbolized "what the average American now has, or can reasonably expect to achieve by his own endeavors under the American democratic system." The interior designs projected comfort and modernity, featuring embroidery by Mariska and furniture by T. H. Robsjohn-Gibbings and Edward Wormley (1907–1995). Mariska provided embroidered wall hangings (*March*, seen in Figure 28, and *Flowers*) and a pillow with an embroidered cat and added embroidered details taken from other motifs in the house to bedspreads and linens in the bedroom, bath, and dining area. The accompanying text indicates that the wall hangings served as "pure art," while the embroidered details on functional textiles provided an example of custom decoration that any housewife could adapt to her own home.[126]

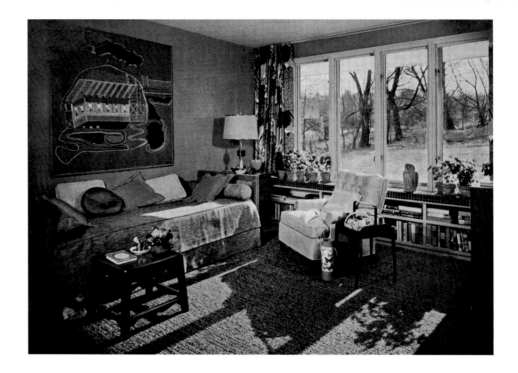

The 1953 Pace Setter House, a contemporary house in Bronxville, New York, featured extensive use of embroidery and printed fabrics by Mariska.[127] In the main room, an eight-panel, six-foot-high, translucent laminated screen of embroidery on pineapple cloth served as a divider between the living and dining areas (Fig. 29).[128] Mariska thoughtfully planned the custom, partially fixed screen in coordination with its architectural surroundings, taking colors from the rest of the room ("the oranges and russets of the stone fireplace, the warm beiges of the plywood, the dark browns of the furniture") and carried the abstract geometric designs in the screen to the table by embroidering them on the placemats. *House Beautiful* included the following description of the screen: "An art object in design, a bit of stagecraft in function, this screen sets the pace for the development of a new class of translucent partitions between living and dining space."[129] The screen is another example of Mariska's interest in experimentation, as the lamination technique employed to create it was new.[130]

The 1953 Pace Setter House also featured three printed fabrics, *Skein*, *Fancy Leaves*, and *All Square*, based directly on embroidered patterns by Mariska and developed by F. Schumacher and Company.[131] Other magazines ran advertisements promoting the fabrics as associated with *House Beautiful*'s Pace Setter House, and one in *Interiors* included the following wording: "These and other distinctive Schumacher fabrics play a dominant role in the charming decoration of this trend setting house."[132] In addition, Schumacher promoted *Skein* (Fig. 30) as used for the drapes of the *S. S. United States*, the newest and largest ocean liner, emphasizing the design's modernity.[133]

House Beautiful explained to its readers that the Schumacher fabrics "were designed to help you stitch your personality into your home. They give you the opportunity to use mass-produced merchandise as a point of departure for your own personal expression."[134] Mariska provided a demonstration of these possibilities by hand-embroidering decorative details throughout the house based on the printed fabrics modeled on her original handwork.[135] For example, the master bedroom featured printed silk gauze curtains with an "embroidered" leaf pattern, *Fancy Leaves*, and she stitched the leaf motif by hand on the bedspreads. The Schumacher fabrics appeared in the house as draperies, but the magazine also recommended *Skein* for use as upholstery on "straight-line" sofas or chairs.[136]

The textiles in the 1954 Pace Setter House included original wall hangings by Mariska as well as embroidered carpets and linens inspired by her and designed and executed by the home's owners.[137] In the presentation of the private ranch home in Biscayne Bay, Florida, *House Beautiful* liberally quoted Frank Lloyd Wright, beginning the article with a statement from him that this home "aims at the highest goal to which architecture may aspire: organic architecture." One of the dominant elements in the main living area was a rug designed by homeowner and architect Alfred Parker and executed under Mariska's direction. The abstract embroidered squiggle pattern reflected the "brain-like convolutions of coral stone" used in the home's masonry, keeping with Wright's description of the house as organic. Mrs. Parker, influenced by her mentor, Mariska, embroidered patterns designed by her husband and inspired by a stone wall in the house on the bedspreads.[138]

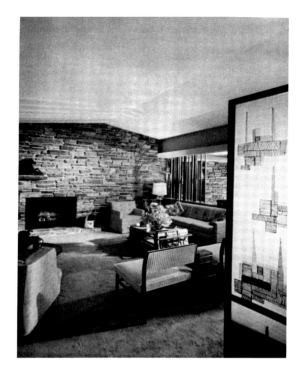

(opposite)
Figure 28
March in 1951 Pace Setter
House
House Beautiful, May 1951
Courtesy of *House Beautiful*
Cat. no. 159

(left)
Figure 29
Screen in 1953 Pace Setter House
House Beautiful, November 1952
Courtesy of *House Beautiful*
Cat. no. 161

(following)
Figure 30
Skein (detail), 1952
Manufactured by
F. Schumacher and Co.
Printed linen, 32¼ x 49¾ inches
Private collection, Cat. no. 158
© Schumacher. Reprinted with
permission. All rights reserved.

In 1956, *House Beautiful* introduced two more printed Schumacher fabrics based on original embroideries by Mariska, *Fair and Square* and *School Figures,* and again offered instructions on adding creative embroidery to household linens inspired by the mass-produced materials.[139] In an advertisement in the *Herald Tribune,* Mariska's name and Schumacher's are both prominently featured with the following words, "the originality of Karasz designs . . . coupled with Schumacher's unmistakable fidelity of reproduction on fine fabrics," indicating that Mariska's reputation was viewed as a commercial asset.[140] The advertisement also notes that *School Figures* was selected for *Textiles U.S.A.,* the Museum of Modern Art's "first exhibition devoted exclusively to contemporary American fabrics."[141] The members of the jury for *Textiles U.S.A.,* held in 1956, included René D'Harnoncourt (1901–1968), director of MoMA;

Arthur Drexler, director, department of architecture and design at MoMA; architect Philip C. Johnson (1906–2005); textile artist Anni Albers (1899–1994); and fashion designer Claire McCardell (1905–1958). The jury selected 190 fabrics from more than 3,500 submissions, based on aesthetic values rather than salability. Also featured were designers Alexander Girard (1907–1993) for Herman Miller Furniture Company, Angelo Testa (1918–1984) for Angelo Testa and Company, and Adriana Scalamandre for Scalamandre Silks, and designs from Knoll Textiles.[142]

Though Mariska designed only a few textiles for manufacture, she did so with notable commercial and critical success, and her textiles stand out because of their close relationship to her handwork. The printed patterns directly relate to stitches she made by hand, and the manufactured fabrics were promoted through *House Beautiful* as points of departure for women to introduce handwork into their homes. Also, though only a small part of her work, these mass-produced textiles and Mariska's representation in *House Beautiful* reached a wider audience than her individual works of art.

Though never employed as a full-time educator, Mariska's active lecture schedule and writings provided numerous instructional opportunities. She held two notable temporary teaching appointments, one at Miami University, in Oxford, Ohio, and the other at Haystack Mountain School, an important and prestigious craft school founded in 1950 in a remote setting in Maine. Between these two experiences, Mariska wrote about teaching:

When I see someone show interest and curiosity about fabrics, threads and stitches, I have a deep feeling of satisfaction. I want to share with them the adventures and inward changes I have known. Teaching others how to work in the medium is one of the ways I have of sharing. Because I have been working in a relatively virgin field, in the sense that embroidery has not been considered a creative art, it is important that new minds and imaginations contribute.[143]

By all accounts, Mariska was an inspiring figure, full of energy, enthusiasm, and passion for her subject. A former student, David Sieler, confirms this, writing to her, "I am coming to understand the faith you have + manage to convey to those wobbling on the brink of creative expression—witness the [illustrated] letterhead! I could never have dared use such 2 <u>mos.</u> ago."[144]

During the summer of 1954, Mariska taught a three-week workshop at Miami University designed for art educators interested in experimenting with and exploring new approaches to design in textiles.[145] The course—titled, according to Mariska, "Creative Stitchery" rather than "Embroidery," in order to increase its chances of being credited—was popular, with twenty-seven students applying for fifteen slots.[146] (Artist and writer David B. Van Dommelen explained in 1962 that while "embroidery" and "stitchery" may refer to the same technique, "stitchery gives a more contemporary and avant-garde impression."[147]) Mariska allowed all of the applicants to participate and enjoyed the variety of ages and educational backgrounds of the students, who were "art teachers, school art superintendents, grade teachers and housewives."[148]

Mariska wrote about her experience at Miami University in an article published in *School Arts*, relating that she taught her students basic stitches, allowed them to work individually and as a group, and emphasized freedom of imagination and creativity as well as practical concerns when embroidering on functional items such as place-mats.[149] After the course, one student wrote to tell her of his satisfaction with doing a "stitchery project" with his classes at the Pennsylvania State University, adding, "I know that my enjoyment of the plants, trees, . . . and the landscape was heightened through my contact with your teaching at Miami."[150]

During 1955, Mariska, Anni Albers, Lili Blumenau, and Jack Lenor Larsen were invited to teach the sessions of a twelve-week summer course at Haystack Mountain School. About the experi-ence Larsen wrote, "representing four distinct approaches to weaving and design, we proved to be, nevertheless, like an integrated quartet, each playing a different instrument which combined to make a harmonic whole."[151] During the course, Albers discussed the history of weaving, Blumenau focused on technique, and Larsen addressed individual concerns and talked about commercial and production aspects of weaving. Of Mariska he wrote,

Embroiderer Mariska Karasz advances indepen-dently in her own medium and, although her work often has the freshness of the primitives, she is part of the contemporary movement. She has always been a modernist and a subjectivist. She thinks and works directly and spontaneously. Techniques are discovered, memorized,

personalized to become automatic in the work that grows out of them. Forms, color balance and composition develop as she works. This is how she taught and her students emulated her dynamic manner of working. She related embroidery to weaving. In drawing inspiration from nature, she urged expression of its life force and personal interpretation of its spatial and linear forms. She stressed the need and desirability of being receptive to nature—in the landscape of fibers and fabrics as well as outdoors. What was important to the weavers and to the stitchers as a group was learning the interrelationship—where weaving ends and where decoration or embroidery begins.[152]

A student from Haystack, Wanda Borders Turk, wrote to Mariska several years later, letting her know that she continued to embroider, her graduate weaving instructor had allowed her to divide her work between weaving and embroidery, she had exhibited several works and sold one, and she had started an embroidery group among the faculty wives at Montana State University.[153] Turk's willingness to change her direction of study and share her knowledge with others clearly demon-strates the success of Mariska's role as an educator and inspiration.

In 1958, Mariska introduced a new material to her embroideries: paper, both handmade and found.[154] She took advantage of the growing field of artistic papermaking and incorporated a variety of unusual papers in her work. Though maintaining the element of stitchery, these new creations, which

primarily were mounted on stiff boards and placed in simple wooden frames, appeared more as collages than as embroideries. Mariska exhibited a final time at Bertha Schaefer Gallery in spring 1959, showing about twenty embroidered collages and seven fabric-based embroideries. A press release describes the "paper series" as "of unique quality, and beauty, conceived in both inner meaning and outer form."[155] A reviewer for the *Tribune* noted Mariska's efforts as a collagist and her use of "arresting materials such as hand-made paper, plastic and luminous threads of various substances."[156] *Craft Horizons* again covered the show, stating in its article, "the effect is somewhat like a brilliant collage with supple spines of thread holding it together, giving it mass and movement. This show, like each of her previous ones, shows Karasz to have reached another peak."[157] In comparison to her embroidered works, one reviewer found the collages "relatively brittle and seemingly fragile," and due to the mix of unstable materials she used (including acidic papers and glues) they have not survived as well as her embroideries and today pose complex conservational issues.[158]

One of Mariska's sources for handmade paper, Douglass Howell (1906–1994), known as the "father of the American reinvention of hand papermaking as an art form," wrote to her after the show conveying his regret at missing her exhibition and expressing excitement over a new mold, 80 by 60 inches ("an historical size!"), hoping that the new large paper he would be able to give her would make up for his absence.[159] Andrea Swanson Honoré, in her essay "Paper Trails, Douglass Howell, and How Paper Won Its Way into Western Art," notes that many artists, including Joan Miró

(1893–1983), Stanley William Hayter (1901–1988), Jasper Johns (b. 1930), Anne Ryan (1889–1954), and Jackson Pollock (1912–1956) "delighted" in Howell's "beautiful and novel substrate," placing Mariska in impressive company. In the mid-1950s Howell exhibited what he called "papetries," with various fabrics and filaments "subtly placed . . . within the paper itself," and Mariska's work includes some paper, possibly made by Howell, with various strings and threads embedded.[160]

Two of Mariska's surviving embroidered collages are *Star Clouds* (Fig. 32, pp. 110–11) and *Honeycomb* (Fig. 31). Both include a variety of handmade papers as well as fabrics and found papers, and both reflect Mariska's desire to pair contrasting materials, shiny with matte and smooth with textured. The stitches are minimal, but important to the structure and design. *Star Clouds*, which retains a sticker from Bertha Schaefer Gallery on the back, features a striped fabric from one of Solveig's dresses. *Honeycomb* incorporates octagonal forms in golden shades mixed with neutral-colored fabrics and papers against a light wood veneer.[161] While embroidered collages such as these constituted only a small portion of Mariska's oeuvre, they were among her last, and when asked if her mother had any favorite works, Solveig replied that she was always fondest of what she had completed most recently.[162]

In early 1960, Mariska traveled to Bolivia to visit her friend Elena Eleska and to collect materials for her work.[163] While on this trip, Mariska noticed that she lacked her usual energy and, after returning home, experienced a long illness followed by a hospital stay. She died of lung cancer on August 27, 1960. The *New York Times, Handweaver and Craftsman,* and *Interiors* printed her obituary, and the Staten Island Institute of Arts and Sciences remarked in its bulletin that the "crafts suffered a great loss when she died."[164]

In 1961, the Museum of Contemporary Crafts presented an exhibition of Mariska's embroidered wall hangings along with a retrospective of the work of ceramicist Katherine Choy (1929–1958). A writer for *Craft Horizons* mourned the loss of both women "at the peak of their creative output," but believed that their influence would flower in many whom they met.[165] In the brochure for Mariska's exhibition, Robert A. Laurer, associate director of the museum, expressed with confidence that Mariska was "assured of a prominent place as a pioneer in the development of the arts in the United States in this century." He acknowledged Mariska's work with fashion design and her intuitive "appreciation of beautiful colors and textures in fabrics," which he described as "an inheritance from the rich folkcraft tradition of her native Hungary." He noted the importance of nature as a source of inspiration for her and recalled that her Brewster studio was filled with "well-tended house plants, while immediately outside, flower and vegetable gardens flourished." He addressed her later works, writing, "the [paper] series constituted an almost exhaustive exploration of the possibilities of introducing elements of embroidery into the context of a new graphic form."[166]

In the last few months of her life, Mariska continued to receive invitations to exhibit her embroideries, requests for advice about techniques and materials, and inquiries about her availability to lecture. She was well positioned to continue being an active, creative, innovative, and inspiring figure in American art and studio crafts. Her last works were fresh and experimental, indicating a vibrant artistic vision and promising years ahead. Though denied those years, Mariska continued to influence and inspire through the inclusion of her works in publications and exhibitions.

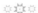

Mariska's embroideries appeared frequently and prominently in books on creative embroidery and stitchery, which were especially popular in the 1960s and 1970s.[167] Well after Mariska's death, Barbara Lee Smith included *Larsen and Lace,* an embroidered collage with handmade paper and antique lace, in the introduction to her book *Celebrating the Stitch: Contemporary Embroidery of North America.* Smith noted that embroidery during the three decades since Mariska's death had "quietly kept pace with the changes in the art world," and that it was an exciting time for the technique.[168]

Mariska's influence is especially obvious in David B. Van Dommelen's book *Decorative Wall Hangings, Art with Fabric,* which includes a quotation from *Adventures in Stitches* preceding the text and an advertisement for it on the back of the jacket. He credits Mariska as "one of the persons most responsible for stimulating a rebirth of stitchery in the United States."[169] *Decorative Wall Hangings* includes illustrations of *Dark Harbor, Textural, Fair and Square* (which is in the collection of the Montclair Art Museum), *Sacrifice,* and *Sand Dollars,* in which Mariska incorporated sand dollars Ilonka brought her from Mexico.[170] In his later book,

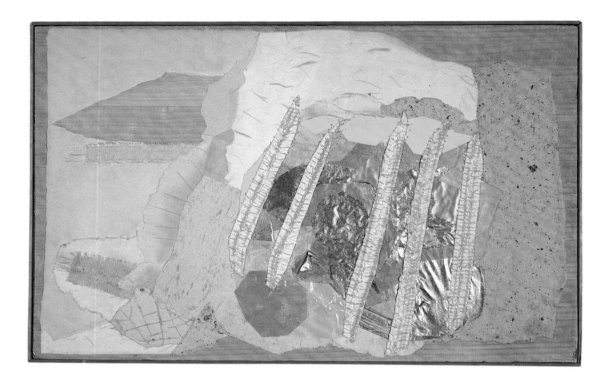

Figure 31
Honeycomb, 1959
Needlework collage
(mixed papers, fabrics, wood
veneer, and threads mounted
on board), 19⅝ x 30½ inches
(framed)
Cat. no. 187

Designing and Decorating Interiors (1965), Van Dommelen featured a section on wall hangings with illustrations of works by Mariska and himself.[171]

In 1963, Mariska's embroideries were illustrated in the book *Art and Design in Home Living* by Frances Melanie Obst, who worked in the department of home economics at the University of California, Los Angeles, and in Vera Guild's *Creative Use of Stitches* in 1964.[172] Jacqueline Enthoven included three works by Mariska in her book *The Stitches of Creative Embroidery* (1964)—*Water, Transcendence,* and *Mustard Seed*—and conveyed her impression of Mariska's influence: "For countless people, she opened a new door to creativity. She gave others the courage to explore an art form she pioneered. She will be remembered as one of the great artists of our time."[173]

Nik Krevitsky illustrated several of Mariska's embroideries in *Stitchery: Art and Craft* (1966). He described the recent developments in contemporary stitchery as both a revival of interest in traditional needlework and as part of the general post-war renaissance in craft. He cited the importance of the growth of the American Craftsmen's Council, the establishment of its Museum of Contemporary Crafts, and the success of its publication, *Craft Horizons*.[174] About Mariska he wrote, "If there is any one significant impetus for a revival in needlework in America and the initiating of a creative attitude, perhaps it can best be seen in the work of the late Mariska Karasz, who popularized contemporary needlework through her book *Adventures in Stitches* . . . ; through being recognized by exhibitions in one of New York's prominent art galleries; and through a series of articles for *House Beautiful*."[175] He believed that her work remained "distinctive and recognizable despite many imitators" and added that "her

successors have gone on into far greater inventive fields and are creating a new image in needlework arts, grateful for Mariska Karasz's contribution and her strong part in reviving a fine art form."[176] Collectively, these publications by Krevitsky, Enthoven, Guild, Obst, and Van Dommelen demonstrate Mariska's stature and influence among artists working with embroidery and related techniques, especially in the decade following her untimely death.

In addition to publications, Mariska's work with embroidery has appeared in numerous exhibitions since 1960, including a solo exhibition in 1963 at the Jefferson Place Gallery in Washington, D.C.; in 1964–65 in *The Wonders of Thread: A Gift of Textiles from the Collection of Elizabeth Gordon* at the Cooper Union Museum (the works from this show are now in the collection of the Cooper-Hewitt, National Design Museum, Smithsonian Institution); in 1977 in the Textile Museum Fiber Craft Gallery; and in 1978 in *Embroidery Through the Ages* at the Cooper-Hewitt.[177] More recently, her work has been included in an exhibition in 1999 titled *The 20th-Century Textile Artist* at the Art Institute of Chicago, which has a significant collection of her work; *A Woman's Hand: Designing Textiles in America 1945-1969* at the Fashion Institute of Technology in 2000–2001; and *High Fiber* in 2005 at the Smithsonian American Art Museum's Renwick Gallery.[178] Solveig occasionally lectures on her mother's work, often using Mariska's slides, which include both images of her work and scenes that inspired her. In 1989, Solveig presented a talk on Mariska for the American Quilt Study Group, an event recorded in a tribute by Bets Ramsey in *Uncoverings 1989*. Ramsey begins, "A

new day for needlework artists dawned in the late 1940s when the Bertha Schaffer [sic] Gallery in New York chose to show the fabric collage and embroidery of Mariska Karasz. The exhibition signaled recognition of textile arts as being worthy of inclusion in the fine arts."[179] Ramsey records that "a show of hands at the 1989 AQSG Seminar revealed dozens of lives influenced by the work of this remarkable woman."[180]

Mariska Karasz, in thirteen quick years, developed an impressive body of unique work and a reputation as an accomplished artist and craftsperson. She was respected by critics and peers and beloved by students and hobbyists. Her youthful enthusiasm for fashion, captured in the description of her flitting around her studio Peter Pan-like, translated into a mature passion for her materials in the final phase of her career. She eagerly shared this passion with others through writing, lecturing, and exhibiting her work. Though her embroideries defy easy classification, they certainly warrant review and respect. Through her intuitive combination of materials and poetic execution of stitches, Mariska contributed a craftsperson's passion for textiles to the field of abstract painting and a fine artist's interpretation of fiber to the world of craft. Considered as a whole, Mariska's career is integrally linked to experiences in her personal life as well as major social shifts and political events, but above all it demonstrates the distinctive vision and drive of a remarkable artist.

Stitches, as I see them today, are so beautiful by themselves, they need not be pictorial representations. The very texture of the medium is rich and full—the thin and the thick, the shiny and the dull, the rough and the smooth. An exciting piece of material serves as the melody for the interplay of threads—in, out, crissed, crossed, detached, and superimposed—weaving patterns of new worlds and forming shapes that are different from yesterday because today is a new day. Let one's attitude of the day be the maker of today's forms, for how could it be otherwise?

—

MARISKA KARASZ, 1955[181]

106

1 Mariska Karasz, exh. broch. from *Abstractions with Thread* at Bertha Schaefer Gallery, December 26, 1950–January 13, 1951, collection of the artist's family.

2 Nik Krevitsky, *Stitchery: Art and Craft* (New York, Amsterdam, London: Reinhold, 1966), 21.

3 While Mariska and her daughters lived at 170 Lexington Avenue, Donald lived at 168 Lexington Avenue. Informal interview with Solveig Cox, June 8, 2004.

4 Informal interview with Solveig Cox, June 6, 2004.

5 Informal interview with Solveig Cox, June 8, 2004; and informal interview with Rosamond Berg Bassett, March 16–17, 2006.

6 Informal interview with Solveig Cox, June 8, 2004. Barnet was Solveig's high school art teacher. Informal interview with Solveig Cox, June 6, 2004.

7 Informal interview with Solveig Cox, June 8, 2004. Solveig specifically recalls silver threads that Liebes gave her mother.

8 Mariska Karasz, "Abstract Stitches," *Craft Horizons* 13 (March/April 1953): 11.

9 Informal interview with Solveig Cox, June 8, 2004.

10 Alberta Dickinson, "Artist with Needle," *Utica Observer-Dispatch*, ca. March 1954, collection of the artist's family; and Ann Pringle, "Mariska Karasz Goes Modern with Stitches," *New York Sun*, April 14, 1947.

11 G. D. Hacket, "An Artist in Needlework," *Harper's Bazaar* 81 (March 1947): 331.

12 Pringle. O. Wyn Richards wrote to Mariska to express his appreciation of their business relations when he retired from the DMC Corporation in 1958. O. Wyn Richards, The DMC Corporation, New York, New York, to Mariska Karasz, New York, New York, June 30, 1958, collection of the artist's family.

13 Informal interview with Solveig Cox, March 3, 2005; and informal interview with Rosamond Berg Bassett, March 16–17, 2006.

14 Pringle; and informal interview with Rosamond Berg Bassett, March 16–17, 2006.

15 Rosamond's image, which features poodles in place of the more usual lions in a circus ring, appears in Mariska Karasz, *Adventures in Stitches: A New Art of Embroidery and More Adventures—Fewer Stitches* (New York: Funk & Wagnalls, 1959), 87, with Mariska's explanation of the sheaf stitch.

16 *Gage Hill* was titled *Our Hill* when first exhibited and *Connecticut Landscape* when illustrated in *Flair* in June 1950. It is referred to most frequently as *Gage Hill*, the name of the area where the Karasz sisters lived. "New England Summer," *Flair* 1 (June 1950), 58–63, illustrated on 60–61.

17 Karasz, "Abstract Stitches," 11.

18 Mary Moore, "A Painter in Thread . . . Mariska Karasz," *Craft Horizons* 9 (Winter 1949): 22.

19 Ibid.

20 Karasz, "Abstract Stitches," 13. When *Ropes on Red* was exhibited at the Riverside Museum in 1954, its price was $500, which would equal about $3,760 in 2006, according to the inflation calculator on the website of the Bureau of Labor Statistics, http://data.bls.gov/cgi-bin/cpicalc.pl, accessed June 23, 2006.

21 Ibid., 10.

22 Ibid., 13.

23 Pringle.

24 Worden (?) to Mariska Karasz, July 2, 1959, collection of the artist's family.

25 Karasz, "Abstract Stitches," 13.

26 Informal interview with Solveig Cox, June 8, 2004; and lecture by Solveig Cox, Unitarian Church, Hollin Hills, Alexandria, Virginia, March 2, 1998.

27 Informal interview with Solveig Cox, June 8, 2004. After seeing the Japanese Exhibition House at the Museum of Modern Art in 1954, Mariska inquired about getting the black cords on the bamboo fence. Arthur Drexler, the curator in the department of architecture, wrote to her that the exhibition was traveling and he still needed the materials, but that he would send her the old cords and tassels if they had to be replaced during the show. Arthur Drexler, Museum of Modern Art, New York, New York, to Mariska Karasz, New York, New York, November 15, 1954, collection of the artist's family.

28 Moore, 20–22; Karasz, "Abstract Stitches," 10–15; Dustin Rice, "Old Wine, New Bottles," unidentified newspaper, November 28, 1956, collection of the artist's family; "Artist Uses Needlework as Means of Expression," ca. 1951, publication and page unknown, collection of the Museum of Arts and Design; Lorraine Har, The Yarn Depot, Inc., San Francisco, California, to Miss Karasz, August 27, 1959, collection of the artist's family; Oppi Untracht, "Karasz-Choy," *Craft Horizons* 21 (March–April 1961): 52; and "Karasz Works on View in Three Arts Show," *Brewster Standard*, August 2, 1951, collection of the de Young Museum, among others.

29 Mariska Karasz, untitled text, ca. 1951, collection of the artist's family. An abbreviated version of this quotation was used in the press release for Mariska's exhibition at the Bertha Schaefer Gallery in 1951, *Mariska Karasz: Abstractions with Thread*, and in the brochure for that exhibition.

30 Juliska (Julia Lukas), Julia Lukas Associates, New York, New York, to Mariska Karasz, Brewster, New York, December 6, 1957, collection of the artist's family.

31 Ibid.

32 W. E. Dempster, Calkins & Holden, New York, New York, to Mariska Karasz, Brewster, New York, April 2, 1958, collection of the artist's family. The Dempsters, Bill and Buff, were family friends. Buff worked in advertising at Elizabeth Arden, where Solveig worked one summer. Their daughter Nancy wore clothing by Mariska. Email from Solveig Cox, May 22, 2006.

33 Informal interview with Rosamond Berg Bassett, March 16–17, 2006.

34 Ibid; and Nini Cnbloch, "Embroidery Raised to Level of Fine Art by Miss Mariska Karasz of Brewster," unidentified New York newspaper, August 19, 1956, collection of the artist's family.

35 Dickinson.

36 Karasz, "Abstract Stitches," 11.

37 Ibid.

38 Karasz, *Adventures in Stitches*, 122.

39 Jacqueline Enthoven, *The Stitches of Creative Embroidery* (New York, Amsterdam, London: Reinhold, 1964), 183.

40 According to the inflation calculator on the website of the Bureau of Labor Statistics, the price range of $100 to $700 in 1955 would equal approximately $750 to $5,300 in 2006, accessed July 5, 2006.

41 E. C. M., "Mariska Karasz," *Art News* 55 (December 1956): 59.

42 Mariska Karasz, Brewster, New York, to Miss Jane Christian, New York, New York, February 27, 1959, collection of the artist's family. A copy of an invoice in Mariska's papers indicates that the commission was completed. Invoice from Mariska Karasz, Brewster, New York, to Jane Christian Interiors, New York, New York, November 20, 1959, collection of the artist's family.

43 Abraham W. Geller, New York, New York, to Mariska Karasz, New York, New York, October 1, 1957, collection of the artist's family.

44 Herbert L. Shapiro, Beach Haven Park, New Jersey, to Ashley Callahan, Athens, Georgia, June 27, 2006. The Shapiros sold the house in 1996, and the embroidery was lost when the house was torn down shortly after. For more on the house, see Paul Goldberger, "Architecture: Abraham Geller, a New York Modernist's New Jersey Landmark," *Architectural Digest* 49 (November 1992): 118–22, 126.

45 Mariska Karasz to James L. Whitehead, Staten Island, New York, July 22, 1960, collection of the artist's family.

46 Mariska Karasz to Bea, December 10, 1959, collection of the artist's family.

47 Lecture by Solveig Cox.

48 Informal interview with Rosamond Berg Bassett, March 16–17, 2006.

49 Margaret Breuning, "Mariska Karasz," *Art Digest* 25 (January 1, 1951): 21.

50 For more information on the history of studio craft see, for example, Janet Kardon, ed., *Craft in the Machine Age, 1920-1945: The History of Twentieth-Century American Craft* (New York: Harry N. Abrams, Inc., Publishers, in association with the American Craft Museum, 1995).

51 Center for the Quilt Online, www.centerforthequilt.org/qsos/show_interview.php?pbd=qsos-a0a3o1-a&force_update=1, accessed January 5, 2005; Bets Ramsey, "A Tribute to Mariska Karasz (1898-1960)," in *Uncoverings 1989*, ed. Laurel Horton (San Francisco: American Quilt Study Group, 1990), 159; and conversations with Solveig Cox.

52 Cnbloch and press release draft, ca. 1953, collection of the Akron Art Museum (this is a press release form sent by Mariska to Akron for their use with the promotion of her exhibition). Rosamond notes that there was an extra immediacy to Mariska's work, as compared to that of painters, because there was no need to wait to stretch a canvas or pause for paint to dry. Informal interview with Rosamond Berg Bassett, March 16–17, 2006.

53 Rice.

54 Informal interview with Rosamond Berg Bassett, March 16, 2006.

55 Rice; "Fabrics by Karasz," *Interiors* 110 (February 1951): 18; and S. F., "Mariska Karasz," *Art Digest* 29 (October 15, 1954), 27.

56 In 1942, the Handcraft Cooperative League of America became the American Craftsmen's Cooperative Council, which became the American Craftsmen's Educational Council in 1943, and the American Craftsmen's Council in 1995. It is known as the American Craft Council today. American Craft Council Online, www.craftcouncil.org, accessed May 15, 2006.

57 The Metropolitan Museum of Art presented the Dept. of State's exhibition prior to its departure, and the *New York Times* illustrated Mariska's work when reviewing the show. Betty Pepis, "Handcrafts of The United States," *New York Times*, October 12, 1952.

58 Informal interview with Solveig Cox, June 8, 2004; Jack Lenor Larsen to Mariska Karasz, New York, New York, December 3, 1959; and Jack Lenor Larsen, New York, New York, to Mariska Karasz, Brewster, New York, January 6, 1959 [sic, should be 1960], collection of the artist's family.

59 Aileen O. Webb, foreword, in *Craftsmanship in a Changing World*, exh. broch. (Museum of Contemporary Crafts, New York, September 20–December 4, 1956), n.p.

60 *Craftsmanship in a Changing World*.

61 R. S., "Wall Hangings and Rugs: Museum of Contemporary Crafts Exhibit," *Craft Horizons* 17 (May–June 1957): 24.

62 Ibid., 18–24.

63 Mariska contributed the work *Trinity* and possibly *Alpha and Omega*, which illustrated an article on the show in *Handweaver and Craftsman*. "Exhibitions," *Handweaver and Craftsman* 9 (Winter 1957–58): 35–37. Though not religious, Mariska submitted works for numerous exhibitions of ecclesiastical art, including *Religious Art of the Western World* at the Dallas Museum of Art in 1958, an exhibition of contemporary ceremonial and synagogue art at the Jewish Museum that same year, a religious art festival at the Berkshire Art Center in 1959, and a show at the Lowe Art Gallery in Coral Gables, Florida, ca. 1960, among others. Dore Ashton, "Art: Synagogue Exhibits," *New York Times*, May 29, 1958, and Clay Aldridge, Coral Gables, Florida, to Mariska Karasz, Brewster, New York, January 12, 1959.

64 American Craft Council Online.

65 Moore, 20–22.

66 Title page, *Craft Horizons* 13 (March/April 1953): 3; and Cnbloch.

67 *Fiberworks*, exh. cat. (The Cleveland Museum of Art, 1977), n.p. Thanks to Madelyn Shaw for bringing this reference to my attention.

68 Mildred Constantine and Jack Lenor Larsen, *Beyond Craft: The Art Fabric* (New York: Van Nostrand Reinhold Company, 1972), 38.

69 Ibid., 11.

70 Ibid., 39.

71 Cnbloch; and Marjorie Montgomery, "Motor Car Age Blamed for Drop in Rewarding Art of Needlework," unidentified newspaper, ca. 1956, collection of the artist's family.

72 E. C. M., 59; and "'Pictures' Evolved from Embroidery," *New York Times*, December 27, 1950.

73 Montgomery.

74 Moore, 22.

75 Mariska Karasz to an unidentified recipient, late 1959, collection of the artist's family. This is a carbon copy of part of a letter on the back of a carbon copy of a letter to Paul, December 29, 1959, collection of the artist's family.

76 Robert Allison worked as art director at Lord and Taylor and designed some of Mariska's announcements. Email from Solveig Cox, April 5, 2004; and informal interview with Solveig Cox, June 8, 2004. He provided photographs for *Adventures in Stitches*. Bonestell also showed works by David Burliuk (1882–1967), Jean Charlot (1897–1979), and scenic designer Oliver Smith (1918–1994).

77 Brochure for exhibition at Bonestell Gallery, 1947, collection of the artist's family.

78 One of the lists of works in Mariska's papers gives the price of *Solveig* as $200, equal to about $1,800 in 2006, according to the inflation calculator on the website of the Bureau of Labor Statistics.

79 Thanks to conservator Julia Brennan for sharing this observation.

80 Informal interview with Rosamond Berg Bassett, March 16–17, 2006.

81 For more on Nuala see "Artist for a Year, to Open Show Here," *New York Times*, March 2, 1947.

82 Museum of Arts and Design object records, especially appraisal by Leatrice Shanker Eagle, 1992.

83 Mariska's second solo exhibition was at the Three Arts Book Shop in Poughkeepsie in June 1948. "Talented Craftsman to Appear on WGNY," *Putnam County Courier*, June 3, 1948; and *Pottery Jewelry Needlework*, exh. broch. (Bertha Schaefer Gallery, November 15–December 4, 1948), collection of the artist's family.

84 O. G., "Case of Ambidexterity: Bertha Schaefer," *Interiors* 116 (April 1957): 94–98, 179; and Jack Lenor Larsen, *Jack Lenor Larsen: A Weaver's Memoir* (New York: Harry N. Abrams, Inc., Publishers, 1998), 148.

85 See Appendix I in this catalogue for checklists from the exhibitions in 1950 and 1952.

86 "On and Off the Avenue," *The New Yorker*, November 27, 1948, 105–106.

87 Press release, Abstractions in Needlework Shown at Bertha Schaefer Gallery, December 26, 1950–January 13, 1951, collection of the artist's family.

88 Margaret Breuning, "Mariska Karasz," *Art Digest* 27 (December 1, 1952): 17.

89 Lists and notes in Mariska's papers indicate that the scrolls ranged in size from 20 to 60 by 12 to 18 inches.

90 S. F.

91 E. C. M., 59; and press release, New Work by Mariska Karasz at Bertha Schaefer Gallery, November 19–December 8, 1956, collection of the Montclair Art Museum.

92 "Art: German Parable," *New York Times*, December 1, 1956.

93 Informal interview with Solveig Cox, June 8, 2004.

94 However, the brochure for the second show at Katonah notes that the exhibition appeared there prior to Bertha Schaefer. Exh. broch., Katonah Gallery, August 5–September 5, 1956, collection of the artist's family.

95 *Moses I* and *Moses II* began as a single work, but Mariska decided that it looked like two works, so she cut it in half. She named the works after renowned folk artist Grandma Moses, who was especially popular in New York at the time and who had admitted cutting up a painting to make multiple paintings. Email from Solveig Cox, July 19, 2006.

96 Arthur Millier, "Koch's Initial Coast Display Wins Praise; Serene Works Have Family Appeal; Karasz Thread Pictures Featured," *Los Angeles Times*, March 18, 1951.

97 Bulletin, The Currier Gallery of Art, October 1951, collection of the artist's family; and "Embroiderer to Give Talk at Gallery," *Union-Leader* (Manchester, New Hampshire), October 26, 1951, collection of the de Young Museum.

98 Elisabeth Moses, San Francisco, California, to Mariska Karasz, New York, New York, February 27, 1952, collection of the artist's family.

99 Maurine Roberts, Portland, Oregon, to Mariska Karasz, March 10, 1953.

100 Alice Price, "Originality in Embroidery," unidentified newspaper, ca. 1957, collection of the artist's family.

101 Untitled, *Christian Science Monitor*, March 13, 1963.

102 Marianne Strengell, Bloomfield Hills, Michigan, to Mariska Karasz, New York, New York, June 5, 1957, collection of the artist's family.

103 Lydia Bush-Brown, New York, New York, to Mariska Karasz, November 7, 1957, collection of the artist's family. Bush-Brown particularly was known for her work with batik in the 1920s.

104 Barbara E. Scott Fisher, "Rummaging Round New York," *Christian Science Monitor*, December 15, 1948; publication of the Pen and Brush, May 1950, collection of the artist's family; and publication of the Pen and Brush, 1952, collection of the artist's family.

105 Publication of the Pen and Brush, May 1950.

106 While the biographical statement at the end of *Adventures in Stitches: A New Art of Embroidery and More Adventures—Fewer Stitches* lists the award as a blue ribbon, it more specifically was an honorable mention in the "Fine Arts of Living" category. Other artists in this category included weavers Trude Guermonprez, Lenore Tawney, and Lili Blumenau; glass artists Edris Eckhardt and Maurice Heaton; furniture maker Sam Maloof; and ceramicist Peter Voulkos. Lee Nordness, New York, New York, to Mariska Karasz, Brewster, New York, April 9, 1959, collection of the artist's family; and *ART:USA:59, a force, a language, a frontier* (New York: 1959), 80–81. The jury included Lloyd Goodrich, Charles Cunningham, and Clement Greenberg.

107 *10 Women Artists*, exh. broch. (Riverside Museum and the National Council of Women of the United States, May 2-23, 1954), collection of the artist's family; *ART:USA:59*, 80; Mariska Karasz to Mr. Lee Nordness, New York, New York, November 23, 1959, collection of the artist's family; and Mariska Karasz to Mr. Walter H. McBride, Grand Rapids, Michigan, December 15, 1959.

108 Lecture flyer for "You Are More Creative Than You Think," Cleveland Museum of Art, collection of the artist's family (the lecture took place on Wednesday, November 5, probably 1952); and lecture flyer for "Texture in Our Homes," DeCordova Museum, collection of the artist's family (the lecture took place on Sunday, November 29, probably 1954).

109 "Creative 'Stitchery' Shown in Work by Mariska Karasz," *Springfield Union* (Massachusetts), March 8, 1952.

110 Dickinson.

111 Margaret F. Hastings (Mrs. John M. Hastings, Jr.), The Syracuse Museum of Fine Arts, Syracuse, New York, to Mariska Karasz, Brewster, New York, October 28, 1958, collection of the artist's family.

112 "Embroiderer to Give Talk at Gallery"; and "Needleworker Must Make Own Designs Says Artist," *Manchester (N. H.) Union Leader*, October 29, 1951.

113 Karasz, "Abstract Stitches," 11.

114 T. H. Robsjohn-Gibbings, New York, New York, to Mariska Karasz, New York, New York, November 1, 1950, collection of the artist's family.

115 "Varied Stitches Termed a Boon to Embroidery," *New York Times*, September 25, 1959.

116 Karasz, *Adventures in Stitches*, 95.

117 Catherine A. Hedlund, "At This Stitch in Time," *Washington Post*, February 9, 1975. In 1963, members of the Woman's Suburban Democratic Club used *Adventures in Stitches* as one of the textbooks for their embroidery group, following Mariska's lead when making their "free and easy stitches." "They're Learning to Stitch Between Campaigns," *Washington Post, Times Herald*, February 7, 1963.

118 Questionnaire, date unknown, collection of the artist's family.

119 The lessons appeared in the following issues of *House Beautiful*: Lesson 1, January 1952; Lesson 2, March 1952; Lesson 3, May 1952; Lesson 4, July 1952; Lesson 5, September 1952; Lesson 6, January 1953; Lesson 7, May 1953; and Lesson 8, December 1953. The magazine reprinted the lessons from 1961 to 1962.

120 "House Beautiful Proved That You Can Be Creative in Embroidery," *House Beautiful* 94 (January 1952): 76–77, 101–102 and "How 6 Unartistic People Embroidered a Fish," *House Beautiful* 94 (January 1952): 78–79.

121 Dickinson. In 1958, Ken J. Uyemura, a representative with Russel Wright Associates, wrote to Mariska regarding a Russel Wright-ICA Handicraft Development Program in Vietnam. He asked her to provide a list of books that would be helpful for teaching young girls and inquired about the possibility of getting copies of her lessons in *House Beautiful*. Ken J. Uyemura, Russel Wright Associates, Saigon, Vietnam, to Mariska Karasz, Brewster, New York, July 16, 1958, collection of the artist's family; Ken J. Uyemura to Russel Wright, New York, New York, July 16, 1958, collection of the artist's family; and Julia Lukas, New York, New York, to Russel Wright, New York, New York, August 7, 1958, collection of the artist's family.

122 Sarah Booth Conroy, "'Art in Stitches': Making a Needle Point," *Washington Post, Times Herald*, March 4, 1973.

123 Mary Carroll Nelson, "Stitchery: The Art of Martha Mood and Wilcke H. Smith," *American Artist* 50 (October 1985): 100–101.

124 For more information on home magazines' annual model homes see: "Magazine Houses," *House and Home* 8 (October 1955): 144–50. Thanks to Tori Cole for her assistance gathering information about the Pace Setter Houses. For more information on the Pace Setter Houses, see Monica Penick, "Pace Setter Houses: Livable Modernism in Postwar America" (PhD diss., University of Texas, forthcoming 2007).

125 "Defining the American Way of Life Executed in the New American Style," *House Beautiful* 93 (May 1951): 107+.

126 Ibid.

127 "House Beautiful Presents the 1953 Pace Setter House," *House Beautiful* 94 (November 1952): 199+.

128 In 1954, Mariska had nine embroidered panels laminated by Copeland, Novak and Associates. Gloria Hogrogian, Copeland, Novak and Associates, New York, New York, to Mariska Karasz, New York, New York, September 17, 1954, collection of the artist's family. She also worked with Herbert Riley, head of Pan-Laminate, Inc. Karasz, "Abstract Stitches," 15.

129 "House Beautiful Presents the 1953 Pace Setter House," 202.

130 Informal interview with Solveig Cox, June 8, 2004.

131 Two American textile firms, Everfast and Textron, had earlier planned to translate Mariska's embroidery designs into fabrics, as highlighted in *American Fabrics* in fall 1949. Textron's design featured a series of images related to baskets, and Everfast planned to produce eight colorways of a pattern from a circus figure with performing poodles, based on Rosamond's design. C. C., "Artist with Needle & Thread," *American Fabrics*, no. 11 (Fall 1949): 88–91.

132 Advertisement, *Interiors* 112 (September 1952): 62.

133 Advertisement, *Interiors* 111 (July 1952): 44.

134 "Fabrics Set the Pace for Your Creative Embroidery," *House Beautiful* 94 (November 1952): 235.

135 Around 1951 Mariska designed patterns for *Today's Woman*, which could be applied to various household items, such as bedspreads, rugs, and room dividers. Marguerite Kohl, "Decorate with Bold Quick Stitches," *Today's Woman*, page and date unknown (ca. 1951), collection of the artist's family.

136 Schumacher produced *Skein* in at least seven different colorways: yarn red and green, pumice, turnip, copper beech and white, linnets egg blue, pheasant gold, and white clover. The repeat is thirty inches. From Schumacher's *Portfolio of Fabrics*, February 1953, collection of F. Schumacher and Company. *Skein* appears on a two-page spread in Richard E. Slavin III, *Opulent Textiles: The Schumacher Collection* (New York: Crown Publishers, Inc., 1992), 119 and plate 146. Kenneth Trapp included a related embroidery in a book highlighting works in the collection of the Renwick Gallery. Renwick Gallery, *Skilled Work: American Craft in the Renwick Gallery*, National Museum of American Art, Smithsonian Institution (Washington, DC, and London: Smithsonian Institution Press, 1998), 98–99. In *Skilled Work*, the related embroidery is titled *Skeins*, as it is in Mariska's article in *Craft Horizons* in 1953, but in *Adventures in Stitches: A New Art of Embroidery and More Adventures—Fewer Stitches*, she titled it *Harvest*.

137 The daughter's room in the 1955 Pace Setter House in Dallas, Texas, also featured two embroidered wall hangings by Mariska, *Trees* and *Evolution*, with a third, *Green Glimpses*, in the family playroom. "The Pace Setter Art Objects," *House Beautiful* 96 (February 1954): 128–32+; and "The Daughter's Room," *House Beautiful* 97 (February 1955): 90, 91, 92, 132.

138 "House Beautiful's 1954 Pace Setter House," *House Beautiful* 95 (November 1953): 217, 219, 222, 263, 269, 276; Elizabeth Gordon, "This Is The House Beautiful," *House Beautiful* 95 (November 1953): 218; Laura Tanner, "The Master Bedroom and Bath," *House Beautiful* 95 (November 1953): 244, 245, 289; Elizabeth Gordon, "This Room Has Style—But Not Any One Style," *House Beautiful* 96 (April 1954): 152, 154, 240.

139 Schumacher produced *School Figures* in four colorways. "How to Work Embroidery into Your Decorating," *House Beautiful* 98 (August 1956): 78–79, 116–19.

140 Advertisement, *Herald Tribune*, October 21, 1956.

141 Ibid.

142 The fall 1956 issue of *American Fabrics* is devoted to this exhibition.

143 Mariska Karasz, "Course in Creative Stitchery," *School Arts* 54 (June 1955): 11.

144 David Sieler to Mariska Karasz, ca. 1957–1958, collection of the artist's family.

145 The course description indicates that she also had taught needlework at two New York schools. *The Summer Student*, Miami University, Oxford, Ohio (July 12, 1954), n.p.

146 Karasz, "Course in Creative Stitchery," 12.

147 David B. Van Dommelen, *Decorative Wall Hangings, Art with Fabric* (New York: Funk & Wagnalls Company, Inc., 1962), 25.

148 Karasz, "Course in Creative Stitchery," 14.

149 Ibid., 11–16.

150 Paul Kalinchak (?), State College, Pennsylvania, to Miss Karasz, August 21, 1957. He refers to working with her "last summer," though she taught at Miami in 1955.

151 Jack Lenor Larsen, "The Weaver as Artist," *Craft Horizons* 15 (November–December 1955): 31.

152 Ibid., 33.

153 Wanda Borders Turk, Missoula, Montana, to Mariska Karasz, January 10, 1959, collection of the artist's family. Artist Joan Koslan Schwartz in 1981 cited Mariska as one of her major sources of inspiration and recalled first seeing her work in New York. In 2003, artist Ardyth Davis mentioned Mariska and Nik Krevitsky as part of the reason she became interested in working with fiber. Deborah Churchman, "Textured Communication Through the Needle's Eye," *Washington Post*, September 3, 1981; and "The Challenges of Time and Inspiration: An In-depth Interview with Fiber Artist Ardyth Davis," *The Crafts Report*, www.craftsreport.com/september01/onlineexclusive.html, accessed January 5, 2005.

154 Slides of Mariska's "paper works" date from October 1958 to April 1959, collection of the artist's family.

155 Press release, New Works by Mariska Karasz at the Bertha Schaefer Gallery, April 13–May 2, 1959, collection of the artist's family.

156 C. B., "Tam, Mexican Show, Morlotti, Karasz Art," *Tribune*, April 26, 1959, collection of the artist's family.

157 Robert Sowers, "Mariska Karasz," *Craft Horizons* 19 (May–June 1959): 40.

158 C. B.

159 Andrea Swanson Honoré, "Paper Trails, Douglass Howell and How Paper Won Its Way into Western Art," Laurence Barker, Paper Artist and Printmaker, www.laurencebarker.com/article_papertrails.html, accessed August 8, 2004; and Douglass Howell, Westbury, Long Island, to Mariska Karasz, June 2, 1959, collection of the artist's family. Howell was working on his third sheet of paper from the mold at the time and hoped soon to be able to produce three sheets a week.

160 Honoré; and *Douglass Morse Howell Retrospective* (New York: American Craft Museum, 1982).

161 Mariska priced *Honeycomb* at $300, equal to approximately $2,010 in 2006, according to the inflation calculator on the website of the Bureau of Labor Statistics.

162 Informal interview with Solveig Cox, June 8, 2004. Mariska continued making embroideries on fabric concurrently with her experimentation with paper. One of her last works, which her daughters found under her rug after she died, was *Split Level Ark*. They also found a work titled *Up the Urubamba* inspired by and composed of materials from her trip to Bolivia. Email from Solveig Cox, July 19, 2006.

163 Informal interview with Solveig Cox, June 8, 2004. Elena was a friend of Julia Lukas. Email from Solveig Cox, August 9, 2005.

164 "Mariska Kavasz [sic] Is Dead at 62; Needlework Artist and Author," *New York Times*, August 28, 1960; "Mariska Karasz," *Handweaver and Craftsman* 11 (Fall 1960): 62; "Mariska Karasz 1898-1960," *Interiors* 120 (September 1960): 215; and *The New Bulletin, Staten Island Institute of Arts and Sciences* (November 1960), 25.

165 Untracht, 52.

166 *Mariska Karasz*, exh. broch. (Museum of Contemporary Crafts, February 17–March 12, 1961).

167 Two of Mariska's early works are illustrated in Catherine Christopher's *The Complete Book on Embroidery and Embroidery Stitches* (New York: Greystone Press, 1948), 63 and 233, marking Mariska's entrance to the field.

168 Barbara Lee Smith, *Celebrating the Stitch: Contemporary Embroidery of North America* (Newtown, CT: The Taunton Press, 1991), 2.

169 Van Dommelen, *Decorative Wall Hangings*, 26.

170 Ibid., 2.

171 David B. Van Dommelen, *Designing and Decorating Interiors* (New York, London, Sydney: John Wiley & Sons, Inc., 1965), 148–49.

172 Frances Melanie Obst, *Art and Design in Home Living* (New York and London: The MacMillan Company and Collier-MacMillan Limited, 1963), 286; and Vera P. Guild, *Creative Use of Stitches* (Worcester, MA: Davis Publications, Inc., 1964), 42–47.

173 Enthoven, 182.

174 Krevitsky also cites the publications *Arts and Activities* and *School Arts* as instrumental in encouraging crafts and stitchery in schools. Krevitsky, 21.

175 Ibid.

176 Ibid.

177 Leslie Judd Ahlander, "Hopkins Exhibit at Art Galleries," *Washington Post, Times Herald*, June 2, 1963; Cooper Union Museum for the Arts of Decoration, *The Wonders of Thread: A Gift of Textiles from the Collection of Elizabeth Gordon*, exhibition Dec. 12, 1964, through Feb. 23, 1965, exh. cat. (New York: Cooper Union Museum, 1964); Rory Quirk, "Etcetera," *Washington Post*, March 20, 1977; and Judith Straeten McGee, "Embroidery Through the Ages," *Craft Horizons* 38 (October 1978): 19.

178 Christa C. Thurman, *The 20th-Century Textile Artist*, exh. broch. (The Art Institute of Chicago, March 31–August 1, 1999), 4–5; and "Smithsonian American Art Museum to Open 'High Fiber,'" December 3, 2005, *Art Daily*, www.artdaily.com.

179 Ramsey, 159.

180 Ibid., 160.

181 Karasz, "Course in Creative Stitchery," 16.

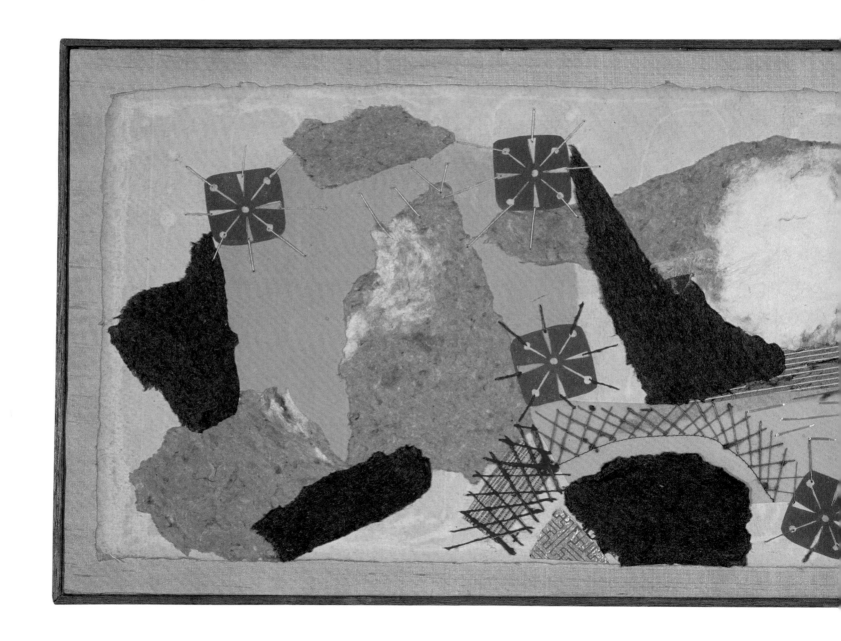

Figure 32
Star Clouds, 1959
Needlework collage (mixed
papers, fabrics, and threads
mounted on board), 11½ x 31⅞
inches (framed)
Cat. no. 186

111 *mariska karasz abstract stitches*

Recent Embroidery by Mariska Karasz, exh. broch. (Bonestell Gallery, New York, April 15–26, 1947), collection of the artist's family.

Mariska's Sampler
Nuala (loaned by Mme. Elsa de Brun)
Tequila Trip
Flowers
Humming Birds
Zodiacs
Solveig
The Goat Tree
Our Hill (from drawing by Solveig)
Dorothy Peterson and Hamlet
Me
Conflict in Geometry
Goatscape I
Goatscape II
Nancy Dempster and Nantucket
Duncan Ferguson Dempster (loaned by Mr. and Mrs. William Dempster)
Out of the Sewing Machine Drawer
Rozsika
Joy Yasumoto
Little Thing
Pennsylvania Airscape
Dream in Blue
Balloons
Chair with Goat
Rug

Mariska Karasz: Abstractions with Thread, exh. broch. (Bertha Schaefer Gallery, New York, December 26, 1950–January 31, 1951), collection of the artist's family.

What Goes Up Must Come Down
Map Mixed with Territory
New Potatoes
Angels
Four Seasons
Bottles
Frog Prince
March
All Whites
Look
Sunday
Flowers
Studies in Botany
Equilibrium
Abstractions I to IV
Short Circuit
Glorified Potatoe [sic] Bag
Glorified Lemon Bag
Juggler
Doors and Windows
The Nervous System of a Child
Reflection
Little One
Madonna
More Angels
Cat Carpet
Watermelon Lady
The Artist
Boats
Strings High and Low
Adam and Eve
Two-Fold-Screen
Labyrinth Screen
Coffee Table

Abstractions in Needlework, exh. broch. (Bertha Schaefer Gallery, New York, November 24–December 20, 1952), collection of the artist's family.

MONOCHROMATIC TEXTURES ON RODS

Many Mansions
Projection
Fragrance
Egypt
Before Frost
Flying Saucers
Arena
As Above, So Below
Spectrum
Kindred
Ropes on Red
Haywire

WALL SEPARATION

Shelter
Earth, Sea and Air

VARIATIONS IN FRAMES

Green
Chartreuse
Beige
On White
Orange
Gray
As the Wind Blows

CHROMATIC TEXTURES

All Squares
Harvest
Long Labyrinth
Communication
Refining
Clarification
The Shadow
Pisces and Pieces
Fall Leaves
First Thaw
Alchemy
Madonna
Mosses

Typed list of works in Mariska Karasz Traveling Exhibition, 1953–54, collection of the Taft Museum of Art.

As Above, So Below
All Whites
Communication
Many Mansions
Windblown Poppies
Shelter from Triangles
Kindred
Magnetism
Refining
Man and Beast
Indirection
Framed
Lures
Sand Dollars
Chartreuse
Moses I
Moses II
Clarification
Vernal Equinox
Faun
Landscape
Small Boats
Doors and Windows
Adventures in Stitches

Typed list of works in Mariska Karasz: Traveling Show, 1955–56, collection of the artist's family.

Magnetism
First Thaw
Harvest
Graphis
Ropes on Red
Moses I
Moses II
Crosspatch
Indirection
Copper Criss-Cross
Conversation
The Ferris Wheel
China Sea
Color Range
Parting
Half & Half
Sage
Overcast
Allegro
Bush
Fountains
Green Glimpse

APPENDIX 2

A SELECTED LIST OF THE VENUES FOR MARISKA KARASZ'S
SOLO EXHIBITIONS:[1]

1951

University of California, Los Angeles, California

The Currier Gallery of Art, Manchester, New Hampshire

Iowa State College, Ames, Iowa

Des Moines Art Center, Des Moines, Iowa

Philadelphia Art Alliance, Philadelphia, Pennsylvania

University of Minnesota, Twin Cities, Minnesota

Columbus Gallery of Fine Arts, Columbus, Ohio

Art Institute of Chicago, Chicago, Illinois

Cummington School of the Arts, Cummington, Massachusetts

Ball State Teachers College, Muncie, Indiana

Ohio State University, Columbus, Ohio

Cornell University, Ithaca, New York

1952

University of Michigan, Ann Arbor, Michigan

M. H. de Young Memorial Museum, San Francisco, California

1953

Binghamton Museum of Fine Arts, Binghamton, New York

Oregon Ceramic Studio, Portland, Oregon

Vancouver Art Gallery, Vancouver, British Columbia

Henry Gallery, University of Washington, Seattle, Washington

Bennington College, Bennington, Vermont

Delaware Art Center, Wilmington, Delaware

Akron Art Institute, Akron, Ohio

Taft Museum of Art, Cincinnati, Ohio

1954

Eastern Illinois State Gallery, Charleston, Illinois

DeCordova and Dana Museum, Lincoln, Massachusetts

Katonah Library Gallery, Katonah, New York

Munson-Williams-Proctor Institute, Utica, New York

Cleveland Museum of Art, Cleveland, Ohio

Oneonta State Teachers College, SUNY, Oneonta, New York

Amagansett Art Gallery, Amagansett, New York

Riverside Museum, New York, New York

1955

University of Delaware, Newark, Delaware

Massillon Museum, Massillon, Ohio

Grand Rapids Art Gallery, Grand Rapids, Michigan

Butler Art Institute, Youngstown, Ohio

Clarke College, Dubuque, Iowa

Michigan State University, East Lansing, Michigan

ca. 1955–56

Saginaw Museum, Saginaw, Michigan

Bennett Junior College, Millbrook, New York

Springfield Museum, Springfield, Massachusetts

Brookfield Art Center, Brookfield, Connecticut

1956

Katonah Gallery, Katonah, New York

Cranbrook Art Museum, Bloomfield Hills, Michigan

Sioux City Art Center, Sioux City, Iowa

Iowa State Teachers College, Cedar Falls, Iowa

1957

State University of Iowa, Iowa City, Iowa

Baltimore Museum of Art, Baltimore, Maryland

Dallas Public Library, Dallas, Texas

Mulvane Art Center, Topeka, Kansas

Indiana University, Bloomington, Indiana

1958

Indiana State Teachers College, Terrre Haute, Indiana

Montclair Art Museum, Montclair, New Jersey

Westchester Workshop in County Center, White Plains,
New York

Staten Island Institute of Arts and Sciences, Staten Island,
New York

1959

Charles Allis Art Library, Milwaukee, Wisconsin

Fitchburg Art Museum, Fitchburg, Massachusetts

1960

Colorado Springs Fine Arts Center, Colorado Springs, Colorado

Drexel Institute of Technology, Philadelphia, Pennsylvania

1 "Many Art Displays Fill Holiday Week," *New York Times*, November
24, 1952; "Designs Presented by Thread Stylist," *New York Times*,
November 25, 1952; "Circuit Show of Needlework," *Craft Horizons*
15 (January–February 1955): 46; post exhibition files, Cranbrook Art
Museum; Joan Andreasen, "She Uses a Needle as a Paint Brush,"
Grand Rapids Herald, April 19, 1955; and papers of Mariska Karasz,
collection of the artist's family.

Adlow, Dorothy. "Paintings from New Zealand, Honolulu, and New England." *Christian Science Monitor*, October 8, 1951.

Advertisement. *Creative Art* 2 (April 1928): vi.

Advertisement. *Creative Art* 3 (October 1928): xvi.

Advertisement. *Creative Art* 6 (March 1930): sup. 52–53.

Advertisement. *Interiors* 111 (July 1952): 44.

Advertisement. *Interiors* 112 (September 1952): 62.

Ahlander, Leslie Judd. "Hopkins Exhibit at Art Galleries." *Washington Post, Times Herald*, June 2, 1963.

"All of a Summer's Day—Be It Party or Play." *Good Housekeeping* (date unknown): 58.

American Art Expositions. *ART:USA:59, a force, a language, a frontier*. New York: Author, 1959.

American Fabrics (Fall 1956).

Ames Daily Tribune. "Mariska Karasz, NY Designer, To Speak Here," January 14, 1950.

Andreasen, Joan. "She Uses a Needle as a Paint Brush." *Grand Rapids Herald*, April 19, 1955.

"Appliqued Yoke and Bolero Themes in Latin-American Embroideries for Girls' Frocks." Unidentified publication, date and page unknown.

"Artist Uses Needlework as Means of Expression." Unidentified publication, ca. 1951, page unknown.

Ashton, Dore. "Art: Synagogue Exhibits." *New York Times*, May 29, 1958.

Austin, Kay. "Little Dresses Appeal to Hearts of All Women." *New York World-Telegram*, January 8, 1935.

B., C. "Tam, Mexican Show, Morlotti, Karasz Art." *Tribune*, April 26, 1959.

Bailey, Gertrude. "Families Go In For Matching Up Their Wardrobes, Even to Dad's Tie." *New York World-Telegram*, May 1, 1937.

Blondel, Elisabeth. "Daughters of the Sun." *McCall's* 61 (May 1934): 133.

Boatwright, Evelyn. "Through a Child's Day." *The New York Woman*, ca. spring 1937, collection of the artist's family.

Brantley, Rebecca. "Mariska Karasz and Hungary: Early Design and Influences." Honors thesis, University of Georgia, 2005.

Breuning, Margaret. "Mariska Karasz." *Art Digest* 25 (January 1, 1951): 21.

———. "Mariska Karasz." *Art Digest* 27 (December 1, 1952): 17.

Brewster Standard. "Karasz Works on View in Three Arts Show," August 2, 1951.

———. "Mariska Karasz to Speak: Artistic Expression Through the Needle," September 6, 1951.

Buell, Ellen Lewis. "'How-to' Books for Children." *New York Times*, June 10, 1951.

Byars, Mel. "What Makes American Design American?" introduction to reprint edition, *Modern American Design by the American Union of Decorative Artists and Craftsmen*, edited by R. L. Leonard and C. A. Glassgold, v–xxvi. New York: Acanthus Press, 1992.

C., C. "Artist with Needle & Thread." *American Fabrics*, no. 11 (Fall 1949): 88–91.

C., L. "Mariska Karasz." *Art News* 53 (October 1954): 59.

Callahan, Ashley. "Enchanting Modern: Designer Ilonka Karasz," *Newsletter of the Decorative Arts Society* 12 (Summer 2004): 7–10.

———. *Enchanting Modern: Ilonka Karasz (1896-1981)*. Exhibition catalogue. Athens, GA: Georgia Museum of Art, 2003.

Caswell, Muriel. "Needle Pushing Fun." *Boston, Massachusetts Post*, September 11, 1949.

Chicago Daily Tribune. "Mariska Karasz is Here," January 9, 1950.

Christian Science Monitor. "An Hungarian Dress Designer," May 25, 1926.

———. Untitled, March 13, 1963.

Christopher, Catherine. *The Complete Book of Embroidery and Embroidery Stitches*. New York: Greystone Press, 1948.

Churchman, Deborah. "Textured Communication Through the Needle's Eye." *Washington Post*, September 3, 1981.

"Circuit Show of Needlework." *Craft Horizons* 15 (January–February 1955): 46.

Cnbloch, Nini. "Embroidery Raised to Level of Fine Art by Miss Mariska Karasz of Brewster." Unidentified New York newspaper, August 19, 1956.

Coleman, Elizabeth Ann. "Jessie Franklin Turner: A Flight Path for Early Modern American Fashion." *Dress* 24 (1998): 58–64.

Conroy, Sarah Booth. "'Art in Stitches': Making a Needle Point." *Washington Post, Times Herald*, March 4, 1973.

Constantine, Mildred, and Jack Lenor Larsen. *Beyond Craft: The Art Fabric*. New York: Van Nostrand Reinhold Company, 1972.

Cooper Union Museum for the Arts of Decoration. *The Wonders of Thread: A Gift of Textiles from the Collection of Elizabeth Gordon, exhibition Dec. 12, 1964, through Feb. 23, 1965*. Exhibition catalogue. New York: Cooper Union Museum, 1964.

Corn, Wanda M. *The Great American Thing: Modern Art and National Identity, 1915-1935*. Berkeley: University of California Press, 1999.

Cotier, Virginia. "Designers of Today and Tomorrow." *Women's Wear Daily*, May 8, 1935.

Craftsmanship in a Changing World. Exhibition brochure. Museum of Contemporary Crafts, New York, September 20–December 4, 1956.

Crawford, M. D. C. "American Styles Created by American Artists." *Women's Wear*, October 3, 1917.

———. "Blouses That Show Beauty and Comfort." Unidentified publication, date and page unknown.

———. "Lack of Peasant Art Handicap to American School." *Women's Wear*, December 8, 1916.

———. "Manicured Chickens More Important Than Art." *Women's Wear*, January 2, 1917.

———. *One World of Fashion*. 1946, 3rd revised edition. Edited by Beatrice Zelin and Josephine Ellis Watkins. Reprint, New York: Fairchild Publications, Inc., 1967.

———. "Persian Found in Hungary." *Women's Wear*, January 3, 1917.

Dahl, Marilyn. "Eighth Annual Art Needlework Fair Begins." *Columbus Citizen,* February 13, 1950.

Dallas, Texas News. "Books in Brief," April 2, 1950.

Danbury News Times. "Local Artist Exhibits Work," August 4, 1951.

"The Daughter's Room." *House Beautiful* 97 (February 1955): 90–92, 132.

Davies, Karen. *At Home in Manhattan: Modern Decorative Arts, 1925 to the Depression.* New Haven, CT: Yale University Art Gallery, 1983.

"Defining the American Way of Life Executed in the New American Style." *House Beautiful* 93 (May 1951): 107+.

Dickinson, Alberta. "Artist with Needle." *Utica Observer-Dispatch,* ca. March 1954.

"Distinctive Modes Shown at Preview." Unidentified publication, ca. 1928, page unknown.

Douglass Morse Howell Retrospective. New York: American Craft Museum, 1982.

"Dresses for Children." Unidentified publication, date and page unknown.

Duncan, Alastair. *American Art Deco.* New York: Harry N. Abrams, 1986.

"Embroidered Christmas Greetings for Very Special Friends." *Woman's Day* (December 1947): 25, 65.

Enthoven, Jacqueline. *The Stitches of Creative Embroidery.* New York, Amsterdam, London: Reinhold, 1964.

Epstein, Beryl Williams. *Fashion Is Our Business.* New York: J. B. Lippincott Company, 1945.

Evening Public Ledger (Philadelphia). "Made-to-Order Easter Clothes for the Growing Miss," March 12, 1940.

"Exhibitions." *Handweaver and Craftsman* 9 (Winter 1957–58): 35–37.

"Expressing Wilhelmina!" Unidentified publication, March 1927.

F., P. R. "Shop Talk." *Child Study: A Journal of Parent Education* 14 (February 1937): 152.

F., S. "Mariska Karasz." *Art Digest* 29 (October 15, 1954): 27.

F. Schumacher & Co. *Portfolio of Fabrics* (February 1953).

"Fabrics by Karasz." *Interiors* 110 (February 1951): 18.

"Fabrics Set the Pace for Your Creative Embroidery." *House Beautiful* 94 (November 1952): 234–35.

Fiberworks. Exhibition catalogue. The Cleveland Museum of Art, 1977.

Fisher, Barbara E. Scott. "Children Should Have Taste, Too." *Christian Science Monitor,* October 13, 1943.

———. "Rummaging Round New York." *Christian Science Monitor,* December 15, 1948.

Fitchburg (Mass.) Sentinel. "Museum Plans 'Symphony in Stitches,'" November 19, 1959.

Flenniken, Margaret. "Creative Effort in Children." *New York Times,* May 25, 1930.

Fort Worth, Texas Post. "Embroidery for Modern Woman Explained in Book," September 10, 1949.

G., O. "Case of Ambidexterity: Bertha Schaefer." *Interiors* 116 (April 1957): 94–98, 179.

G., R. "Mariska Karasz." *Art News* 49 (January 1951): 49.

———. "Mariska Karasz." *Art News* 51 (December 1952): 43.

Gardner, Marilyn. "Take a Second Look at the Art of Embroidering." *Milwaukee Journal,* October 18, 1959.

Gervers-Molnár, Veronika. *The Hungarian Szür: An Archaic Mantle of Eurasian Origin.* Toronto: Royal Ontario Museum, 1973.

Goldberger, Paul. "Architecture: Abraham Geller, a New York Modernist's New Jersey Landmark." *Architectural Digest* 49 (November 1992): 118–22, 126.

Gordon, Elizabeth. "This Is The House Beautiful." *House Beautiful* 95 (November 1953): 218.

———. "This Room Has Style—But Not Any One Style." *House Beautiful* 96 (April 1954): 152, 154, and 240.

Green, Betty. "Designed for You by Mariska Karasz, New York." *Parents' Magazine* 14 (February 1939): 84, 88–89.

Guild, Vera P. *Creative Use of Stitches.* Worcester, MA: Davis Publications, Inc., 1964.

Hacket, G. D. "An Artist in Needlework." *Harper's Bazaar* 81 (March 1947): 331.

"Half and Half Tonic for Juveniles." Unidentified publication, date and page unknown.

Hall, Guin. "Needlework Expert Urges Inventiveness." *New York Herald Tribune,* September 25, 1959.

Hedlund, Catherine A. "At This Stitch in Time." *Washington Post,* February 9, 1975.

Henkscher, August. "American Craft Museum: 25 Years." *American Craft* 41 (October/November 1981): 9–17.

Hofer, Tamás, and Edit Fél. *Hungarian Folk Art.* Oxford, London, New York: Oxford University Press, 1979.

Hook, Barbara. "New Book Gives Fresh Approach to Feminine Art, Embroidery." *Virginian-Pilot* (Norfolk, Virginia), September 11, 1949.

Honoré, Andrea Swanson. "Paper Trails, Douglass Howell and How Paper Won Its Way into Western Art." Laurence Barker, Paper Artist and Printmaker. www.laurencebarker.com/article_papertrails.html.

"House Beautiful Presents the 1953 Pace Setter House." *House Beautiful* 94 (November 1952): 199+.

"House Beautiful Proved That You Can Be Creative in Embroidery." *House Beautiful* 94 (January 1952): 76–77, 101–102.

"House Beautiful's 1954 Pace Setter House." *House Beautiful* 95 (November 1953): 217, 219, 222, 263, 269, 276.

"The House in Good Taste." *House Beautiful* 64 (August 1928): 149–52.

"How 6 Unartistic People Embroidered a Fish." *House Beautiful* 94 (January 1952): 78–79.

"How to Work Embroidery into Your Decorating." *House Beautiful* 98 (August 1956): 78–79, 116–19.

Hughes, Alice. "Woman's New York." *Indianapolis, Indiana Star,* September 2, 1949.

The Hungarian Foreign Trade Board, ed. *Hungarian Domestic Crafts and Peasant's Art.* Budapest: Ernest Koltia, 1940–48?.

Journal-Every Evening, Wilmington. "Strings, Wire, Shells Produce Art," October 12, 1953.

Karasz, Mariska. "Abstract Stitches." *Craft Horizons* 13 (March/April 1953): 10–15.

———. *Adventures in Stitches: A New Art of Embroidery.* New York: Funk & Wagnalls, 1947.

———. *Adventures in Stitches: A New Art of Embroidery and More Adventures—Fewer Stitches.* New York: Funk & Wagnalls, 1959.

———. "Borrow Design Ideas from Your Furnishings: Lesson No. 5." *House Beautiful* 94 (September 1952): 82–85.

———. "Borrow Your Embroidery Designs from the Beauty Around You: Lesson No. 4." *House Beautiful* 94 (July 1952): 80–83, 91–93, 95, 104–105.

———. "Color-Scheme or Color-Scream." Unpublished article, submitted to *Charm,* 1931.

———. "Course in Creative Stitchery." *School Arts* 54 (June 1955): 11–16.

———. "Create Golden Glamour with Needle and Thread: Lesson No. 8." *House Beautiful* 95 (December 1953): 124–25, 220–23.

———. *Design and Sew.* New York: Lippincott, 1946.

———. *The Good Housekeeping See and Sew: A Picture Book of Sewing.* New York and Philadelphia: Frederick A. Stokes Company, 1943.

———. "How to Begin: Lesson No. 1." *House Beautiful* 94 (January 1952): 82–89.

———. "How to Create with One Stitch: Lesson No. 2." *House Beautiful* 94 (March 1952): 100–101, 163–71.

———. *How to Make Growing Clothes for Your Baby.* New York: Pelligrini & Cudahy, 1952.

———. "Lesson Number 7: A Quick Creative Needle." *House Beautiful* 95 (May 1953): 174–75, 233–34, 236–37.

———. "On the Long Trail: Part I." *Art Life of the Studio Club of New York* 4 (November 1919): 3 and 10.

———. "On the Long Trail: Part II." *Art Life of the Studio Club of New York* 6 (December 1919): 5, 10–11.

———. "See How Creative Embroidery Ties Together All Furnishings: Lesson No. 6." *House Beautiful* 95 (January 1953): 90–91, 116–17.

———. "Three Stitches Can Look Like a Dozen: Lesson No. 3." *House Beautiful* 94 (May 1952): 170–71, 216–22.

Kardon, Janet, ed. *Craft in the Machine Age, 1920-1945: The History of Twentieth-Century American Craft.* New York: Harry N. Abrams, Inc., Publishers, in association with the American Craft Museum, 1995.

Kay, Ruth Mac. "White Collar Girl." *Chicago Daily Tribune,* April 30, 1949.

Keyes, Helen Johnson. "Clothes and the Child." *Christian Science Monitor,* November 21, 1934.

———. "Clothes to Express the Child." *Christian Science Monitor,* November 15, 1935.

———. "Diversity Within the Law." *Christian Science Monitor,* December 23, 1931.

———. "Diverting Little Frocks." *Christian Science Monitor,* June 12, 1935.

Kinchin, Juliet. "Hungary: Shaping a National Consciousness." In Wendy Kaplan, *The Arts and Crafts Movement in Europe and America, 1880–1920: Design for the Modern World,* 142–77. New York: Thames and Hudson, in association with the Los Angeles Museum of Art, 2004.

Kirkwood, Marie. "The Point Is—She Needles Artfully." *Cleveland News,* March 20, 1954.

Krasne, Belle. "Needle, Thread and Scraps of Cloth." *Craft Horizons* 15 (January–February 1955): 16–19.

Krevitsky, Nik. *Stitchery: Art and Craft.* New York, Amsterdam, London: Reinhold, 1966.

Kristó-Nagy, Kataling, and Margit Nagy-Jara. *Hungarian Embroideries.* Passaic, NJ: Hungarian Folk Museum and New York: Püski-Corvin, 1983.

Larsen, Jack Lenor. *Jack Lenor Larsen: A Weaver's Memoir.* New York: Harry N. Abrams, Inc., Publishers, 1998.

———. "The Weaver as Artist." *Craft Horizons* 15 (November–December 1955): 30–34.

Leitner, Loretta. "How to Make It—." *Chicago Daily Tribune,* October 26, 1952.

Los Angeles Times. "Books for Women," October 31, 1941.

———. "California Art Club to Be Host," July 17, 1928.

———. "Local Statuary Draws Criticism at Art Dinner," July 20, 1928.

M. A. C. Supplement, *Modern Art Collector* 1 (September 1915): n.p.

M., E. C. "Mariska Karasz." *Art News* 55 (December 1956): 59.

M., M. "Lady of the House." *Chicago Daily Tribune,* July 31, 1949.

"Magazine Houses." *House and Home* 8 (October 1955): 144–50.

Manchester (N. H.) Union Leader. "Needleworker Must Make Own Designs Says Artist," October 29, 1951.

Mariska Karasz. Exhibition brochure. Museum of Contemporary Crafts, February 17–March 12, 1961.

"Mariska Karasz." *Handweaver and Craftsman* 11 (Fall 1960): 62.

"Mariska Karasz 1898-1960." *Interiors* 120 (September 1960): 215.

"Mariska Karasz—A Name to Watch." Unidentified publication, ca. 1934, page unknown.

Martin, Richard. *Cubism and Fashion.* New York: The Metropolitan Museum of Art with Harry N. Abrams, Inc., 1998.

Martin, Viahnett S. "Scraps from the Sewing Basket." *News-Review,* Roseburg, Ohio, November 15, 1949.

McCully, Helen. "Born to Be a Best Cook." *McCall's* 76 (July 1949): 50–51.

McGee, Judith Straeten. "Embroidery Through the Ages." *Craft Horizons* 38 (October 1978): 19–21.

McGregor, Donald. "AUDAC in Brooklyn." *Good Furniture and Decoration* 36 (June 1931): 322–25.

Mears, Patricia E. "Jessie Franklin Turner: American Fashion and 'Exotic' Textile Inspirations." In *Creating Textiles: Makers, Methods, Markets*, 431–40. New York: Textile Society of America, 1998.

"Merishka Karass [sic]." *Art News* 46 (April 1947): 46–47.

Milbank, Caroline Rennolds. *New York Fashion: The Evolution of American Style.* New York: Harry N. Abrams, Inc., 1989.

Millier, Arthur. "Koch's Initial Coast Display Wins Praise; Serene Works Have Family Appeal; Karasz Thread Pictures Featured." *Los Angeles Times*, March 18, 1951.

Montgomery, Marjorie. "Motor Car Age Blamed for Drop in Rewarding Art of Needlework." Unidentified newspaper, ca. 1956.

Monze, Mary E. "Recipe for a Two-Story Room." *American Home* 53 (May 1955): 46–47.

Moore, Mary. "A Painter in Thread . . . Mariska Karasz." *Craft Horizons* 9 (Winter 1949): 20–22.

Nelson, Mary Carroll. "Stitchery: The Art of Martha Mood and Wilcke H. Smith." *American Artist* 50 (October 1985): 68–70, 100–104.

The New Bulletin, Staten Island Institute of Arts and Sciences 10 (November 1960): 25.

"New England Summer." *Flair* 1 (June 1950): 58–63.

New Hampshire Sunday News. "Poetry of Embroidery Is Stressed at Current Exhibit at Art Gallery," October 7, 1951.

"New York Gallery Groups." *Art Digest* 26 (June 1, 1952): 17.

New York Herald Tribune. "Families of Society to Take Part in Piping Rock Horse Show," September 24, 1939.

———. "Mariska Karasz Shows Children's Spring Garb," February 2, 1940.

———. "A Navy Blue Coat Over a Print Frock Makes a Smart Spring Ensemble for the Small Girl," March 24, 1937.

New York Times. "Advertising News and Notes," April 30, 1946.

———. "Art: German Parable," December 1, 1956.

———. "Artist for a Year, to Open Show Here," March 2, 1947.

———. "At Last, Something New," July 15, 1928.

———. "Designs Presented by Thread Stylist," November 25, 1952.

———. "Early Exhibitions of the Season: Art at Home and Abroad," October 20, 1918.

———. "Film Arts Guild Opens New Theatre," February 2, 1929.

———. "Gustav A. Weidhaas," August 23, 1938.

———. "Hughes Mearns, Educator, Dead," March 14, 1965.

———. "Many Art Displays Fill Holiday Week," November 24, 1952.

———. "Mariska Kavasz [sic] Is Dead at 62; Needlework Artist and Author," August 28, 1960.

———. "Museum's Display Heads Art Events," April 14, 1947.

———. "New Things Seen in the City Shops," November 20, 1938.

———. "'Pictures' Evolved from Embroidery," December 27, 1950.

———. "Some New Ways with Wall Decorations," May 16, 1955.

———. "Trimmings Are Quaint," January 4, 1925.

———. "Varied Stitches Termed a Boon to Embroidery," September 25, 1959.

———. "Windsor, Told to 'Hurry Up,' Speeds to Reunion Today," May 4, 1937.

Obst, Frances Melanie. *Art and Design in Home Living.* New York and London: The MacMillan Company and Collier-MacMillan Limited, 1963.

"On and Off the Avenue." *The New Yorker*, November 27, 1948, 105–106.

P., S. "Art Events in the Galleries." *New York Times*, December 7, 1952.

"The Pace Setter Art Objects." *House Beautiful* 96 (February 1954): 128–32+.

"Park East Shopper." Unidentified publication, ca. April 1941, page unknown.

Pepis, Betty. "Handcrafts of the United States." *New York Times*, October 12, 1952.

———. "ONE of a Kind." *New York Times*, December 30, 1951.

———. "Pictures Painted with Yarn and Thread." *New York Times*, December 12, 1954.

Pepper, Nancy. "Tricks for Teens." *Washington Post*, February 23, 1947.

Philadelphia Evening Public Ledger. Untitled, March 12, 1936.

———. Untitled, March 4, 1937.

Pope, Virginia. "Six Stores Exhibit Summer Fashions." *New York Times*, April 28, 1943.

Portner, Leslie Judd. "The American Artist as a Designer." *The Washington Post and Times Herald*, August 14, 1955.

Price, Alice. "Originality in Embroidery." Unidentified newspaper, ca. 1957.

Pringle, Ann. "Mariska Karasz Goes Modern with Stitches." *New York Sun*, April 14, 1947.

Putnam County Courier. "Talented Craftsman to Appear on WGNY," June 3, 1948.

Quirk, Rory. "Etcetera." *Washington Post*, March 20, 1977.

Rae, Margery. "A Sunday in Mezőkövesd." *National Geographic* 67 (April 1935): 489–504.

Ramsey, Bets. "A Tribute to Mariska Karasz (1898-1960)." In *Uncoverings 1989*, edited by Laurel Horton, 159–60. San Francisco: American Quilt Study Group, 1990.

Reno, Doris. "Lowe Show Has Sharp Contrast." *Miami Herald*, February 21, 1960.

Renwick Gallery. *Skilled Work: American Craft in the Renwick Gallery*, National Museum of American Art, Smithsonian Institution. Washington, DC, and London: Smithsonian Institution Press, 1998.

Rice, Dustin. "Old Wine, New Bottles." Unidentified newspaper, November 28, 1956.

Ridley, Mary Wells. "Sew a Fine Seam, Darling Daughter!" *New York World-Telegram*, September 20, 1943.

Russel, Ruthana. "Books in Review." *Practical Home Economics* 28 (June 1950): 264.

S., R. "Wall Hangings and Rugs: Museum of Contemporary Crafts Exhibit." *Craft Horizons* 17 (May–June 1957): 18–24.

Shaeffer, Claire B. *Couture Sewing Techniques.* Newtown, CT: The Taunton Press, 2001.

Shaw, Madelyn. "American Fashion: The Tirocchi Sisters in Context." In *From Paris to Providence: Fashion, Art, and the Tirocchi Dressmakers' Shop, 1915-1947,* edited by Susan Hay, 105–30. Providence, RI: Museum of Art, Rhode Island School of Design, 2000.

———. "American Silk from a Marketing Magician: H. R. Mallinson & Co." In *Silk Roads, Other Roads: Proceedings of the Textile Society of America's 8th Biennial Symposium.* Northampton, MA: Textile Society of America, Inc., 2002, CD-ROM.

———. "H. R. Mallinson & Co., Inc." In Jacqueline Field, Marjorie Senechal, and Madelyn Shaw, *American Silk: Artifacts and Entrepreneurs, 1830-1930.* Lubbock, TX: Texas Tech University Press, forthcoming, spring 2007.

Shilliam, Nicola J. "Emerging Identity: American Textile Artists in the Early Twentieth Century." In Marianne Carlano and Nicola J. Shilliam, *Early Modern Textiles—From Arts and Crafts to Art Deco,* 28–44. Boston: Museum of Fine Arts, Boston, 1993.

Slavin, Richard E., III. *Opulent Textiles: The Schumacher Collection.* New York: Crown Publishers, Inc., 1992.

Smith, Barbara Lee. *Celebrating the Stitch: Contemporary Embroidery of North America.* Newtown, CT: The Taunton Press, 1991.

Smith, Roberta. "A Fashion Statement Draped in Cubism." *New York Times,* December 11, 1998.

"Smithsonian American Art Museum to Open 'High Fiber.'" December 3, 2005. *Art Daily,* www.artdaily.com.

Smuts, Alice Boardman. *Science in the Service of Children, 1893-1935.* New Haven, CT, and London: Yale University Press, 2006.

Sonzogni, Valentina, comp. "Biography." In *Friedrich Kiesler, Designer: Seating Furniture of the 30s and 40s.* Ostfildern-Ruit: Hatje Cantz; Portchester: Art Books International [distributor], 2005.

Sowers, Robert. "Mariska Karasz." *Craft Horizons* 19 (May–June 1959): 40.

Springfield Union (Massachusetts). "Creative 'Stitchery' Shown in Work by Mariska Karasz," March 8, 1952.

Storey, Walter Rendell. "Arts and Crafts Attuned to the Hour." *New York Times,* May 3, 1931.

"'Studio Type' Blouse also Uses Gabardine, in Wool." Unidentified publication, date and page unknown.

Tachau, Hanna. "Modern Ideas for Very Young Moderns." *American Home* 14 (September 1935): 259–61, 292.

Tanner, Laura. "The Master Bedroom and Bath." *House Beautiful* 95 (November 1953): 244, 245, 289.

Techy, Margaret. "Writes New Technical Book to Aid Embroidery Workers." *Cleveland Plain Dealer,* October 23, 1949.

Thomson, Peggy. "Crewel." *Washington Post's Potomac,* November 28, 1965.

Thurman, Christa C. *The 20th-Century Textile Artist.* Exhibition brochure. The Art Institute of Chicago, March 31–August 1, 1999.

Toledo Blade. "Thread 'Abstractions,'" March 28, 1952.

"A Touch of the European." Unidentified publication, date and page unknown.

"Trade Book Clinic Studies Current Title Pages." *Publishers' Weekly,* October 1, 1949, 1616.

"Tyrolean Success Inspires Designer to Open Salon." Unidentified publication, date and page unknown.

Union-Leader (Manchester, New Hampshire). "Embroiderer to Give Talk at Gallery," October 26, 1951.

Untracht, Oppi. "Karasz-Choy," *Craft Horizons* 21 (March–April 1961): 52.

Van Dommelen, David B. *Decorative Wall Hangings, Art with Fabric.* New York: Funk & Wagnalls Company, Inc., 1962.

———. *Designing and Decorating Interiors.* New York, London, Sydney: John Wiley & Sons, Inc., 1965.

Vreeland, Alida. "Hungarian Ideas Modernized." *Christian Science Monitor,* December 18, 1929.

Walch, Margaret. *Living Colors: The Definitive Guide to Color Palettes Through the Ages.* San Francisco: Chronicle Books, 1995.

Washington Post, Times Herald. "They're Learning to Stitch Between Campaigns," February 7, 1963.

Weber, Eva. *Art Deco in America.* New York: Exeter Books, 1985.

White, Margaret. "Wrought with the Needle." *The Museum* 10 (published by The Newark Museum) (Spring 1958), 1–17.

Whitley, Lauren. "Morris De Camp Crawford and American Textile Design 1916-1921" (Master's thesis, State University of New York, Fashion Institute of Technology, 1994).

Wilmington Sunday Star. "Needle Artist to Show Slides," October 18, 1953.

Wilson, Elizabeth. "The Students." In *Fifty Years of Association Work Among Young Women, 1866-1916: A History of Young Women's Christian Associations in the United States of America.* New York and London: Garland Publishing, Inc., 1987.

Wilson, Richard Guy, et al. *The Machine Age in America.* New York: Brooklyn Museum, 1986.

Women's Wear Daily. "Appliques Suggest Suspenders and Apron Effects in Karasz Custom Designs," October 29, 1941.

———. "Candy Sticks, Rose Leaves, Watermelon Motifs Adorn Girls' Frocks for Spring," February 5, 1940.

———. "Central European Peasant Inspires Spring Collection by Mariska Karasz," March 2, 1938.

———. "Chambray Appliqued in Gayest Contrasts in Custom-Made Group," October 26, 1938.

———. "Colorful Appliques Identify 'Dateless' Princess Frocks," October 20, 1937.

———. "Mariska Karasz Designs for Children Have a Refreshing and Imaginative Quality," March 14, 1934.

———. "Mariska Karasz Does Apron and Petticoats By Color Contrasts," March 2, 1939.

———. "Mariska Karasz Turns Her Creative Talents to Designing of Children's Clothes," date unknown.

———. "Military and Exotic Themes Developed in Summer Negligees by Uptown Designer," March 25, 1937.

———. "Mother and Daughter Fashions Differ In Silhouette," March 31, 1937.

———. "Mother-and-Daughter Theme Gains Momentum for Exclusive Trade," March 17, 1937.

———. "Practical Features Treated with Imagination by Young Designer," April 17, 1935.

———. "Still Present—the Peasant Theme in an American Mood," December 21, 1938.

———. "Sun Skirts, Peasant Jackets New in Mariska Karasz Summer Fashions," March 25, 1936.

———. "'Youngest Set' Wears Expensive Handmades at Recent Outdoor Event," June 23, 1937.

Wood, Prunella. "Little Girls' Garb Grows Up for Mothers." *New York American,* April 30, 1937.

CATALOGUE OF THE EXHIBITION

All works by Mariska Karasz (American, b. Hungary, 1898–1960) unless otherwise noted.
All works collection of the artist's family unless otherwise noted.

Women's Clothing

1 Ensemble, ca. 1927
Silk
Dress (a), length at CB 41¾ inches; Jacket (b), length at CB 32 inches
Lent by The Metropolitan Museum of Art
Gift of Katherine J. Judson, in memory of Jeanne Wertheimer, 1977 (1977.284.2ab)

2 Ensemble, ca. 1927
Silk
Dress (a), length at CB 32½ inches; Jacket (b), length at CB 24 inches
Lent by The Metropolitan Museum of Art
Gift of Katherine J. Judson in memory of Jeanne Wertheimer (1977.284.1ab)

3 Jacket, ca. 1927
Silk
Length of body approx. 16½ inches; length of sleeve approx. 21 inches

4 Jacket, ca. 1928
Wool on challis, silk pockets, metal buttons
Length approx. 33 inches

5 Dress (orange and green), ca. 1930
Silk with zipper
Length approx. 53 inches

6 Dress with slip (black and white), ca. 1930
Silk with zipper
Length approx. 51 inches

7 Dress (scarlet and light peach), ca. 1930
Silk with zipper
Length approx. 53¼ inches

8 Embroidered jacket, ca. 1935
Multicolored wool embroidery on wool
Length approx. 19 inches

9 Dress, ca. 1938
Linen appliqué on linen with zipper
Length approx. 40 inches
Georgia Museum of Art, University of Georgia; museum purchase
GMOA 2005.85

Drawings of Women's Fashion

Designed by Mariska Karasz, drawn by unidentified artist(s).

10 No 410 dress (tunic dress with fractured graphics), ca. 1925–30
Ink over erased graphite on Fabriano paper
11¹³⁄₁₆ x 9 inches

11 No 450 dress (tunic dress with American Indian design), ca. 1925–30
Ink and crayon over graphite on Fabriano paper, measurements written on back
11¹³⁄₁₆ x 9 inches

12 Dress (with cape and pleated skirt, with appliquéd decoration), ca. 1925–30
Graphite on Fabriano paper
11¹⁄₁₆ x 9 inches

13 Dress (sleeveless, with appliquéd designs in corners), ca. 1925–30
Graphite on Fabriano paper
11⅛ x 9 inches

14 Dress (two-color dress with crocheted seams, with jacket), ca. 1925–30
Graphite on Fabriano paper
11¼ x 9 inches

15 Two dresses (with telephone setting), ca. 1925–30
Ink over erased graphite on Fabriano paper
11¹⁄₁₆ x 9 inches

16 Dress (appliquéd modern design), ca. 1925–30
Graphite on Fabriano paper
11¹⁄₁₆ x 9 inches

17 Two dresses (with tulip and circle patterns), ca. 1925–30
Graphite on Fabriano paper
11⅛ x 9 inches

18 Dress (with tulip pattern, seen in two views, with jacket), ca. 1925–30
Graphite on Fabriano paper
11¹⁄₁₆ x 8¹⁵⁄₁₆ inches

19 Dress (with allover double chevron pattern, with jacket), ca. 1925–30
Graphite on Fabriano paper
11⅛ x 9 inches

20 Dress (with triangular embroidered panel on front and collar, with jacket), ca. 1925–30
Graphite on Fabriano paper
11⅛ x 9 inches

21 Dress (with allover flowers and central void, with jacket), ca. 1925–30
Graphite on Fabriano paper
11⅛ x 9 inches

22 Two dresses (with zigzag pattern and embroidered waist), ca. 1925–30
Graphite on Fabriano paper
11¹⁄₁₆ x 9¹¹⁄₁₆ inches

23 Szür-style jacket, ca. 1926
Graphite on Fabriano paper
11⅛ x 9 inches

24 Dress, ca. 1928
Graphite on Fabriano paper
11 x 9 inches

25 Dress with embroidered vest, ca. 1928
Graphite on Fabriano paper
11⅛ x 9 inches

Photographs of Women's Fashion

26 J. C. Milligan (American)
Model wearing dress and coat by Mariska Karasz, ca. 1928
Photograph
9⅝ x 7¹¹⁄₁₆ inches

27 J. C. Milligan (American)
Model wearing dress by Mariska Karasz, ca. 1928
Photograph
9¹¹⁄₁₆ x 7¹¹⁄₁₆ inches

28 J. C. Milligan (American)
Model wearing dress by Mariska Karasz, ca. 1928
Photograph
9¹¹⁄₁₆ x 7¾ inches

29 J. C. Milligan (American)
Model wearing dress by Mariska Karasz, ca. 1928
Photograph
9¹¹⁄₁₆ x 7¹¹⁄₁₆ inches

30 J. C. Milligan (American)
Three models wearing dresses by Mariska Karasz, ca. 1928
Photograph
9¹¹⁄₁₆ x 7¾ inches

31 Herbert Photography, Inc.
Scarves by Mariska Karasz, ca. 1928
Photograph
9⅝ x 7⅝ inches

32 Unidentified photographer
Model wearing ensemble by Mariska Karasz, ca. 1930
Photograph
8 x 10 inches

33 Unidentified photographer
Model wearing dress by Mariska Karasz, ca. 1930
Photograph
8 x 10 inches

34 Unidentified photographer
Actress Dorothy Peterson modeling dress by Mariska Karasz, ca. 1930
Photograph
9¹⁵⁄₁₆ x 8 inches

35 Unidentified photographer
Model wearing dress by Mariska Karasz, ca. 1930
Photograph
10 x 8 inches

Photographs and Paintings of Mariska Karasz

36 Ilonka Karasz (American, b. Hungary, 1896–1981)
Untitled (portrait of Mariska Karasz), ca. 1920
Watercolor and gouache on paper
12⅛ x 16⅜ inches
Collection of Jennifer Alden Cox

37 Nickolas Muray (American, b. Hungary, 1892–1965)
Mariska Karasz (wearing dress with tulip design), ca. 1926
Photograph
10 x 8 inches

38 Nickolas Muray (American, b. Hungary, 1892–1965)
Mariska Karasz (wearing *szür*-style coat), ca. 1926
Photograph mounted on board
10 x 8 inches
17½ x 12½ inches (board)

39 Nickolas Muray (American, b. Hungary, 1892–1965)
Mariska Karasz (wearing necklace and hat), ca. 1928
Photograph mounted on board
10 x 8 inches
17½ x 12½ inches (board)

40 Nickolas Muray (American, b. Hungary, 1892–1965)
Mariska Karasz (sitting in studio), ca. 1928
Photograph
8 x 10 inches

41 Nickolas Muray (American, b. Hungary, 1892–1965)
Mariska Karasz and Donald Peterson, 1928
Photograph
9½ x 7¼ inches
15⅞ x 11½ inches (matted)

42 Nickolas Muray (American, b. Hungary, 1892–1965)
Mariska Karasz (standing in studio), ca. 1928
Photograph
10 x 8 inches

43 Nickolas Muray (American, b. Hungary, 1892–1965)
Mariska Karasz (with embroidered patch on shoulder), ca. 1928
Photograph mounted on paper
9⅛ x 7¹¹⁄₁₆ inches (photo)
13 x 10 inches (paper)
Collection of the Portas family

44 Nickolas Muray (American, b. Hungary, 1892–1965)
Mariska Karasz (profile), ca. 1928
Photograph
10 x 8 inches

Ephemera related to women's fashion

45 Mariska Karasz's sketchbook, n.d.
Paper
9 x 6⅝ x ⅝ inches

46 Clipping from *Women's Wear*, 1917
(with M. D. C. Crawford, "American Styles Created by American Artists")
Newsprint mounted on paper
10 x 11⅞ inches (unfolded)

47 Clipping from unidentified newspaper, ca. 1917
(with M. D. C. Crawford, "Blouses That Show Beauty and Comfort")
Newsprint mounted on paper
9⅝ x 8 inches

48 Unidentified photographer
Mariska Karasz climbing a fence, 1918
Photograph
3½ x 2½ inches
Collection of the Portas family

49 Unidentified photographer
Mariska Karasz wearing pants, 1918
Photograph
5⅝ x 3¼ inches
Collection of the Portas family

50 Unidentified photographer
Mariska Karasz in a field of flowers, n.d.
Photograph
3¼ x 4¼ inches
Collection of the Portas family

51 Two pages from Mariska Karasz's scrapbook with photographs from her trip to Hungary, n.d.
Photographs mounted on paper
6⅝ x 9⅝ inches each

52 Brochure for the Studio Club of New York, n.d.
(Cover illustration by Mariska Karasz)
Ink on paper
4⅞ x 5½ inches (folded)

53 Unidentified designer
Announcement for fall collection, n.d.
("I hope you will come to see me at my new studio. I have some interesting fall and winter dresses to show you.")
Ink on paper
4⅛ x 5⅛ inches (unfolded)

54 Sketches for dress tops, n.d.
Graphite on paper
11 x 8⅜ inches

55 Unidentified designer
Announcement for spring fashion show, n.d.
("Mariska Karasz cordially invites yuo [*sic*] + your friends to her Fashion Show")
Ink on paper
Approx. 5½ x 9¾ inches
Collection of the Portas family

56 Unidentified designer
Invitation to 228 Madison Avenue, n.d.
("I promised to let you know of my return from abroad.
When you are shopping in my neighborhood do come up
to see the models I brought back with me.")
Ink on paper
Approx. 4¼ x 7½ inches (unfolded)

57 Unidentified designer
Announcement for Mariska Karasz, n.d.
("Mariska Karasz has returned from her trip abroad with
many colorful things.")
Ink on paper
Approx. 5½ x 3½ inches

58 Unidentified designer
Announcement for spring opening, n.d.
(with large flower)
Ink on paper
Approx. 5⅛ x 7 inches (folded)

59 Unidentified designer
Announcement for fashion show at the Roosevelt-
Hollywood Hotel, 1928
Ink on paper
10⅞ x 8⅝ inches

60 Unidentified designer
Announcement for fall opening, 1928
Ink on paper
5 x 6⅝ inches

61 List of possible descriptive titles for fall 1929 collection,
1929
Ink and graphite on Street & Finney letterhead
10¾ x 8⅜ inches

62 Unidentified designer
Announcement for spring opening, 1929
Ink on paper
19¹⁵⁄₁₆ x 6⅛ inches (unfolded)

63 Unidentified designer
Announcement for spring showing, 1930
Ink on paper
4⅜ x 5⅝ inches

64 Receipt from Mariska Karasz to Film Guild Cinema, ca.
1929
Ink on paper
6⅜ x 8⅝ inches

65 Receipt from Mariska Karasz to Dorothy Peterson, ca.
1929
Ink on paper
8¾ x 7¼ inches

66 Receipt from Mariska Karasz to Mrs. Fred Guinzburg, ca.
1929
Ink on paper
7³⁄₁₆ x 9⅛ inches

Children's Clothing

67 Pajamas, ca. 1935
Cotton
Length of top 18 inches; length of pants 25¾ inches

68 Jacket with snail pocket, n.d.
Cotton
Length approx. 31 inches
Collection of the Portas family

69 Dress with collar and daisy pockets, n.d.
Cotton
Length approx. 27½ inches
Collection of the Portas family

70 Smock with clock motif, n.d.
Cotton
Length 20¼ inches
Collection of the Portas family

71 Scarf with "SP," n.d.
Probably silk
Approx. 24 x 25 inches

72 Scarf with "Solveig" and cats, n.d.
Silk
Approx. 29 x 28¼ inches

73 Scarf with "Rozsika" and cherubs, n.d.
Silk
Approx. 34 x 34½ inches

Drawings of Children's Fashions

Designed by Mariska Karasz, drawn by unidentified artist(s).

74 Two dresses (with pineapple motif), ca. 1937
Gouache over graphite on paper
12¼ x 9⅛ inches

75 Dress (with floral heart sleeves), ca. 1937
Graphite on paper
10½ x 8 inches

76 Dress (with people on the collar), ca. 1937
Graphite on paper
10½ x 8 inches

77 Dress (with flowers on the skirt), ca. 1938
Graphite on paper
11⅞ x 9¼ inches

78 Dress (red with flower pockets), ca. 1938
Watercolor over graphite on paper
11⅞ x 9¼ inches

79 *Corsage*, ca. 1939
Graphite on paper
10½ x 8 inches

80 *Pockets Full of Rye*, ca. 1939
Graphite on paper
11⅞ x 9¼ inches

81 Dress (with grape motif), ca. 1939
Graphite on paper
11¹¹⁄₁₆ x 9⅜ inches

82 *Tulip Tree*, ca. 1940
Gouache, graphite, and ink on folded paper
Inside: metal straight pin with fabric sample
6 x 5½ inches (folded)

83 *Candy Stick*, ca. 1940
Gouache, graphite, and ink on folded paper
Inside: metal straight pin with three fabric samples
6 x 5½ inches (folded)

84 *Rose Leaf*, ca. 1940
Gouache, graphite, and ink on folded paper
5¹⁵⁄₁₆ x 5⁷⁄₁₆ inches (folded)

85 *Pit-a-Pat*, ca. 1940
Gouache, graphite, and ink on folded paper
Inside: metal straight pin with two fabric samples
6 x 5⁷⁄₁₆ inches (folded)

86 Dress (with chicks on the collar), ca. 1940
Graphite on paper
11⁷⁄₈ x 9¼ inches

87 Dress (with roadrunner motif), ca. 1941
Graphite on paper
10⁷⁄₈ x 8³⁄₈ inches

88 *Banana Blossom*, ca. 1941
Graphite on paper
10⁷⁄₈ x 8⁷⁄₁₆ inches

Photographs of Children's Fashion

89 Clara Sipprell (American, b. Canada, 1885–1975)
Mariska with baby (probably Solveig), ca. 1931
Photograph
8⁷⁄₈ x 7 inches

90 Unidentified photographer
Solveig wearing a sundress, ca. 1933
Photograph
8⁷⁄₈ x 5⁵⁄₈ inches

91 Unidentified photographer
Solveig and Rosamond, ca. 1934
Photograph
8¹¹⁄₁₆ x 6⁵⁄₁₆ inches

92 Stanley H. Goldsmith, Jr. (American)
Dewees window, ca. 1936
Photograph mounted on board
7⁵⁄₈ x 8¾ inches
9¾ x 8¹³⁄₁₆ inches (board)

93 Unidentified photographer
Dewees window, ca. 1936
Photograph
7¹¹⁄₁₆ x 9¼ inches

94 Harry Watts Studio (New York, New York)
Solveig and Rozsika with dolls, ca. 1938
Photograph
10 x 8 inches

Ephemera related to children's fashion

95 Unidentified photographer
Mariska and Solveig, ca. 1932
Photograph
4½ x 2¾ inches

96 Unidentified photographer
Solveig, friend, Rosamond, and Mariska's niece Carola, 1934
Photograph
2¾ x 4½ inches

97 Unidentified photographer
Solveig wearing a dress, for *Good Housekeeping*, ca. 1934
Photograph
4½ x 2¾ inches

98 Unidentified designer
Announcement for spring collection, ca. 1934
("Play suits that are fun to get into . . . ")
Ink on paper
11 x 8½ inches
Collection of the Portas family

99 Unidentified designer
Sleeve for McCall's pattern for child's dress with panties by Mariska Karasz, ca. 1934
Ink on paper
7⁷⁄₁₆ x 6³⁄₈ inches

100 Unidentified designer
Sleeve for McCall's pattern for child's sun suit and hat by Mariska Karasz, ca. 1934
Ink on paper
8 x 6¼ inches

101 Unidentified designer
Sleeve for McCall's pattern for child's sun suit with hat by Mariska Karasz, ca. 1934
Ink on paper
8 x 6³⁄₈ inches

102 Unidentified designer
Sleeve for McCall's pattern for child's dress and panties by Mariska Karasz, ca. 1934
Ink on paper
8 x 6³⁄₈ inches

103 Unidentified designer
Announcement for special showing at Dewees, ca. 1936
Ink on paper
6¼ x 4⁷⁄₁₆ inches

104 Unidentified designer
Flyer for fall collection, 1936
(children with apples)
Ink on paper
10 x 8½ inches
Collection of the Portas family

105 Unidentified designer
Flyer for spring showing, ca. 1937–41
(hand with flowers)
Ink on paper
10⁷⁄₈ x 8½ inches
Collection of the Portas family

106 Unidentified designer
Flyer for new collection, n.d.
(girl on carousel)
Ink on paper
11 x 8½ inches

107 Receipt from Mariska Karasz to Mrs. A. A. Berle, Jr. (New York), 1937
Ink on paper
5⁷⁄₈ x 7¾ inches

108 Receipt from Mariska Karasz to Miss Evelyn Carmey (New York), 1937
Ink on paper
6 x 7¾ inches

109 Receipt from Mariska Karasz to Mrs. Birchall Hammer (Ellis Park, Pennsylvania), 1938
Ink on paper
6 x 7¾ inches

110 Unidentified designer
Announcement for spring showing, ca. 1938
("back from hungary")
Ink on paper
7½ x 6 inches (folded)

111 Unidentified photographer
Mariska Karasz sewing with Rosamond and Solveig, ca. 1939

Photograph
9⅛ x 6¹¹⁄₁₆ inches

112 Unidentified designer
Flyer for spring collection, 1940
(bird and dress form)
Ink on paper
8½ x 10⅞ inches

113 *Harper's Bazaar,* March 1, 1940
Magazine (with photograph of Rozsika and Solveig
Peterson, page 80)
13 x 9¹³⁄₁₆ x ⁵⁄₁₆ inches

114 Unidentified designer
Program for spring collection, ca. 1941
("costumes from sololá . . . ")
Ink on paper
Approx. 6 x 7½ inches

115 Unidentified designer
Announcement for spring collection, ca. 1941
("just back from mexico and guatemala. will you come in
to see my new collection?")
Ink on paper
Approx. 6 x 3¾ inches

116 Unidentified designer
Flyer for fall collection, 1941
(woman and children with wheat)
Ink on paper
11 x 8½ inches

117 Unidentified designer
Flyer for fall collection, 1941
(mother and daughter against leaf)
Ink on paper
8½ x 10⅞ inches

118 Unidentified photographer
Solveig, Rosamond, and Carola sewing, ca. 1943
Photograph mounted on board
10¼ x 11½ inches
Approx. 12 x 13⅛ inches (board)

119 *The Good Housekeeping See and Sew: A Picture Book of
Sewing,* 1943

New York and Philadelphia: Frederick A. Stokes Company
Book
7⁹⁄₁₆ x 10¹⁄₁₈ x ⁷⁄₁₆ inches
Private collection

120 *Good Housekeeping's Show Me How to Sew,* 1947
London: The National Magazine Co., Ltd.
Booklet
9⁷⁄₁₆ x 7³⁄₁₆ x ⅛ inches
Private collection

121 *Design and Sew,* 1946
New York and Philadelphia: J. B. Lippincott Company
Book
7⁵⁄₁₆ x 10⅛ x ½ inches
Private collection

122 Conrad Eiger (American)
Mariska Karasz sewing with Solveig and Rosamond, ca.
1946
Photograph
8⅛ x 10 inches

123 *How to Make Growing Clothes for Your Baby,* 1952
New York: Pelligrini & Cudahy
Book
12¼ x 9⅛ x ⅜ inches
Private collection

124 Clara Sipprell (American, b. Canada, 1885–1975)
Home of Mariska Karasz (with croquet set), n.d.
Photograph mounted on paper mounted in folded paper
9 x 9½ inches (signed paper)

125 Clara Sipprell (American, b. Canada, 1885–1975)
Home of Mariska Karasz (with trees), n.d.
Photograph mounted on paper mounted in folded paper
9 x 9⁷⁄₁₆ inches (signed paper)

Embroideries

126 *Solveig,* 1947
Multicolored embroidery on cotton
23⅜ x 20½ inches

127 *Rozsika,* 1947
Multicolored embroidery on cotton
23¹³⁄₁₆ x 19⁵⁄₁₆ inches

128 *Harlem Valley from the Air,* 1946
French DCM cotton, embroidered
24½ x 25½ inches; 32⅞ x 32⅝ x 1½ inches (framed)
Museum of Arts & Design, New York. Gift of Rosamond
Berg Bassett and Solveig Cox, 1992 (1992.20.4)

129 *Elsa De Brun,* 1947
Linen, wool; embroidered, sewn
27¾ x 23⅞ inches
Museum of Arts & Design, New York. Gift of Rosamond
Berg Bassett and Solveig Cox, 1992 (1992.20.8)

130 *Victoriana,* 1945–47
Wool
28 x 27¼ inches
Cooper-Hewitt, National Design Museum, Smithsonian
Institution; gift of Solveig Cox and Rosamond Berg, the
artist's daughters (1977.45.1)

131 *Gage Hill,* ca. 1947
Multicolored cotton embroidery on cotton
30 x 25½ inches

132 Self-portrait, ca. 1947
Embroidery on linen
22 x 15½ inches

133 Self-portrait, ca. 1947
Embroidery on linen
22 x 15½ inches

134 *Tequila Trip,* ca. 1947
Cotton on unidentified handwoven fiber with wooden slats
Approx. 12¾ x 15¼ inches

135 *Alphabet,* ca. 1947
Mixed fibers, metal wire, and plastic on linen with wooden
dowel
Approx. 53 x 26¼ inches

136 *Goat Tree,* ca. 1947
Mixed fibers on unidentified four-selvage vegetal fiber
with wooden dowel
Approx. 43 x 47½ inches

137 *Glorified Lemon Bag,* ca. 1950
Mixed fibers, straw, and paper with wooden slats
Approx. 20½ x 16¼ inches

138 *Ropes on Red*, ca. 1952
Mixed fibers on linen with wooden slats
Approx. 62½ x 47¾ inches

139 *The Trailer House*, ca. 1953
Mixed fibers on chenille with wooden slats
Approx. 27½ x 21½ inches

140 *Moses I*, 1953
Mixed fibers on linen (?)
Approx. 12¼ x 15 inches (framed)

141 *Moses II*, 1953
Mixed fibers on linen (?)
Approx. 12¼ x 15 inches (framed)

142 *Phoenix*, 1953
Linen, wool, and hemp on linen with wooden slats
51 x 70½ inches
Georgia Museum of Art, University of Georgia; museum purchase
GMOA 2006.51

143 *No Strings Attached*, ca. 1954
Mixed fibers, leather, plastic, and wood on unidentified fiber with wooden slats
Approx. 29 x 14 inches

144 *Babble*, ca. 1955
Mixed fibers and metal on mixed fibers with wooden slats
Approx. 35¾ x 16½ (slat) and 14⅜ (textile) inches

145 *Dawn*, ca. 1955
Mixed fibers on mixed fibers
Approx. 54½ x 18⅛ (slat) and 16 (textile) inches

146 Title unknown, ca. 1955
Mixed fibers on linen with wooden slats
56⅝ x 53 (slat) inches

147 *Alternate B*, ca. 1955
Mixed fibers on linen
17 x 22¹⁵⁄₁₆ inches (framed)

148 Title uncertain, probably *Strata (Pinks)*, ca. 1956
Mixed fibers on cotton with wooden slats
Approx. 83¼ x 14 (slat) and 13¼ (textile) inches

149 *Color Range II*, ca. 1956
Mixed fibers on mixed fiber (probably linen and rayon blend) with wooden slats
Approx. 57⅛ x 82¾ inches

150 *Rose Garden*, 1957–58
Handwoven mercerized cotton, wool, chenille, silk, and rayon
60 x 56⅝ inches
Museum of Arts & Design, New York. Gift of Rosamond Berg Bassett and Solveig Cox, 1992 (1992.20.2)

151 *Transcendence*, 1958
Handwoven wool and cotton, with wool, silk, DMC cotton, Lurex fibers, linen mercerized cotton thread; embroidered, stitched, couched
61 x 62 inches
Museum of Arts & Design, New York. Gift of Rosamond Berg Bassett and Solveig Cox, 1996 (1996.13)

152 *Beacon Light*, ca. 1958
Mixed fibers on linen with wooden slats
61 x 54⅝ inches
Georgia Museum of Art, University of Georgia; museum purchase with funds provided by the Virginia Y. Trotter Decorative Arts Endowment
GMOA 2003.14

153 *Split Level Ark*, 1960
Mixed fibers on handwoven wool with wooden slats
Approx. 37¼ x 60 inches

154 *Hieroglyphics*, 1960
Mixed fibers on mixed fibers with wooden slats
Approx. 66 x 55⅛ (slat) and 48 to 50 (textile) inches

Ephemera and other materials related to embroideries

155 Untitled (placemat with fish), 1952
Linen, metallic cords
18⅞ x 18⅛ inches
Cooper-Hewitt, National Design Museum, Smithsonian Institution; gift of Miss Elizabeth Gordon (1964.35.15)

156 Untitled (placemat with swirls and starbursts), 1952
Straw, silver cord
18⅞ x 12 inches
Cooper-Hewitt, National Design Museum, Smithsonian Institution; gift of Miss Elizabeth Gordon (1964.35.21)

157 Untitled (placemat and napkin with shells), 1952
Cotton
18½ x 18⅛ inches (mat); 17½ x 12 inches (napkin)
Cooper-Hewitt, National Design Museum, Smithsonian Institution; gift of Miss Elizabeth Gordon (1964.35.18, a and b)

158 *Skein*, 1952
Manufactured by F. Schumacher and Co.
Printed linen
32¼ x 49¾ inches
Private collection

159 Board with enlarged page from *House Beautiful*, featuring Mariska Karasz's embroidery *March*, in the 1951 Pace Setter House
12¾ x 9⅝ inches

160 Pages 84–85 from *House Beautiful* with Mariska Karasz's Lesson 4, July 1952
Magazine pages
12¾ x 9¾ inches each

161 *House Beautiful*, November 1952
Magazine
12¾ x 9⅝ x ⁹⁄₁₆ inches
Private collection

162 James Abbé, Jr. (American, 1883–1973)
Sewing group, ca. 1952
Photograph
9⅜ x 9½ inches

163 *Adventures in Stitches: A New Art of Embroidery*, 1949
New York: Funk & Wagnalls Company
Book
9 x 11 x ⁹⁄₁₆ inches
Private collection

164 *Adventures in Stitches: A New Art of Embroidery and More Adventures—Fewer Stitches*, 1959
New York: Funk & Wagnalls
Book
9 x 10⅞ x ¹¹⁄₁₆ inches
Private collection

165 Japanese version of *Adventures in Stitches: A New Art of Embroidery and More Adventures—Fewer Stitches*, 1960
Tokyo: Nippon Vogue-Sha through Orion Press
Book
7⅛ x 8⅛ x ⅜ inches

Exhibition, n.d.
Unidentified photographer
Photograph, 7 3/8 x 2 5/8 inches

166 Unidentified photographer
Photograph of *Night and Day*, ca. 1949
Photograph
8 1/16 x 9 15/16 inches

167 Unidentified photographer
Exhibition installation with *Adventures in Stitches*, n.d.
Photograph
8 1/16 x 9 15/16 inches

168 Unidentified photographer
Mariska Karasz with baskets of materials, 1958
Photograph
10 x 8 1/2 inches

169 Oppi Untracht (American, b. 1922)
Mariska Karasz eating melon, n.d.
Photograph
9 15/16 x 8 inches

170 Unidentified photographer
Mariska Karasz with *Adventures in Stitches* sampler, n.d.
Photograph
10 x 8 1/2 inches

171 Unidentified designer
Brochure for *Recent Embroidery by Mariska Karasz*
exhibition at Bonestell Gallery, April 15–26, 1947
Ink on paper
5 3/4 x 8 3/8 inches (folded)

172 Unidentified designer
Announcement for *The Modern Embroideries of Mariska
Karasz* exhibition at America House, Sept. 13–28, 1949
Ink on paper
3 7/16 x 4 inches

173 Unidentified designer
Announcement for exhibition (Jan. 9–11, 1950) and
appearance at Carson Pirie Scott & Co., Chicago, 1950
Ink on paper
4 5/8 x 5 inches

174 Unidentified designer
Brochure for *Mariska Karasz: Abstractions with Thread*
exhibition at Bertha Schaefer Gallery, Dec. 26, 1950–Jan.
13, 1951
Ink on paper
5 3/4 x 4 7/8 inches

175 Unidentified designer
Flyer for *A Collection of Embroidered Paintings and
Fabrics* exhibition (March 12–25, 1951) and lecture at the
University of California, Los Angeles, 1951
Ink on paper
11 x 8 1/2 inches

176 Unidentified designer
Flyer for illustrated lecture, "You Are More Creative Than
You Think," at the Cleveland Museum of Art, Nov. 15,
1952
Ink on paper
10 15/16 x 8 1/2 inches

177 Unidentified designer
Brochure for *Abstractions in Needlework* exhibition at
Bertha Schaefer Gallery, Nov. 24–Dec. 20, 1952
Ink on paper
4 5/8 x 5 1/2 inches (folded)

178 Unidentified designer
Announcement for *Abstractions in Needlework* exhibition
at Oregon Ceramic Studio, Feb. 10–March 7, 1953
Ink on paper
3 5/8 x 6 1/2 inches

179 Unidentified designer
Announcement for preview of *The Creative Needlework of
Mariska Karasz* exhibition and lecture at the Akron Art
Institute, Dec. 15, 1953
Ink on paper
5 x 6 1/8 inches

180 Unidentified designer
Brochure for Creative Stitchery course, Miami University
summer session, 1954
Ink on paper
8 1/2 x 11 inches (unfolded)

181 Unidentified designer
Brochure for *Mariska Karasz* exhibition at Bertha Schaefer
Gallery, Oct. 4–23, 1954
Ink on paper
4 5/8 x 6 inches (folded)

Mariska and friend, 1957
Unidentified photographer
Photograph, 3½ x 3½ inches

mariska karasz

127

catalogue of the exhibition

182 John Berg (American, b. 1932)
Announcement for *Mariska Karasz* exhibition at Bertha
Schaefer Gallery, Nov. 19–Dec. 9, 1956
Ink on paper
4⅛ x 9⅛ inches

183 Unidentified designer
Announcement for exhibition preview at America House,
Sept. 24, 1959
Ink on paper
4 x 7¾ inches

Embroidered Collages

184 *Snowbirds*, 1959
Needlework collage (mixed papers, fabrics, and threads
mounted on board)
20⁵⁄₁₆ x 14⁹⁄₁₆ inches (framed)

185 *Lighthouse*, 1959
Needlework collage (mixed papers, fabrics, and threads
mounted on board)
27⅜ x 15⅜ inches (framed)

186 *Star Clouds*, 1959
Needlework collage (mixed papers, fabrics, and threads
mounted on board)
11½ x 31⅞ inches (framed)

187 *Honeycomb*, 1959
Needlework collage (mixed papers, fabrics, wood veneer,
and threads mounted on board)
19⅝ x 30½ inches (framed)

188 *At Sea*, ca. 1959
Needlework collage (mixed papers, fabrics, and threads
mounted on board)
10¹⁵⁄₁₆ x 26⁷⁄₁₆ inches (framed)

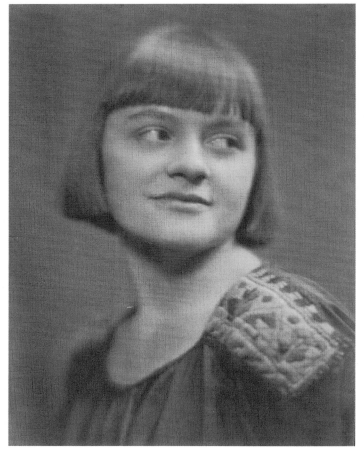